Blue Sky 07/08

September 2007 – Doug Dubois & Sage Sohier
October 2007 – Phil Bergerson & Brenda Ann Kenneally
November 2007 – Victor Cobo & Rita Godlevskis & Saul Robbins
December 2007 – Kirk Thompson & Bil Zelman
January 2008 – Beth Dow & Elaine Ling
February 2008 – Jason Horowitz & Joseph Vitone
March 2008 – Raphael Goldchain & Edis Jurcys
April 2008 – Alex Fradkin & Danielle Mericle & Lisa Robinson
May 2008 – Stephen Berkman
June 2008 – KayLynn Deveney & Karen Glaser & Nicole Jean Hill
July 2008 – Robert Rauschenberg & Ellen Susan
August 2008 – Ntare Guma Mbaho Mwine & Donald Weber

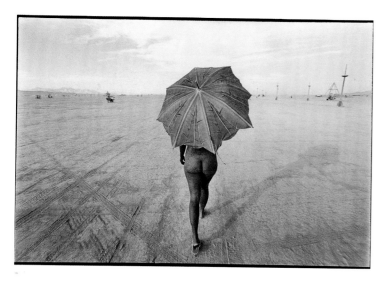

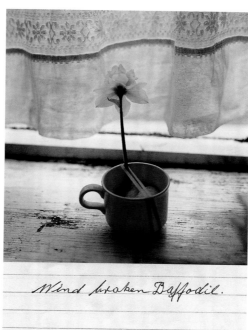

Wind broken Daffodil.

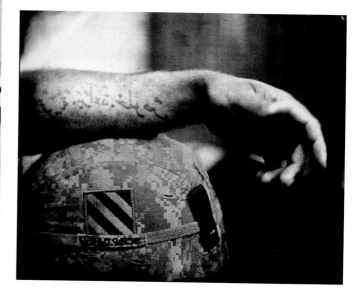

Edis Jurcys, KayLynn Deveney, Ellen Susan (SGT Scripture's Tattoo), Elaine Ling, Raphael Goldchain (Self Portrait as Mojszes Precelman), Donald Weber

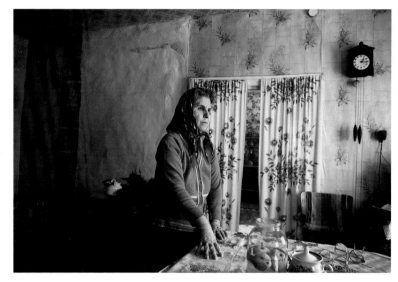

Blue Sky is proud and happy to have had another great lineup of artists this year. As always, we thank our members for making it all possible.

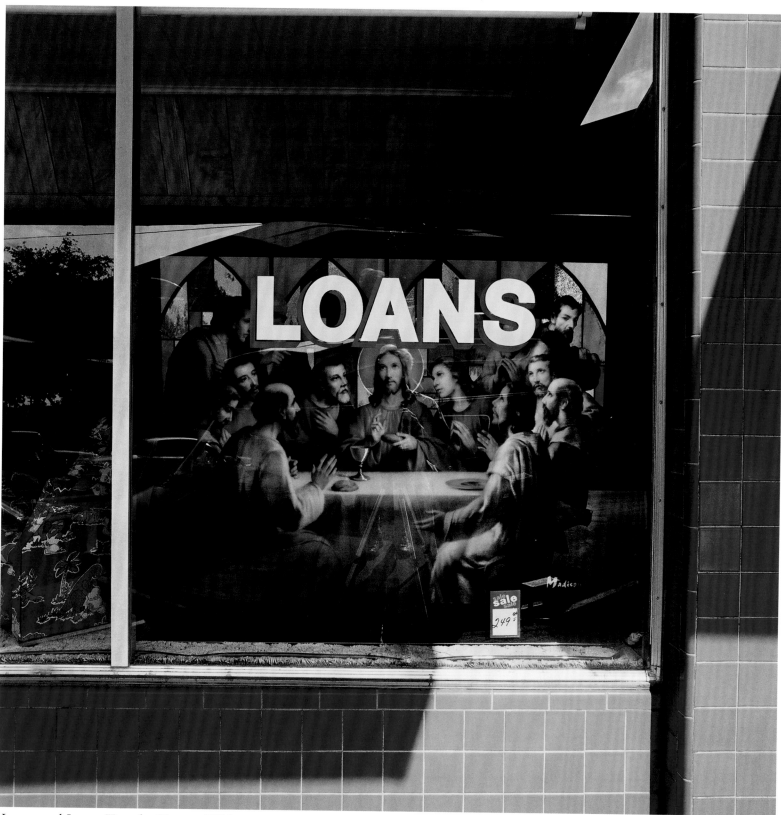

Loans and Jesus, Temple, Texas, 1998

Phil Bergerson

Cle Elum, Washington, 1993 Phil Bergerson

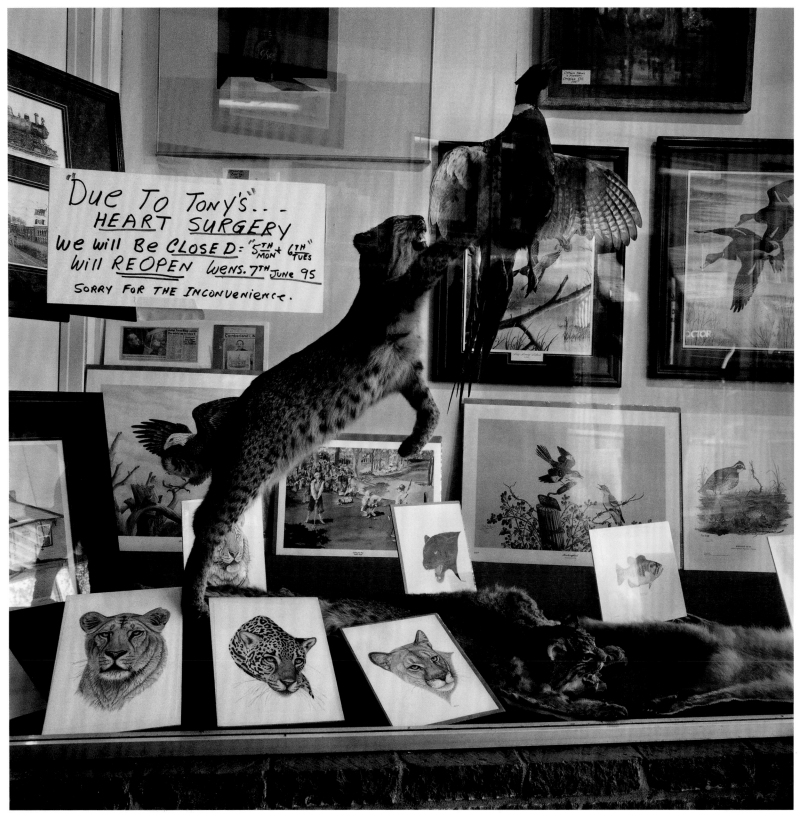

Tony's Heart Surgery, Tennessee, 1996

Phil Bergerson

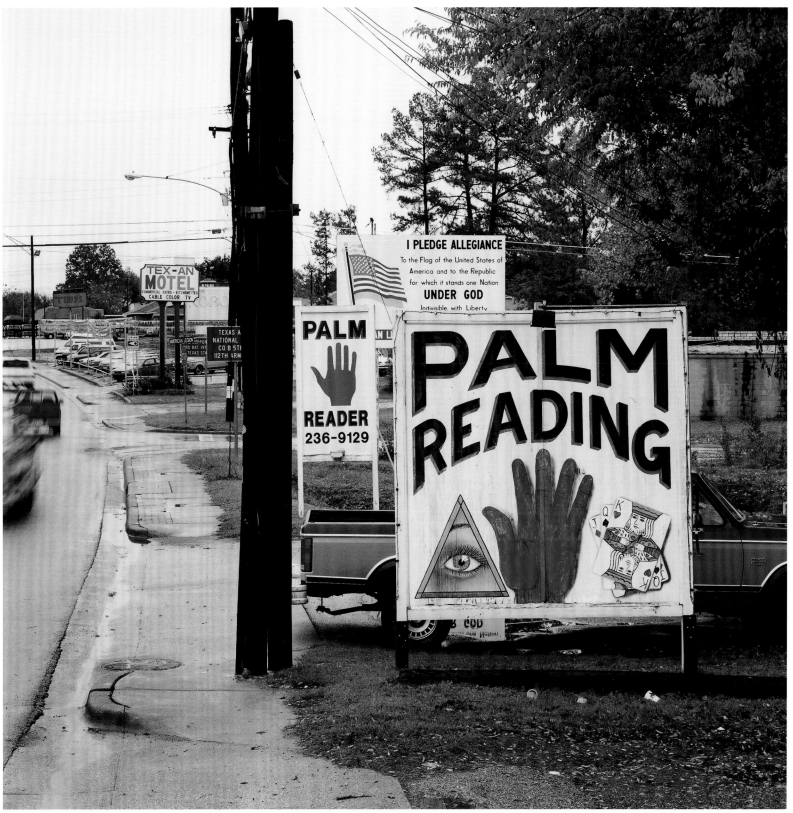

Longview, Texas, 1997

Phil Bergerson

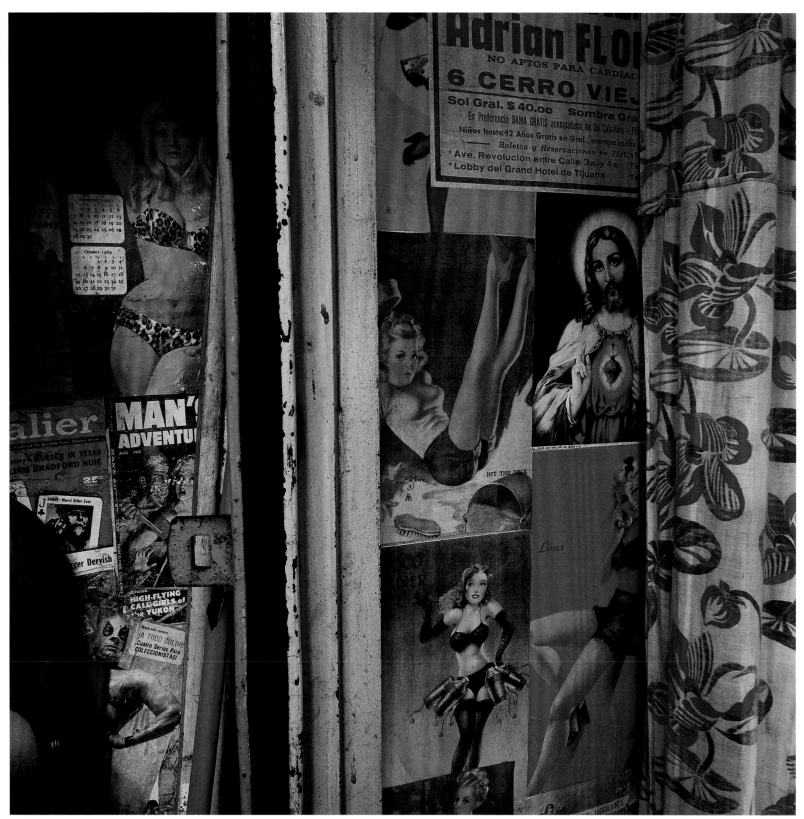

Jesus and Pinups, New York, N.Y., 2001

Phil Bergerson

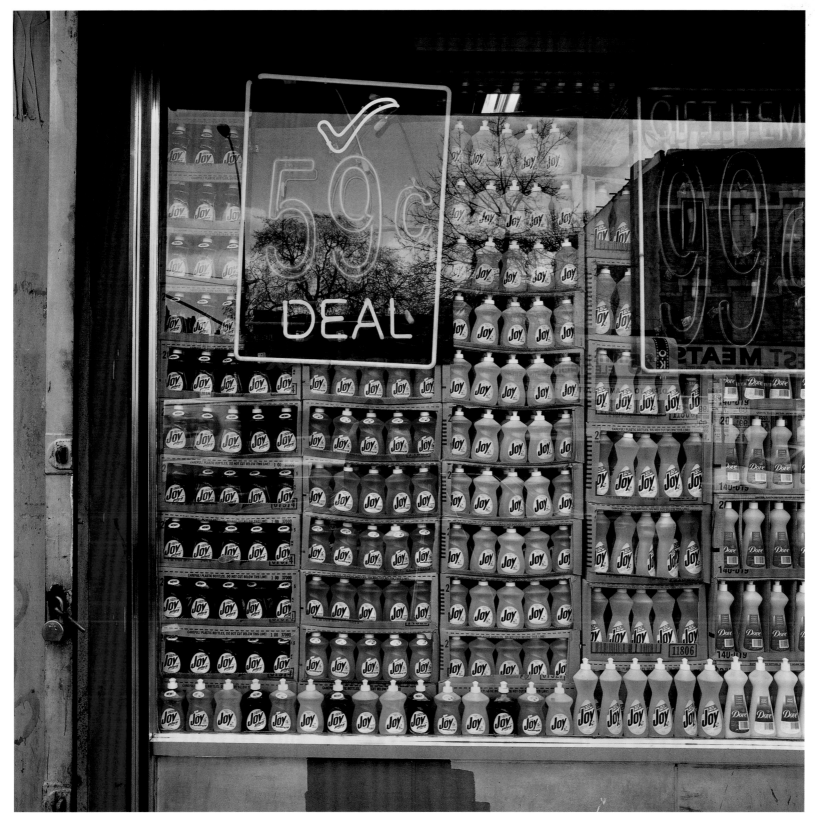

Joy Joy, Brooklyn, N.Y., 2002

Phil Bergerson

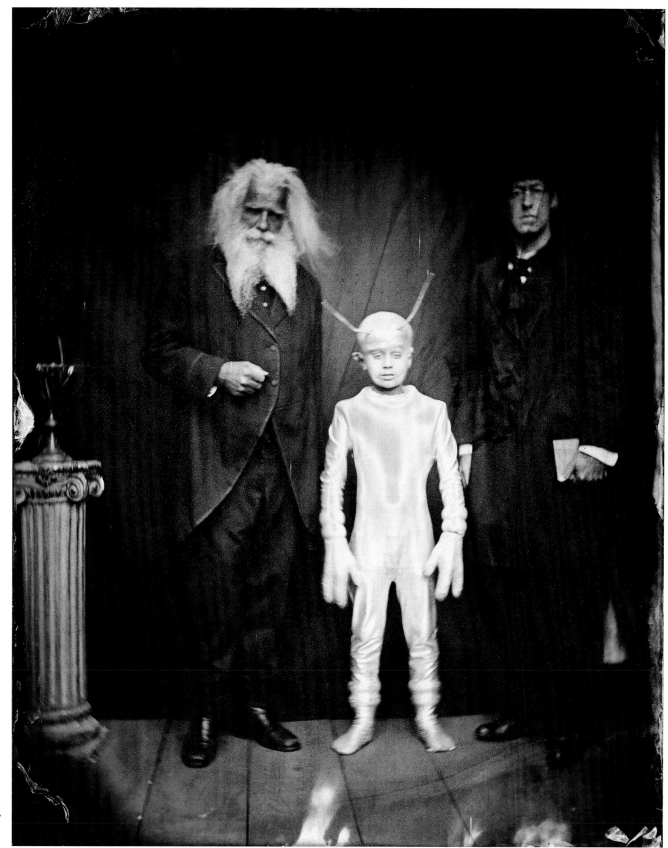

The Exhibit (from the Archives of the Academie des Sciences)

Stephen Berkman

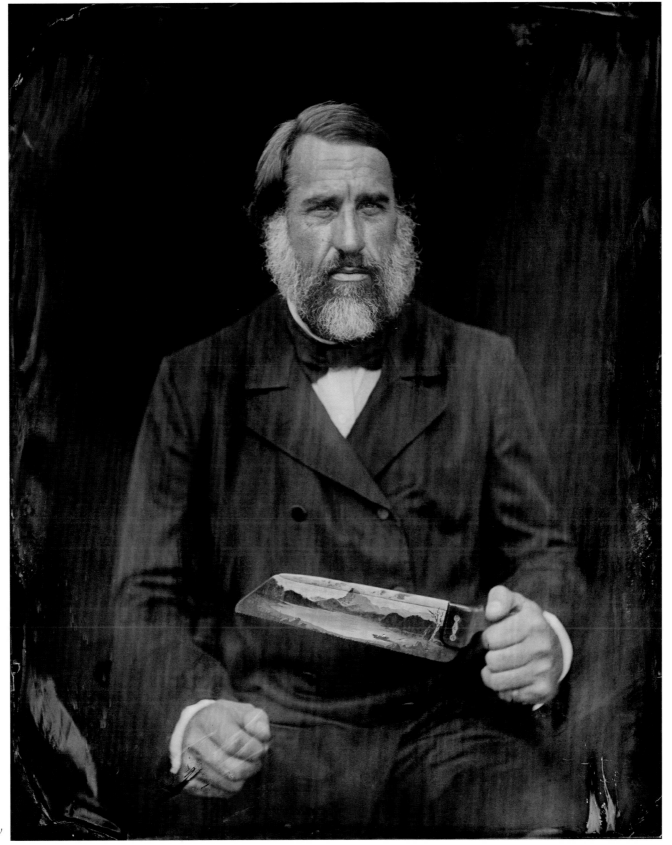

Surgeon with Scenic Saw Stephen Berkman

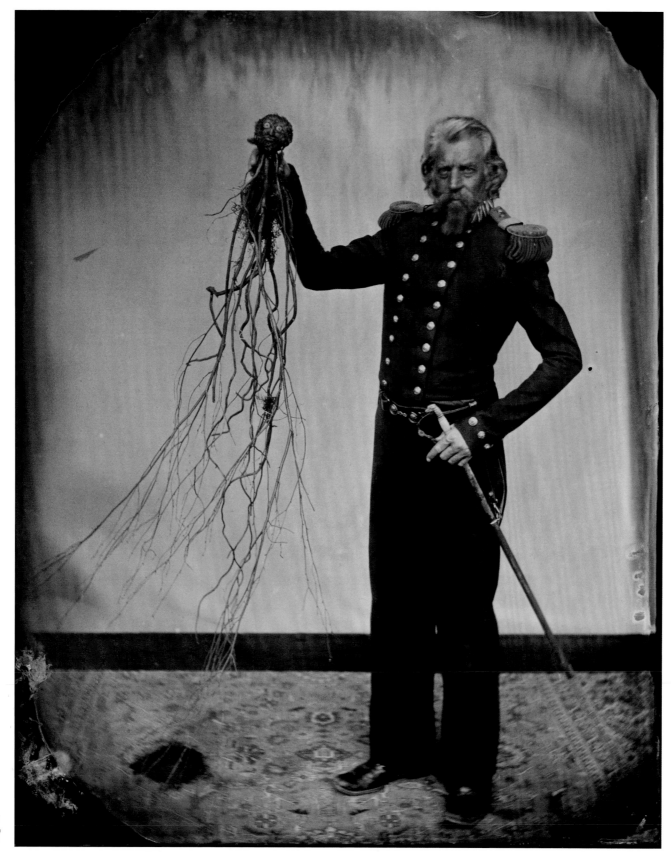

Man Revealing the
Root of Evil

Stephen Berkman

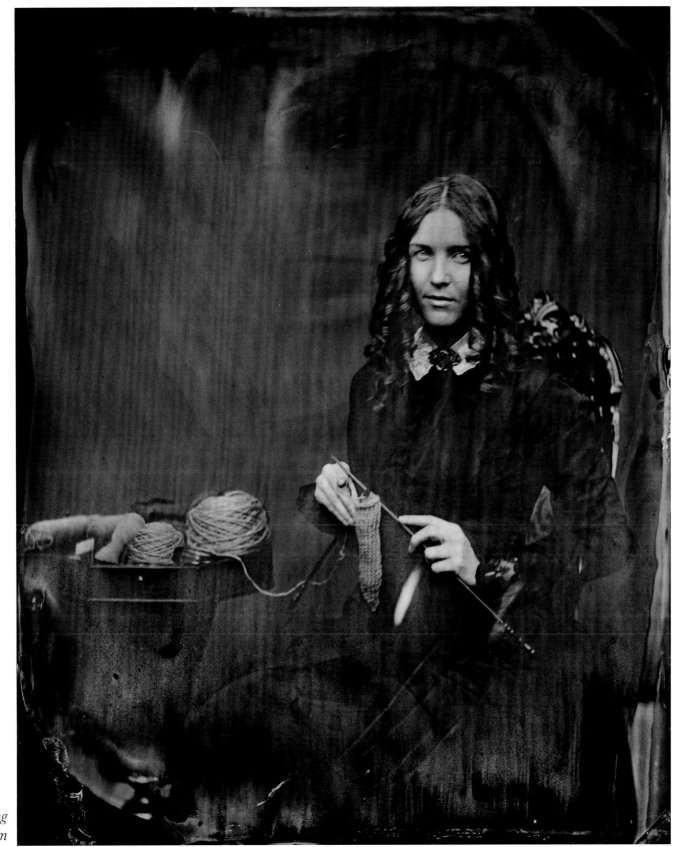

Woman Handknitting a Condom

Stephen Berkman

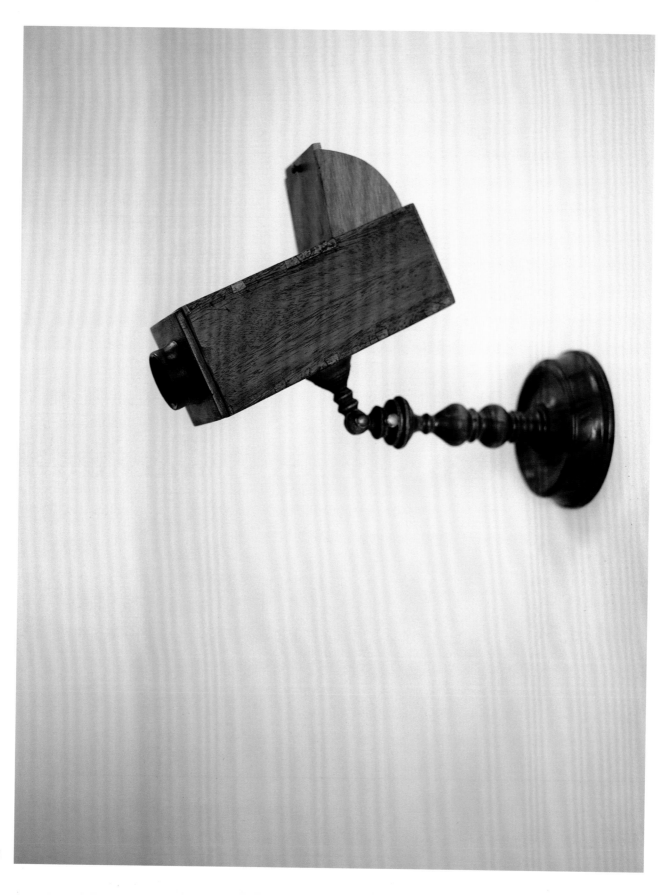

Surveillance Obscura

My work revolves around the use of antiquated photographic and optical processes. In my photographs, I utilize the historic wet-collodion photographic process of exposing images onto glass and tin plates. By exploiting the archaic quality of this medium, which dates back to the 1850's I am attempting to re-imagine the nineteenth century, by creating displacements between notions of the past and the present. One of my primary objectives is to refute the notion of history being a closed circuit, instead history is viewed as a evolving work in progress, still receptive to moments of serendipity.

Expanding the realm of my photographs into the three-dimensional world, my sculptural installation work explores the era of pre-chemical photography both literally and philosophically. My constructions encompass optical projections and sculptural reinterpretations of the camera obscura, which seek as a whole to examine the intrinsic nature of photography during this nascent period when it was possible to create fleeting images, but it was impossible to fix them into permanent photographs. This search to rediscover the ephemeral nature of pre-photographic history, the scientific interplay of light and optics, and the quest for optical amusements, also known as philosophical instruments are considered throughout my installation work. A few of the installation projects that employ the camera obscura principle include "Surveillance Obscura", "A Wandering Eye", "The Obscura Object", and "Looking Glass", which is perhaps the world's first transparent camera obscura.

Stephen Berkman

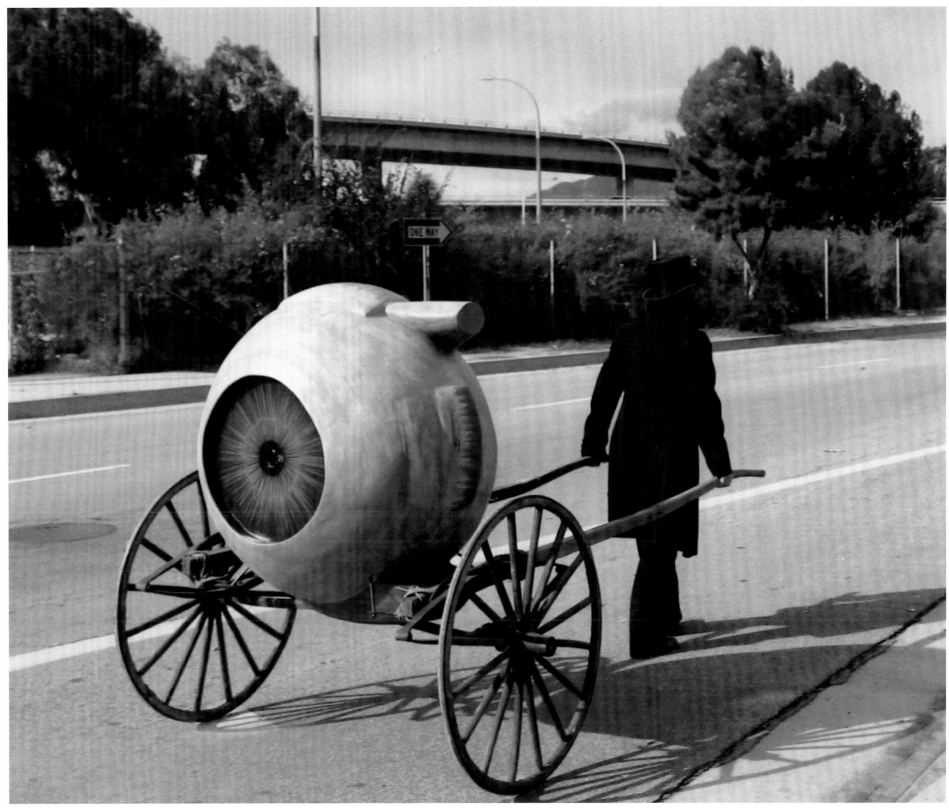

A Wandering Eye

Stephen Berkman

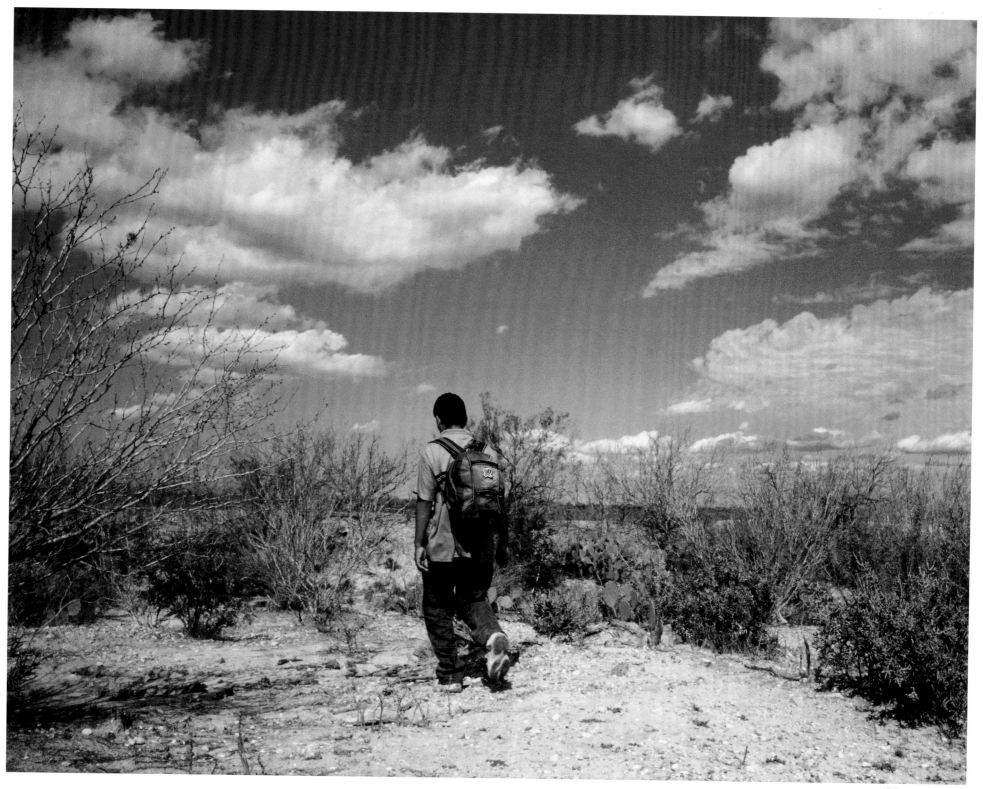

Victor Cobo

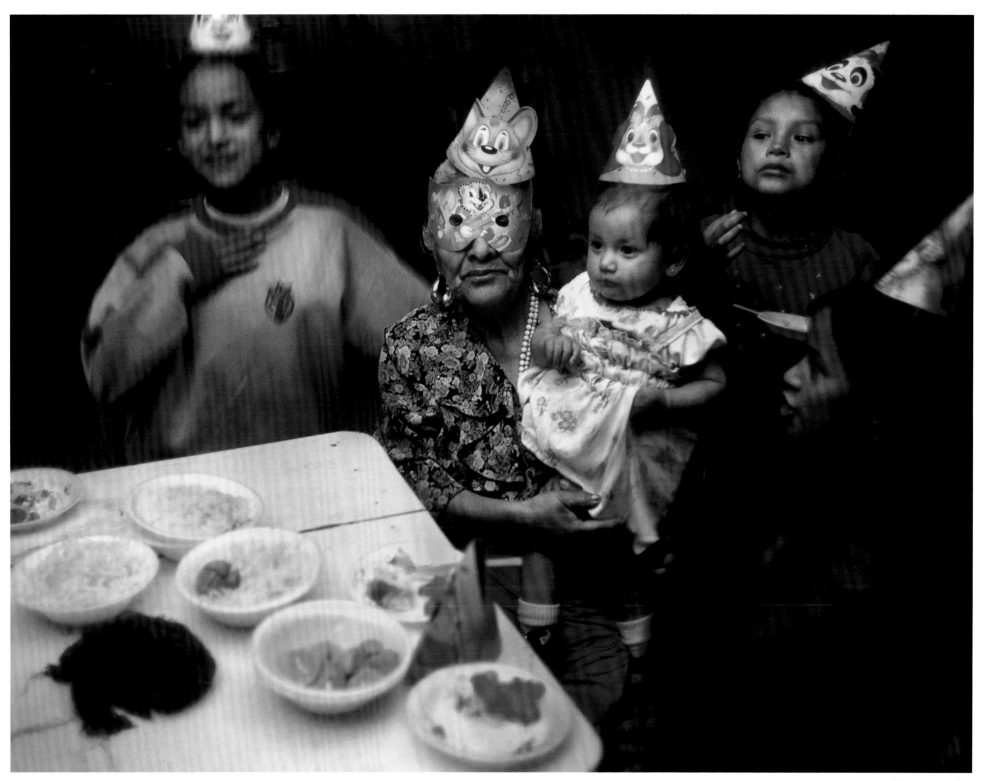

Victor Cobo

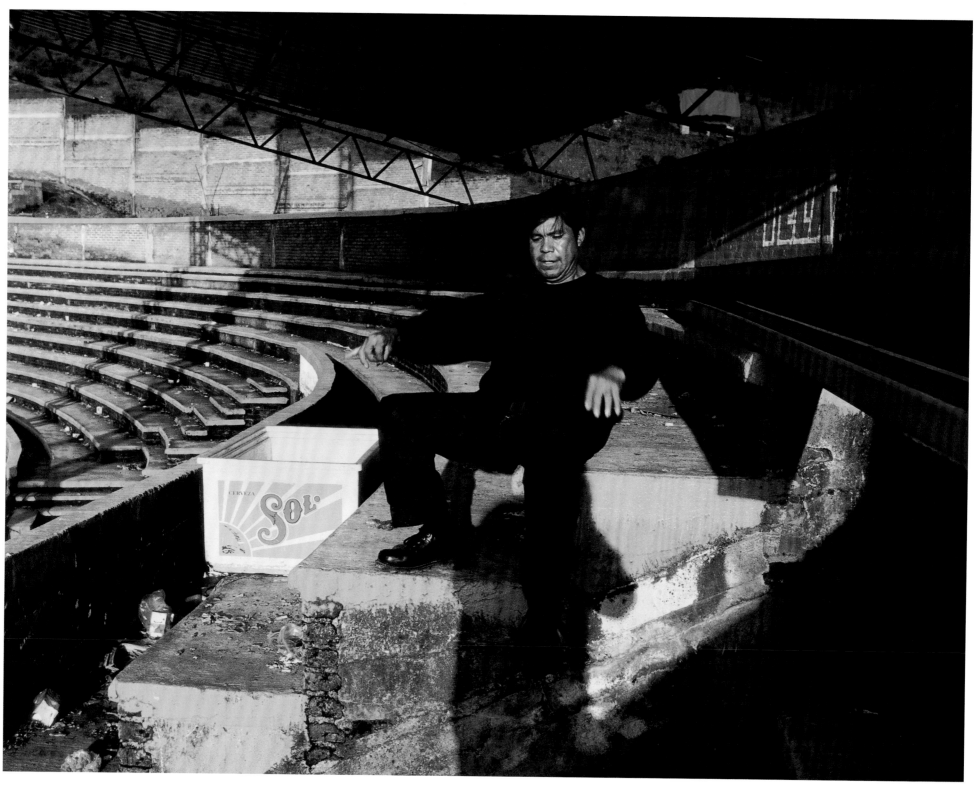

Victor Cobo

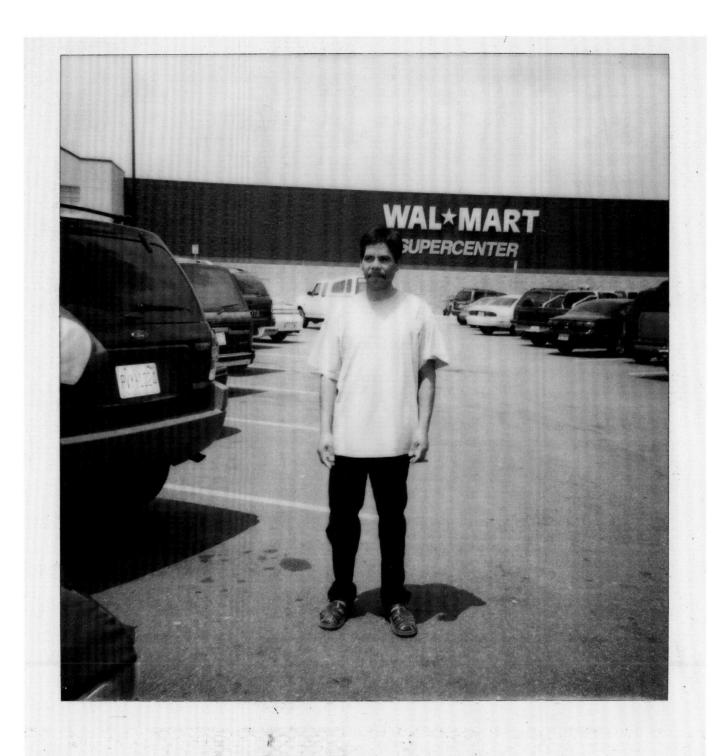

Victor Cobo

This series is a complex, anthropological tour through the landscape of the indigenous Central American – by means of memory, spirituality, longing and isolation. Lives are concentrated with a vibrancy, an intensity of being that many of us have never experienced. The under-represented reality between fiction and objective thought. An existence akin to a world fueled and charged by love and loss, by commitment to family and the need for survival at all costs. One that cannot be bound by laws from political systems on either side of the border. Often this human drama is intensified with its reflection of deprivation. Yes, there is struggle. There is also joy, and the life of a dream, of opening a pathway heretofore unacknowledged in American society. It is here that the viewer is urged to ponder the relationship between the real and the surreal or imagined, and to question their own existence in comparison to that of the subjects'.

Perhaps a brief journey through this stream of consciousness will remind the American public and their politicians of the fundamental humanity shared between themselves and the immigrants, whose lives have become such political playthings.

Victor Cobo

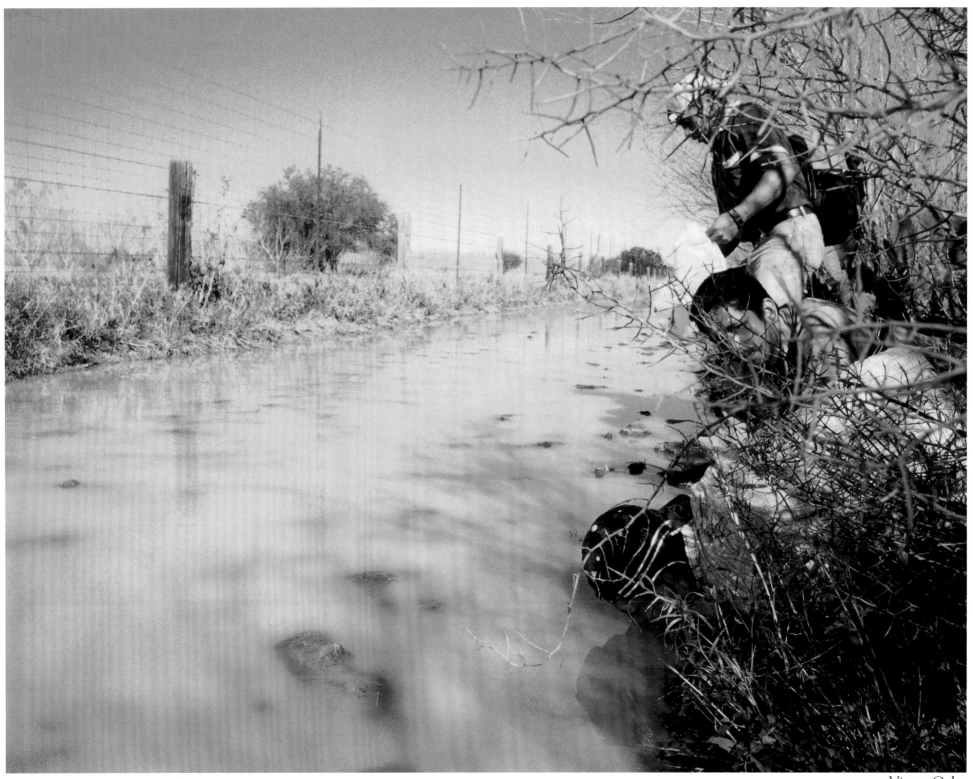

Victor Cobo

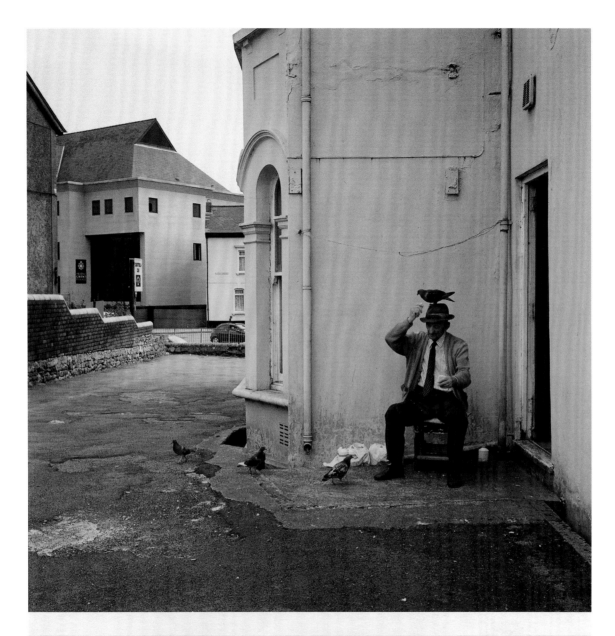

Pigeons getting used
to the camera now.
One on my head and
One about to fly up
to my hand.

KayLynn Deveney

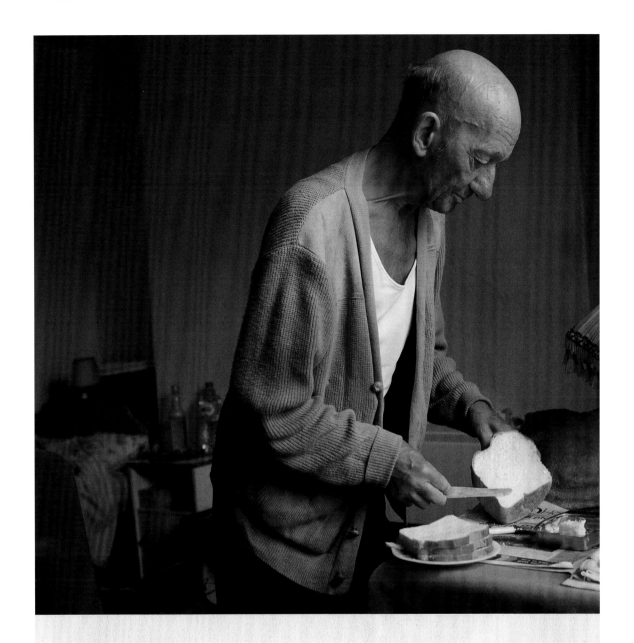

Preparing a snack.

KayLynn Deveney

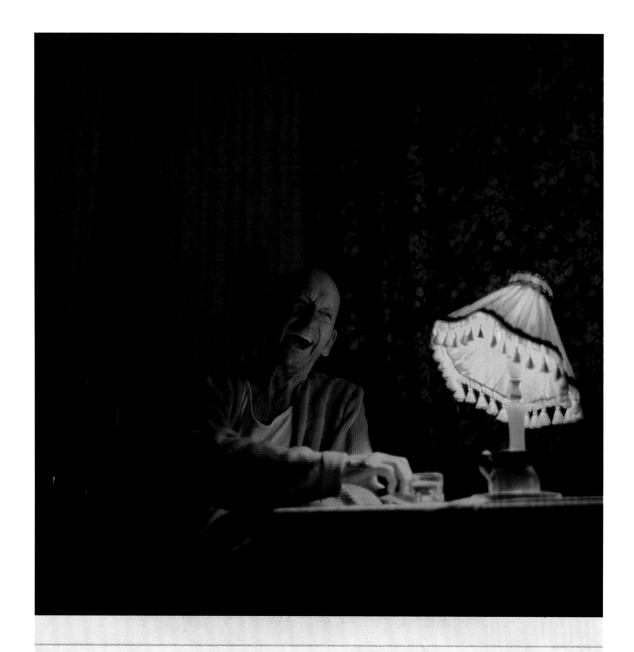

Enjoying my
evening whiskey

KayLynn Deveney

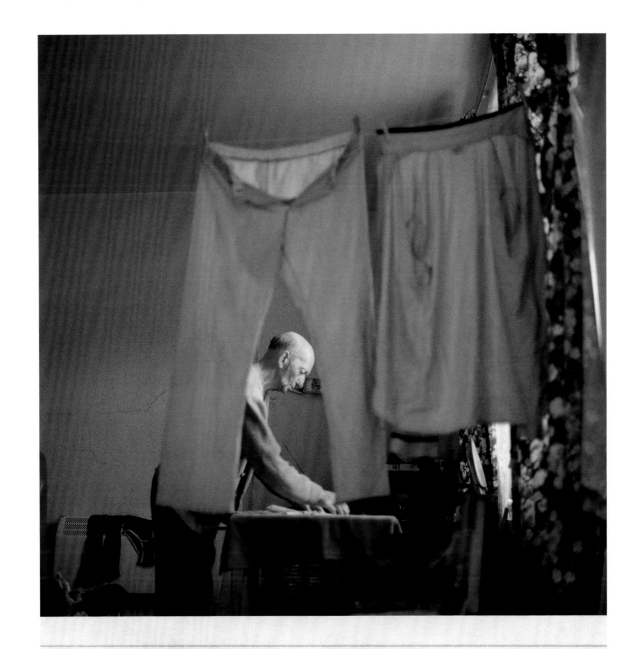

P. Jays drying

KayLynn Deveney

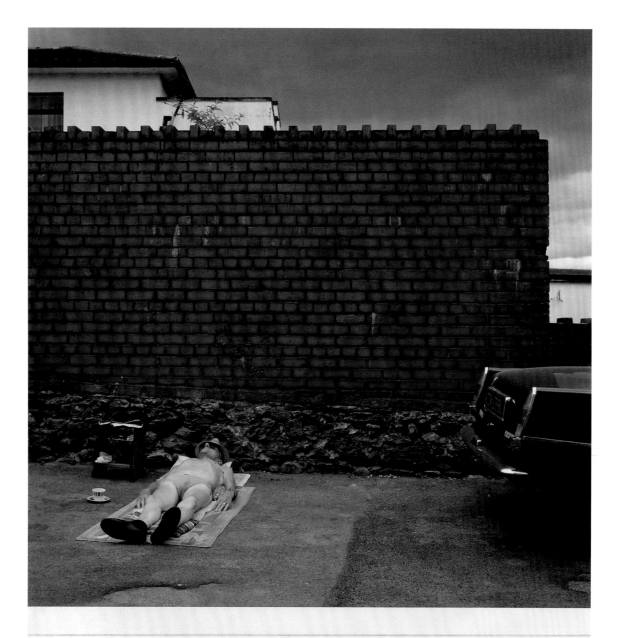

Enjoying the sun.

KayLynn Deveney

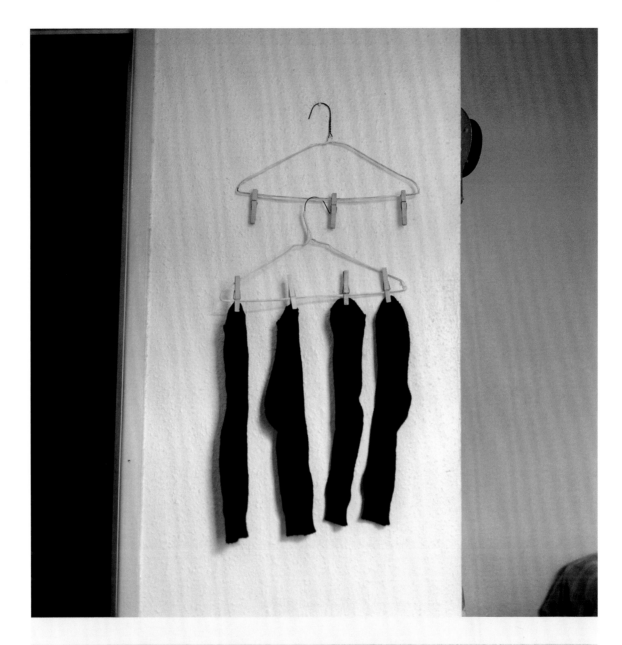

Laundry airing.

The Day-to-Day Life of Albert Hastings

I met Albert Hastings in 2001 when we lived in the same neighborhood in Wales.

As I became acquainted with Bert, photographing his daily routine, I noticed the way he organized his things and his time, and I found his approaches thoughtful.

To better understand Bert's reactions to being photographed, I asked him to caption small prints I kept in a notebook. These captions, in turn, create a new context for my photographs.

In this work Bert's vision of his life meets the new eye of a stranger. Together our versions of his experience create a new tale.

KayLynn Deveney

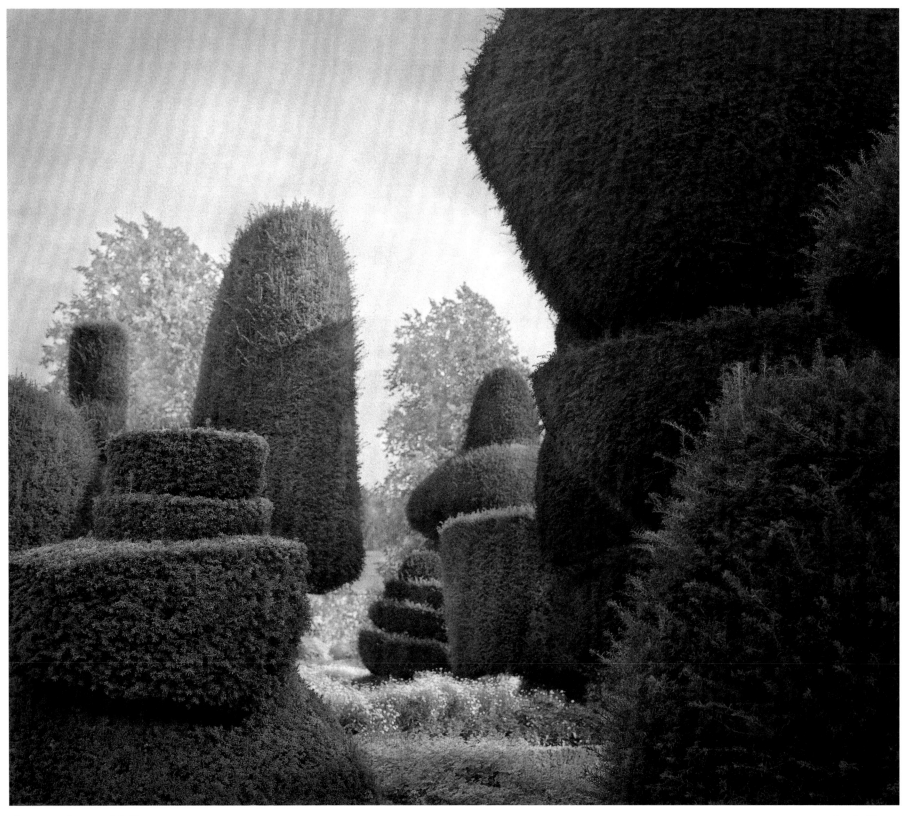

Passage, Levens Hall

Beth Dow

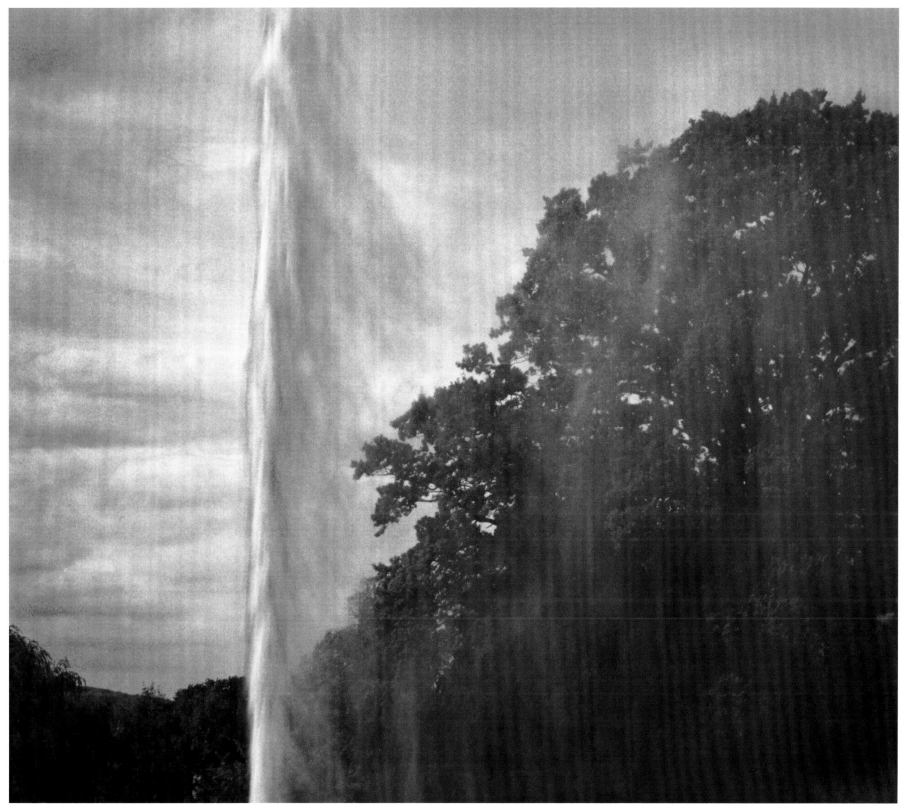

Fountain, Stanway

Beth Dow

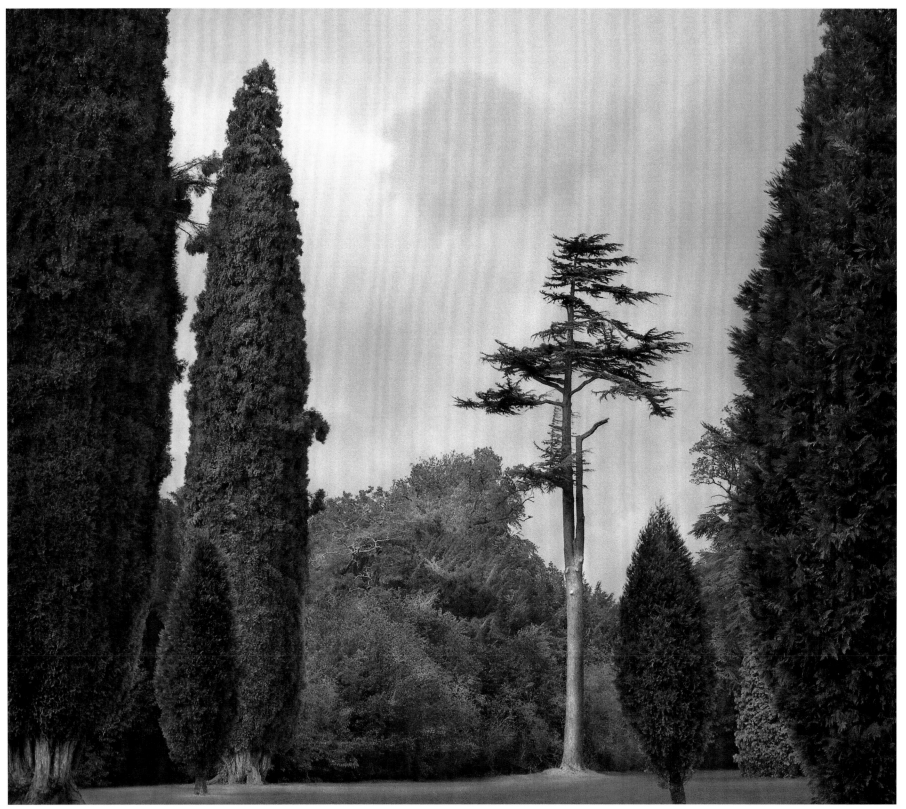

Trees, Blenheim Palace Beth Dow

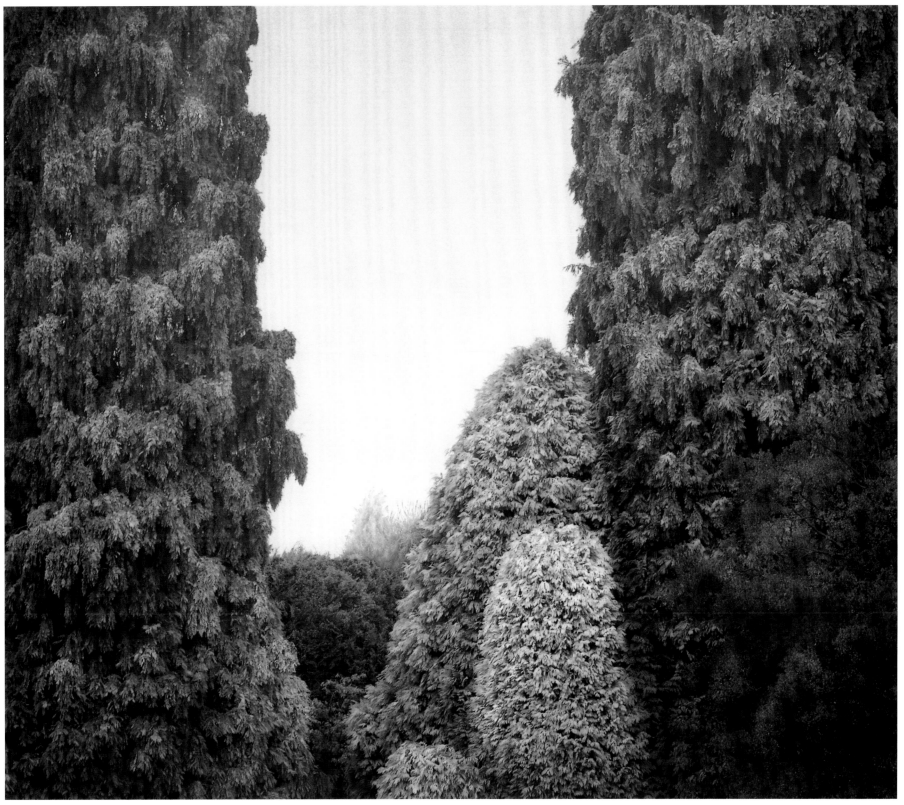

The Pinetum, Wakehurst Place Beth Dow

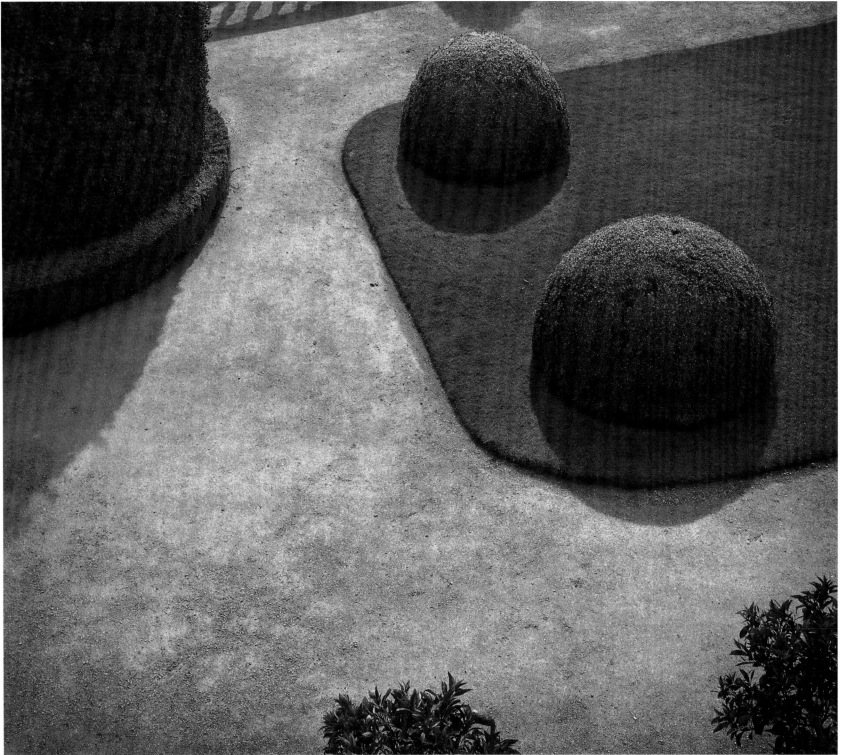

These 16" x 18.5" platinum prints of formal gardens were made in England, where I lived for many years. While most people love gardens for their beauty, I'm seduced by something else entirely, and my favorite landscapes are overgrown, shaggy, and a bit off their game. Gardens attempt to control and dominate nature, but nature resists - it bolts, leans, withers, and isn't as malleable as we pretend. These places use the familiar conventions of centuries of garden making, yet their forms are still surprising. My photographs are not topographical descriptions, and color is irrelevant. Instead, I use the land before me as a jumping-off point, implying light and shadow as a way to create my own path through the garden. By guiding the viewer's eye through a picture, I feel that I too am a gardener in a sense. I'm after that "slant of curious light" that is the genius of place. My photographs describe the territory between appearance and experience, and extend the moment when I first glimpse something extraordinary – that purely sensory flash before things make sense. They were shot quickly with a hand-held camera, yet are composed to emphasize the still, subtle hum and buzz of insects and rustling leaves. I use the warm tones of early landscape photography, and the richness of my platinum process complements the experiment in immortality that is a cultivated landscape.

Terrace, Powis Castle

Beth Dow

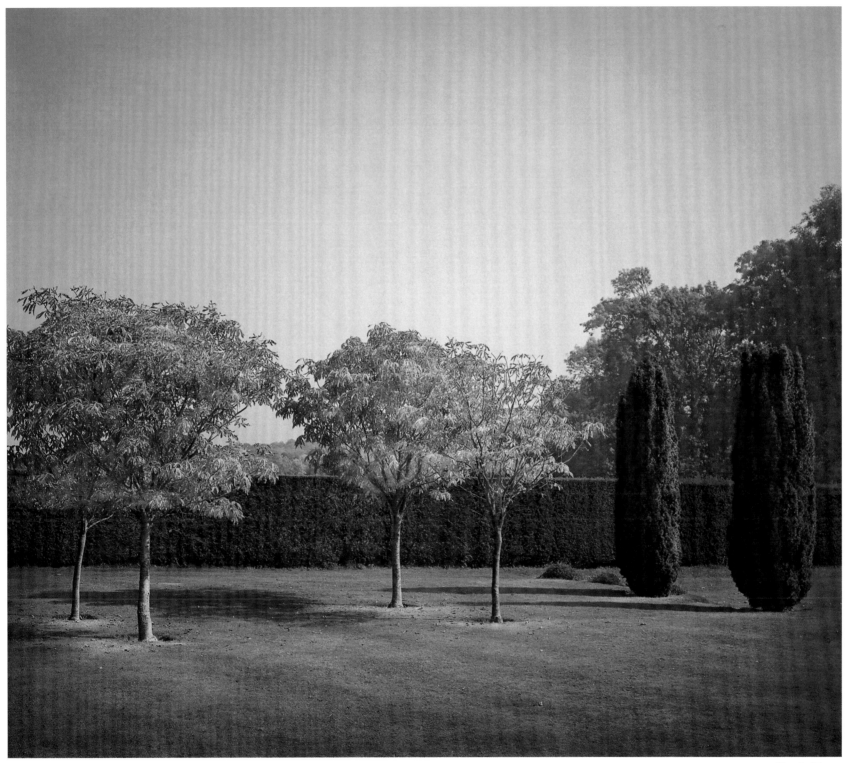

Six Trees, Batemans

Beth Dow

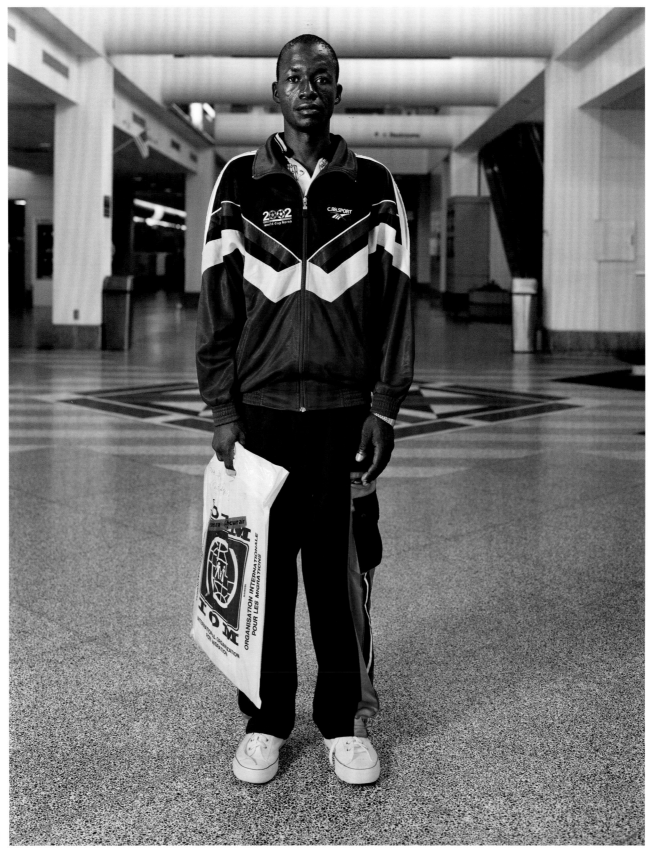

Muktar Kamuna Doug Dubois

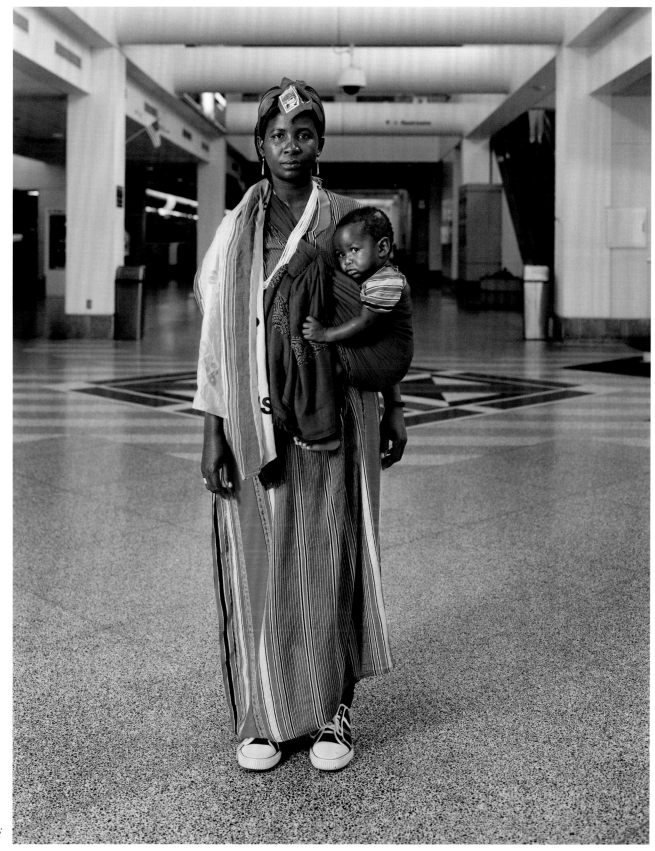

Halima Mberwa and Hakima Haji

Doug Dubois

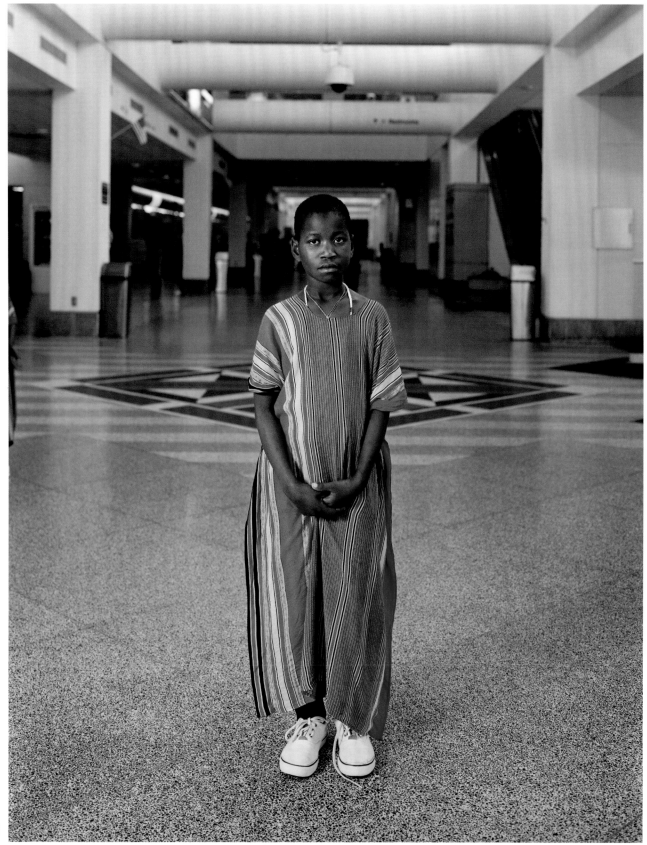

Mana Haji Doug Dubois

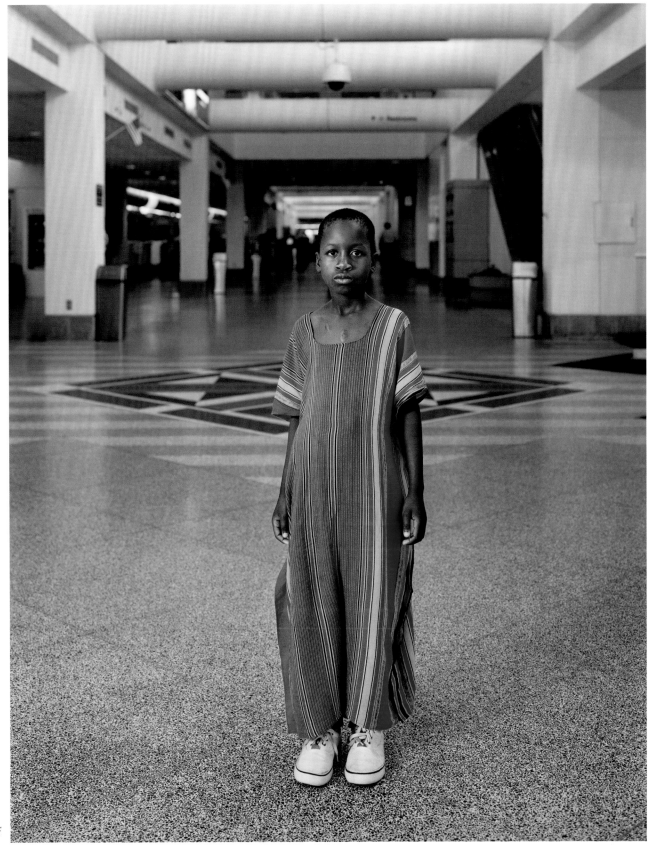

Sitey Haji Doug Dubois

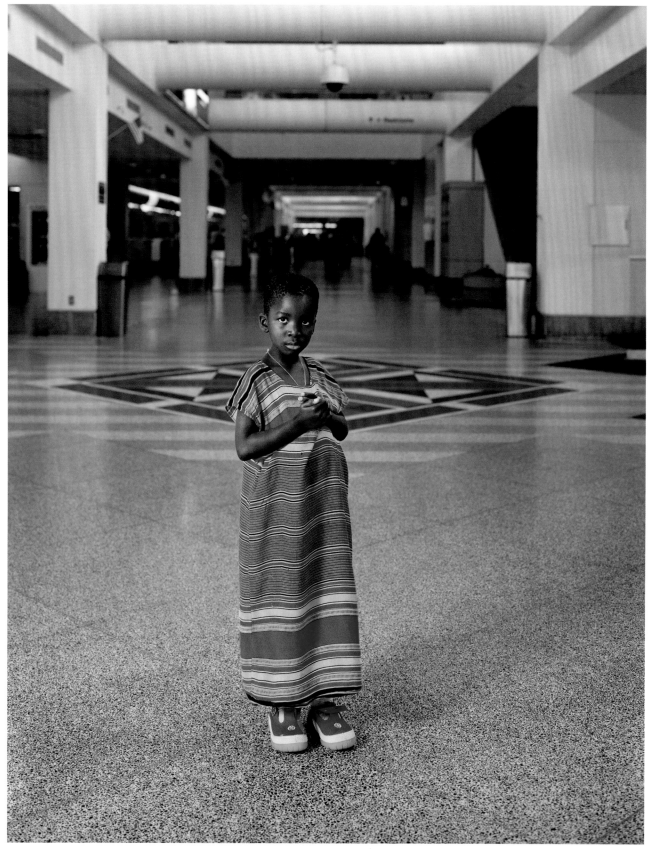

Asha Haji

Doug Dubois

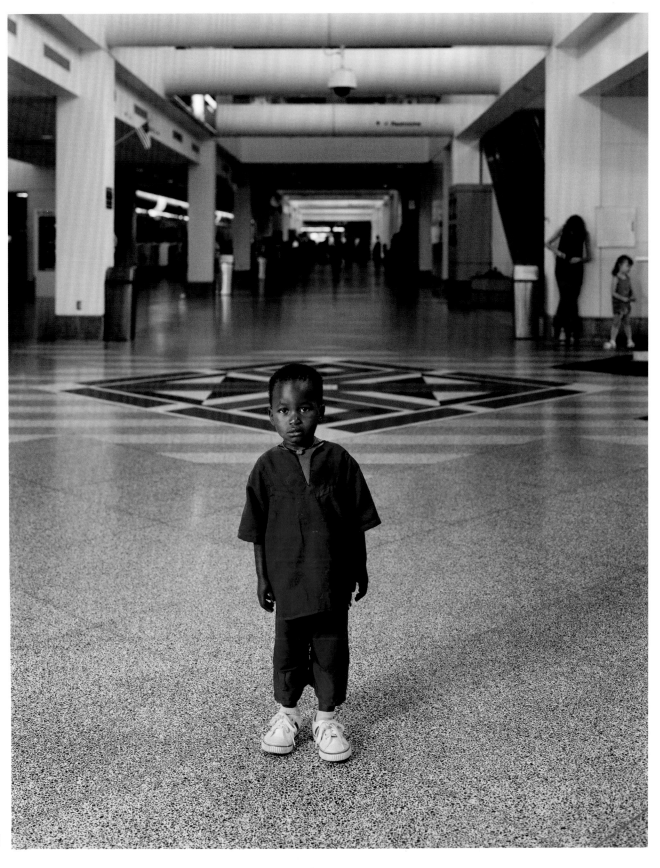

Dadiri Haji

Arrival

Between 2003 and 2004 twelve thousand Somali Bantu were resettled to the United States from refugee camps along the Kenyan–Somali border. Arrival consists of individual portraits of two Bantu families at the Hancock International Airport in Syracuse, New York. The families were met by a small contingent of local Somalis and members of Catholic Charities, one of several organizations in charge of settling the Bantu in Syracuse.

I photographed the family members at their moment of entry into the United States. Dressed with a unique combination of east African cloth, UNHCR issue blankets and generic tennis shoes, each individual stands at a threshold between an unreconciled past and the unrealized prospect of life in the United States. The significance of this passage, deeply imbedded in our national myths and debates on public policy, is no less critical to the formation of individual and family identity. These photographs offer a visual account of origin and lineage, destined to become more opaque and mysterious with each generation.

Doug Dubois

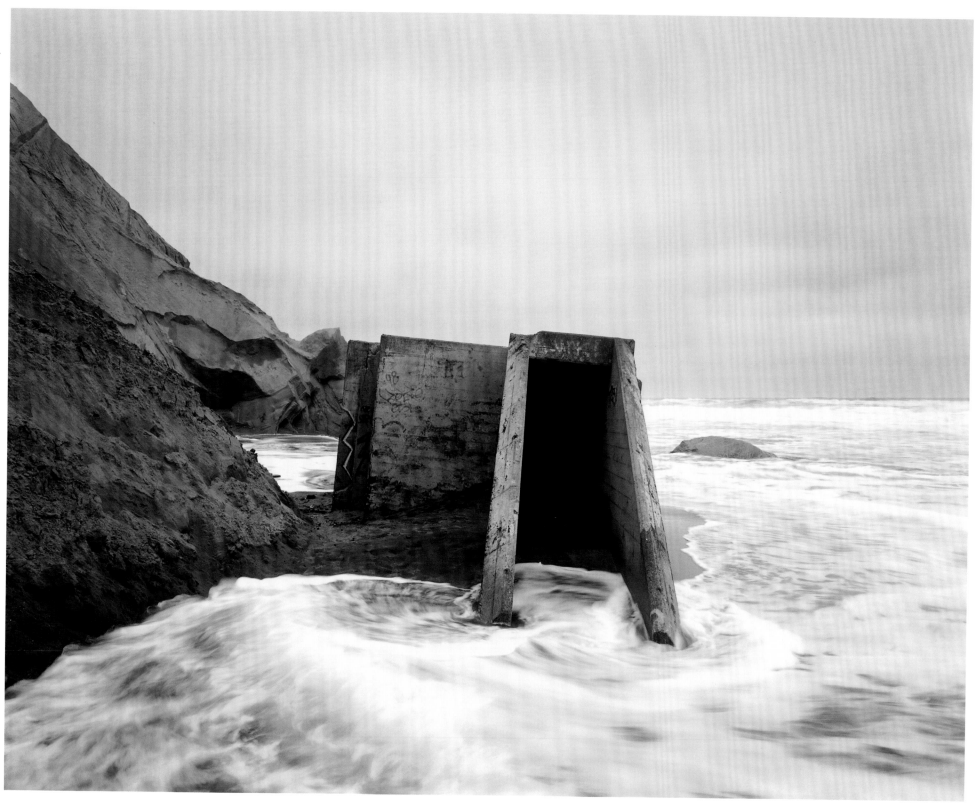

Alex Fradkin

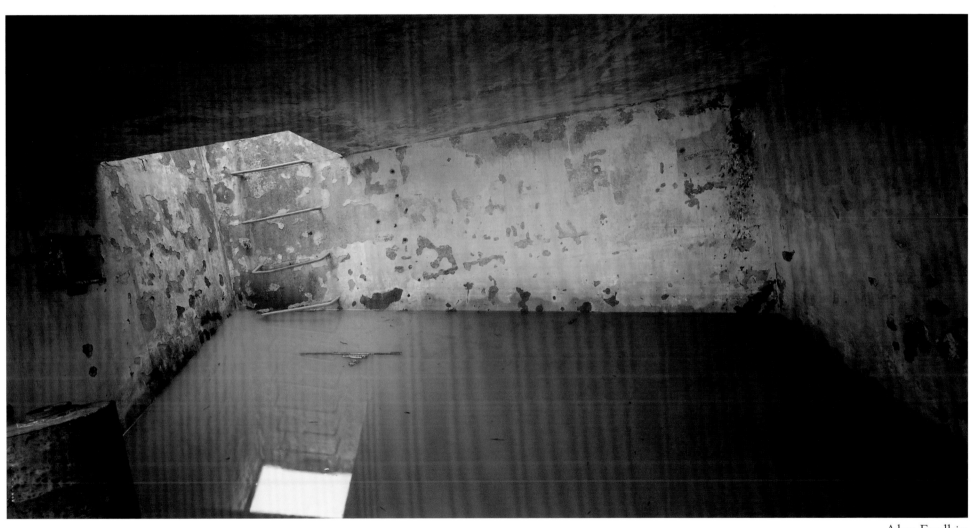

Alex Fradkin

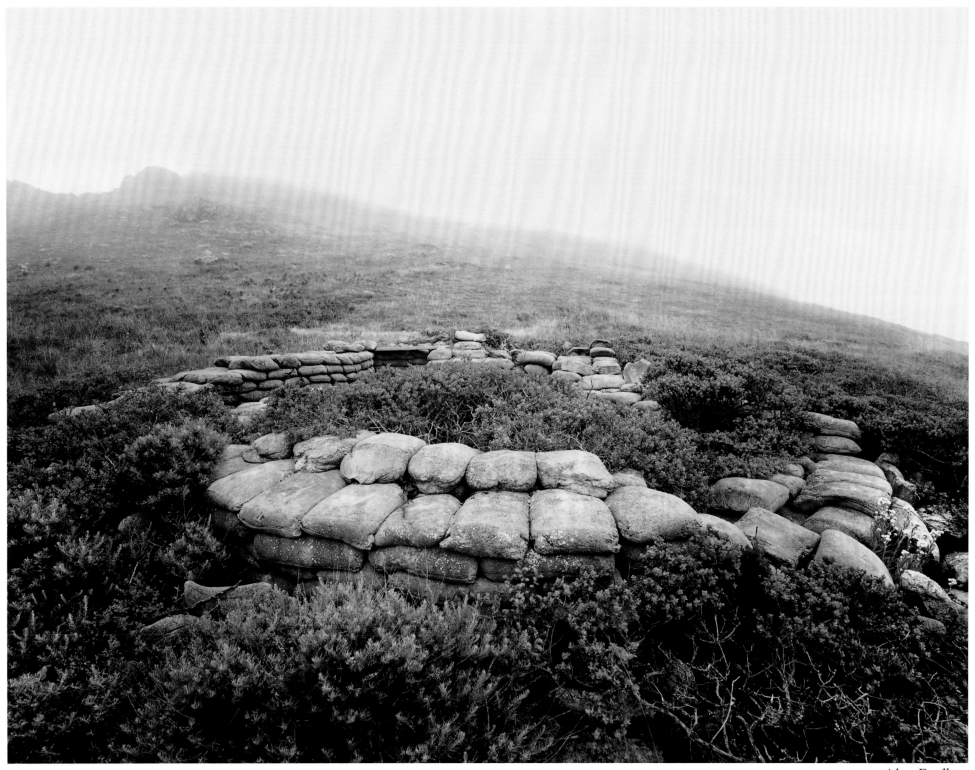

Alex Fradkin

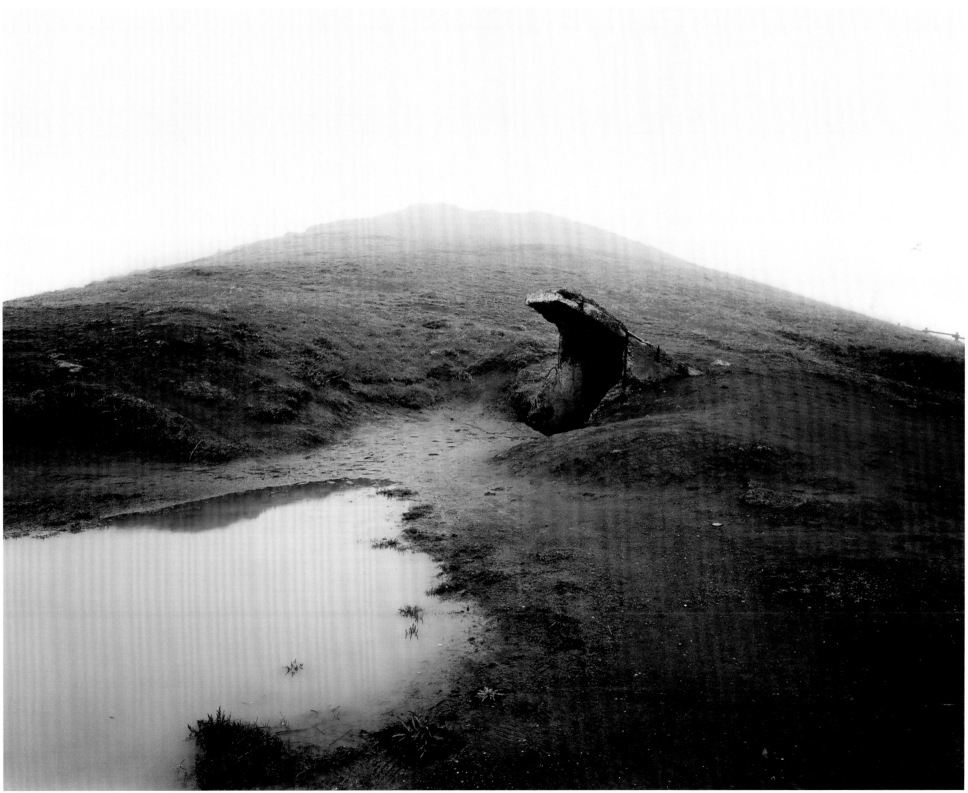

Alex Fradkin

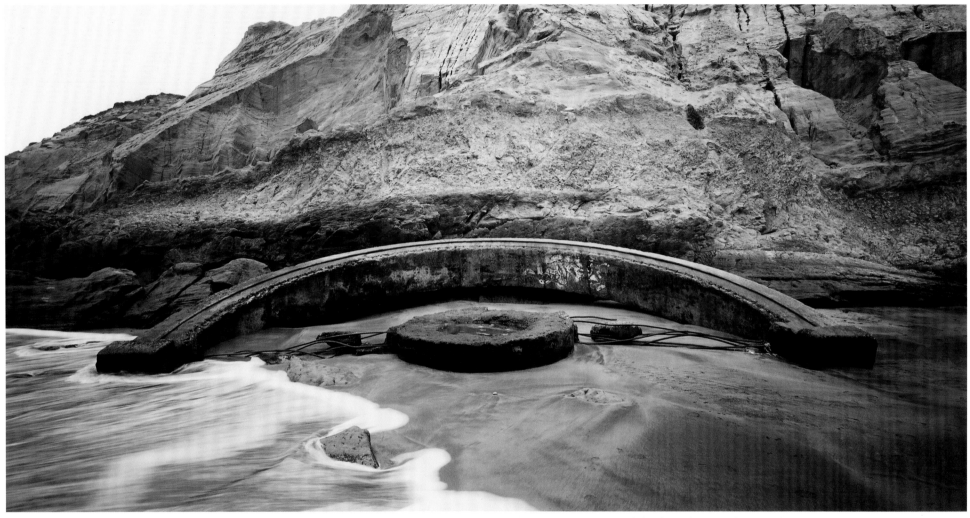

Bunkers: Ruins of War in a New American Landscape

Emerging from the sand and sage brush lay hundreds of concrete forms whose alien appearance stands in stark contrast to the sublime coastal landscape of the San Francisco Bay Area. The serenity of the landscape is broken apart by the process of erosion and seismic activity that is gradually ripping the bunkers and the hillsides apart, slowly depositing the remnants into the Pacific Ocean. Whole and partially intact ruins of war litter the land like the wreckage of a plane or the aftermath of an epic battle. It is a landscape that alludes to a series of historic events that in actuality, never came to pass.

The architecture of war depicted here is a historic monument to every real and imagined threat to the Western United States. The earliest fortifications were built in the early 1800's when the land was taken from Mexico. Subsequent conflicts with Mexico, Spain, the Civil War, WWI, WWII and the Cold War brought rapid techno-logical innovations in bunker design. These designs were quickly outpaced by the faster development of weaponry that could kill more effectively. In most cases the bunkers were obsolete before they were finished being con-structed.

Facing the endless horizon of the Pacific Ocean, each generation since the conquest of the West has waited in apprehension for the enemy that never came. Today, more than ever, the bunkers are considered ineffectual in this new age of unconventional warfare. The new threat of invasion is from the less defensible threat of fear and paranoia. These structures now inhabit the landscape as silent metaphors of our current national mood.

During my explorations of the bunkers I have sought to question my fascination with these remains and with ruins in general. Contrary to my former professional architectural background which emphasized the constructive nature of the built form and all of its potential, I have found myself to be more intrigued with a building's inevitable process of decay and ruin. A structure when reduced to its component pieces becomes an archeological equation that invites metaphor, speculation and the potential for narrative fictions, often in opposition to the determinacy of a building's intended purpose. The "entropological" process of the architectural form is a dynamic evolutionary cycle, with a beginning, middle and an end. It is a visceral reminder of our own mortality and temporary existence on this earth. It is this "end" component where a structure has recorded its own biography, the record of its success or failures for which it was intentionally designed, that I find to be so compelling.

"Ruins are emblematic and can better provide allegorical meaning than can complete structures" (Gordon Matta-Clark).

"Slowed down in his physical activity but attentive, anxious over the catastrophic probabilities of his environ-ment, the visitor in this perilous place is beset with a singular heaviness; in fact he is already in the grips of that cadaveric rigidity, from which the shelter was designed to protect him" (Paul Virilio; Bunker Archeology)

Alex Fradkin

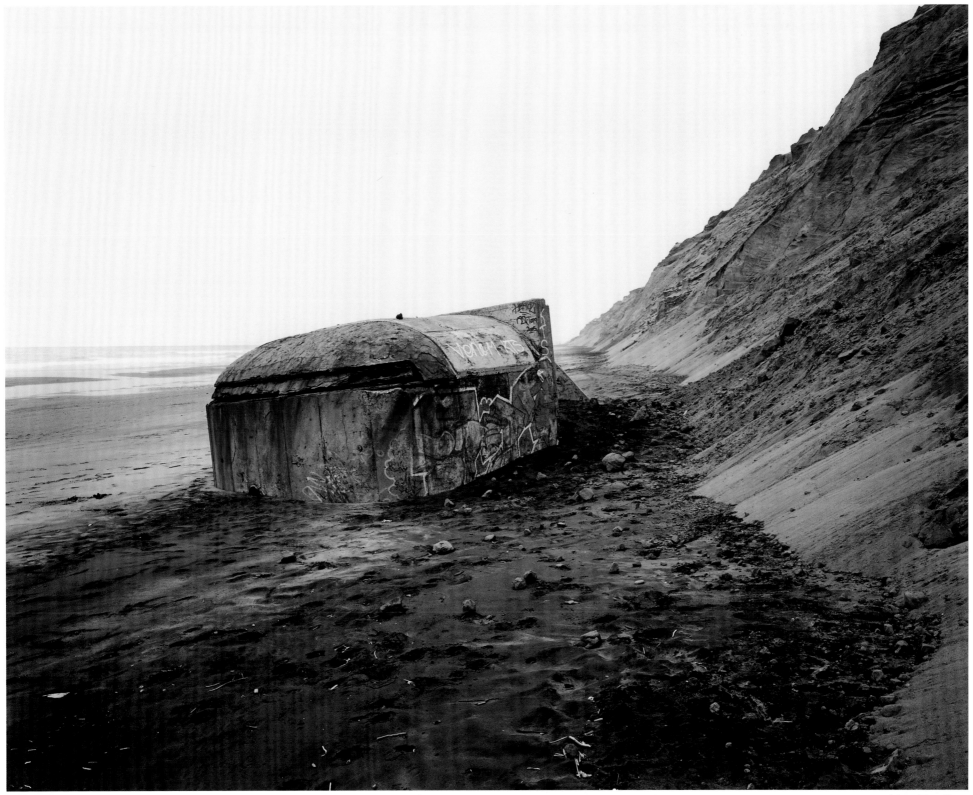

Alex Fradkin

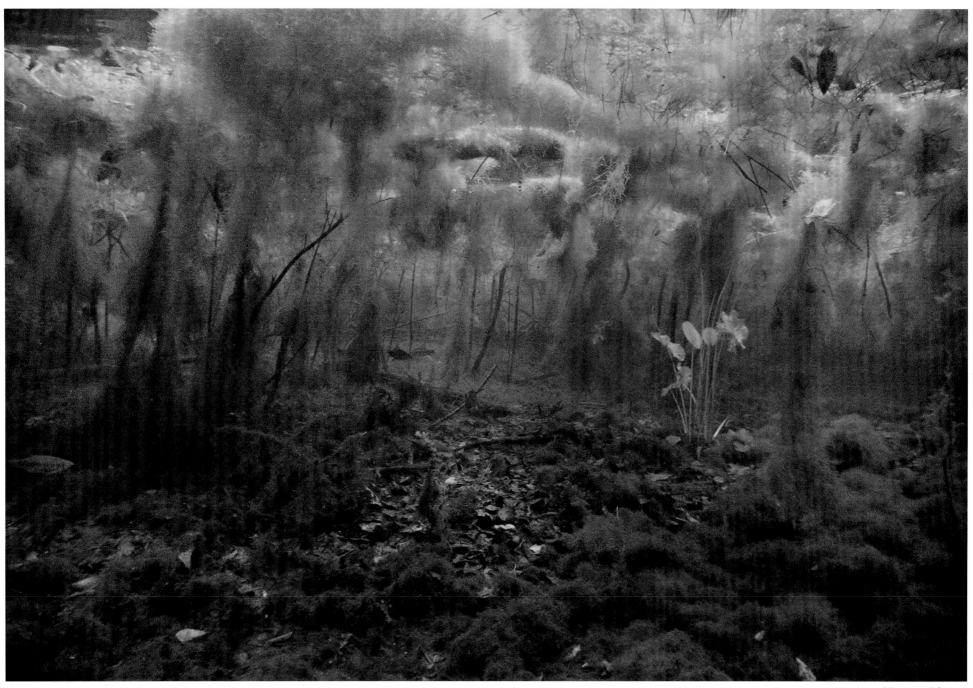

Karen Glaser

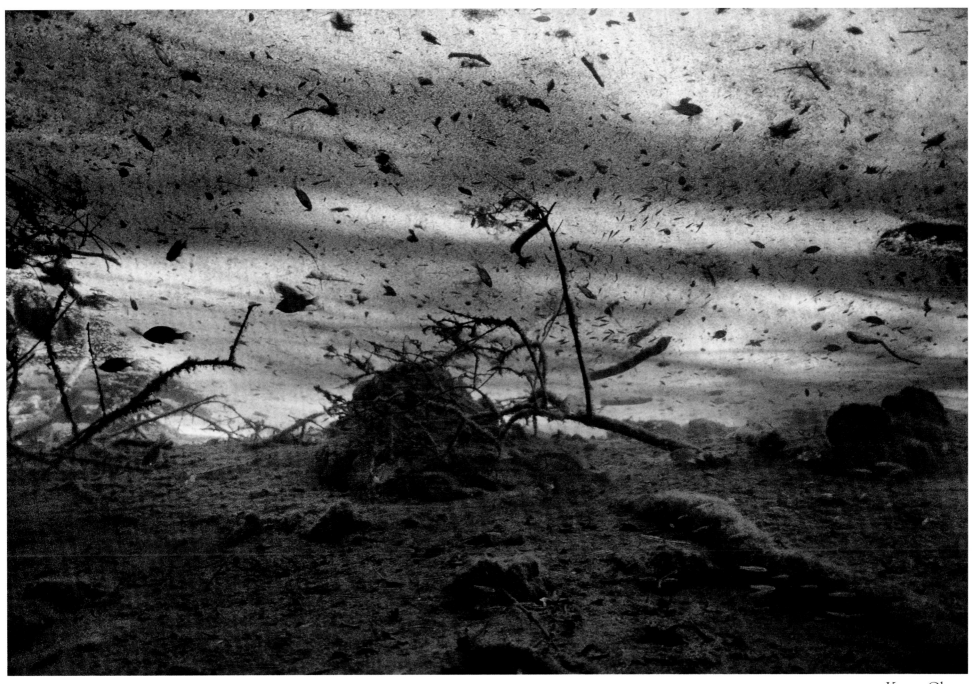

Karen Glaser

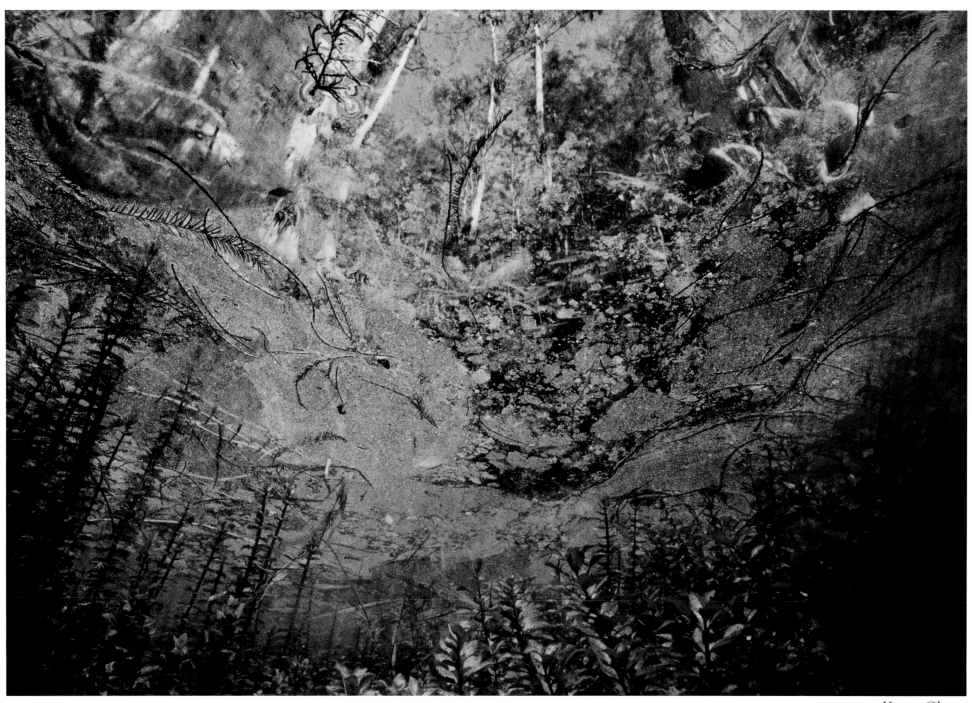

Karen Glaser

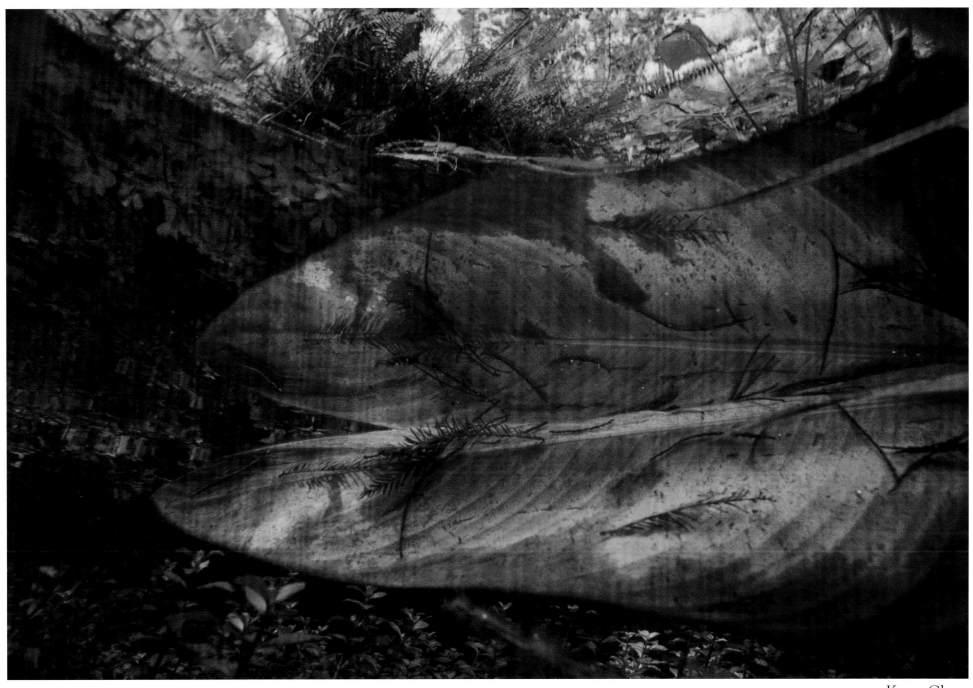

Karen Glaser

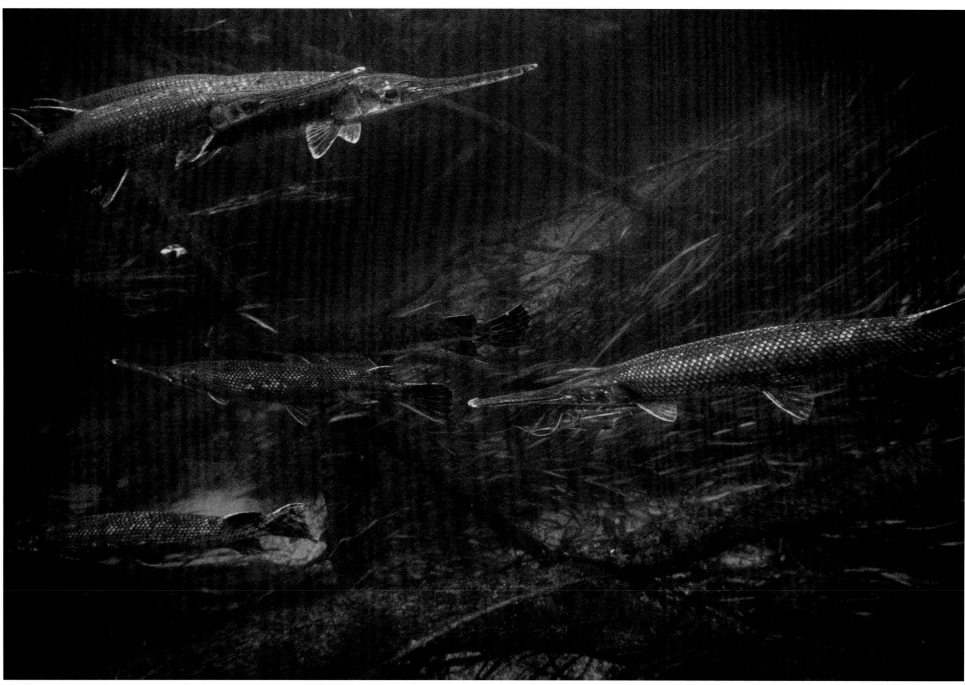

The photographs provide a unique view – shot from a vantage point unfamiliar to most. They are hard to classify, try as people might. No one genre fits. They are landscapes, shot underwater, and combined with elements of street shooting, documentary, the pictorial and the ethereal. This ambiguity is their strength and very much part of the world from which they come. The photographs are not manipulated. A description given to the pictures by one keen-eyed viewer is, that the images "instruct us on where natural history gives way to the sublime, the ineffable – the esthetic".

The photographs were made in a geographical location that is both seductive and sickening. This place is Florida, home to some of the most unique and breathtaking ecosystems in the world but a home that must live alongside unceasing development. The pictures in this exhibition are from two related bodies of work, Springs and Swamps. The first series was shot in the pristine freshwater rivers and springs of north and central Florida. The exquisite

Karen Glaser

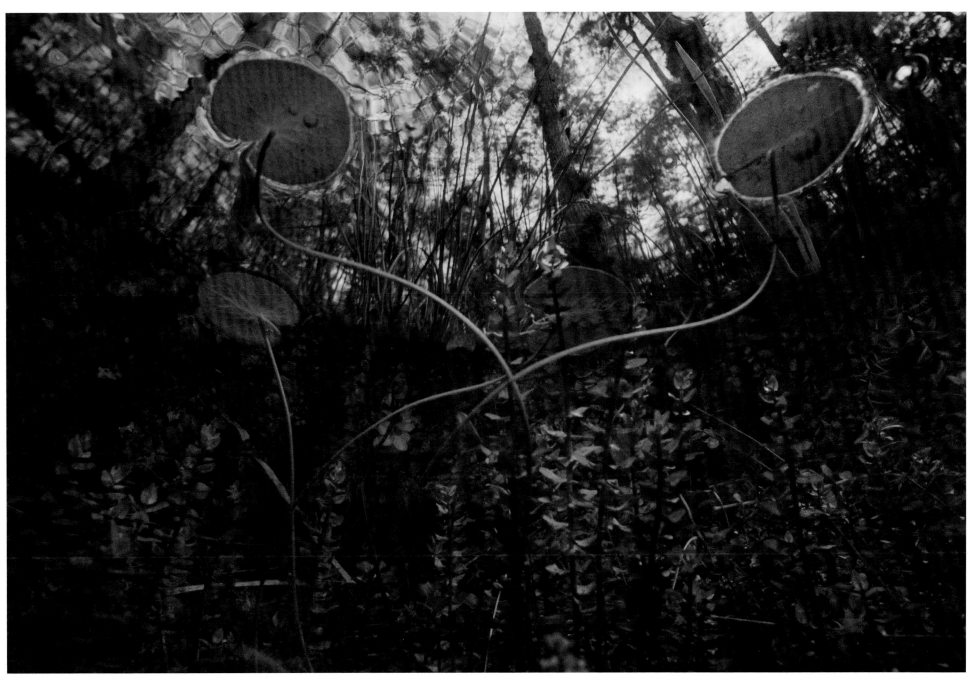

natural light that graces these environments is used solely to illuminate these pictures. In open water there is ever-present particulate matter. This layering of mud and muck, although it may appear to interfere with the water's clarity, is in fact it's lifeblood: the living, and breathing, matter seasons the soup and reflects, refracts and bends the light to create its complexity. This exploration and the resulting photographs inspired a trek to the southern part of the state where the most magnificent primordial swamps are located in Big Cypress National Preserve. A neighbor to the Everglades and a mere forty-five minutes from the sprawl of Miami to the east and Naples to the west, much of the preserve is completely wild and untouched. Via the good fortune of an Artist-in-Residence award from the preserve, the Swamps series began. The allure and mystery of these waters and the complicated puzzle of their continued existence inspires these pictures and continues to summon you and me to look even deeper.

Karen Glaser

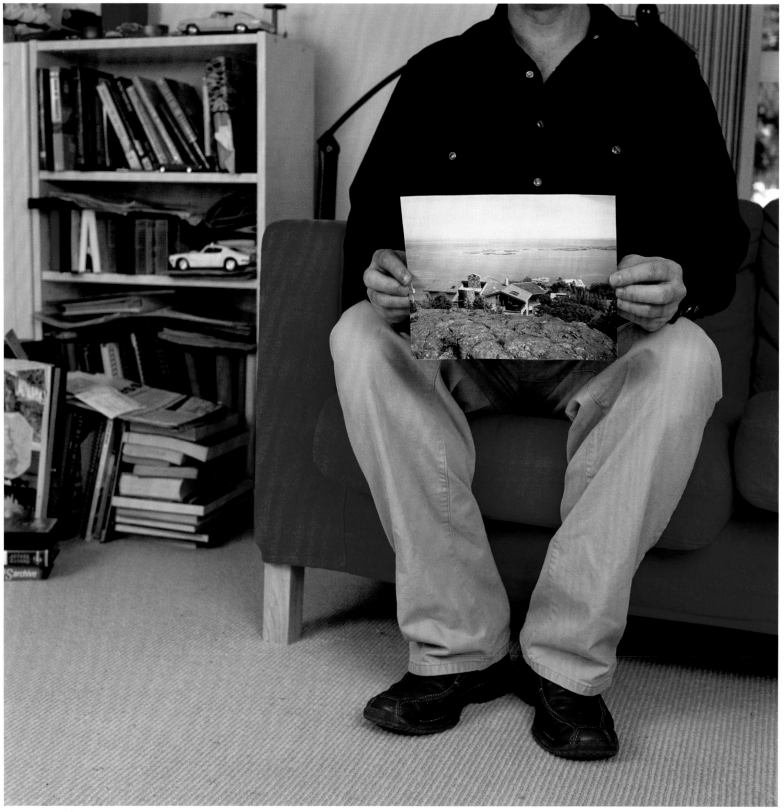

Don, 2005

Rita Godlevskis

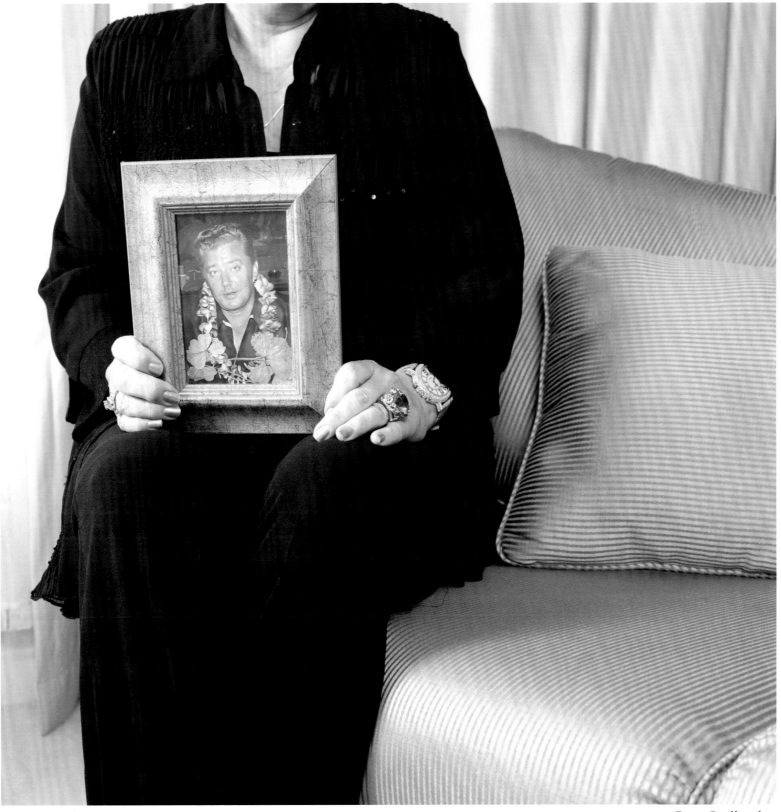

Roxy, 2005

Rita Godlevskis

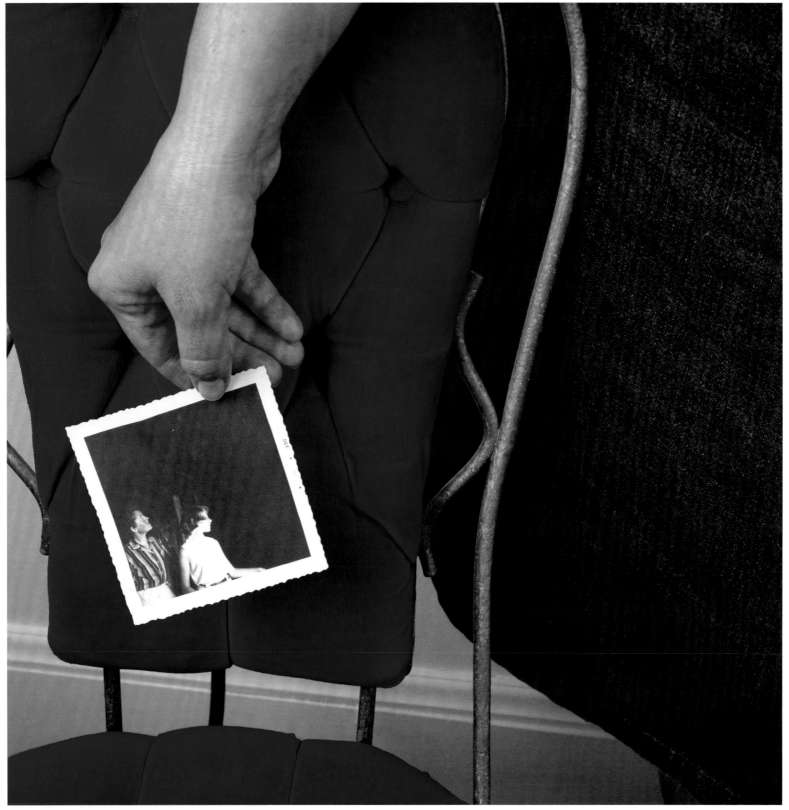

Jenn, 2003 Rita Godlevskis

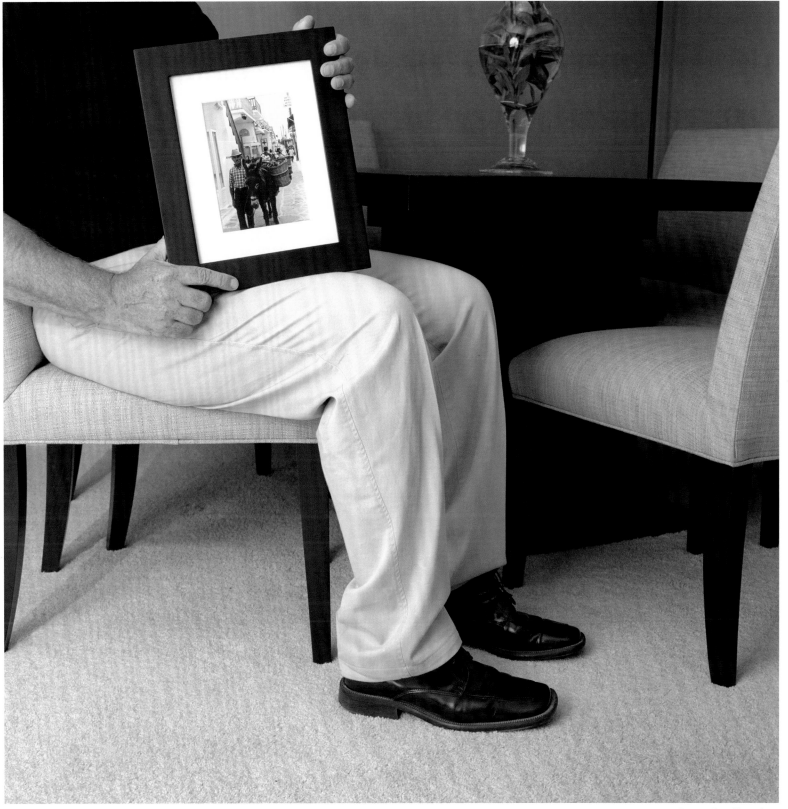

Lucien, 2003

Rita Godlevskis

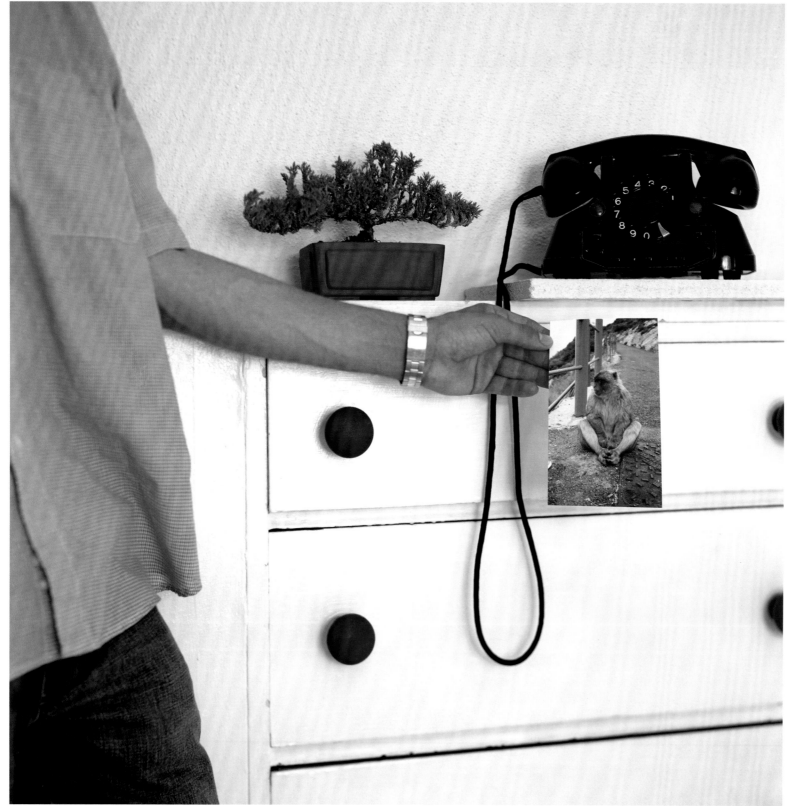

Eric, 2003

Rita Godlevskis

Mementos

Most people's first encounters with photographic images start at home. Frames displayed with images of ancestors, relatives and events from one's own family and community act as reminders of people and places that once were. These visual relics can form a mental picture of one's personal history and evoke feelings of personal attachment. It is this complex relationship with personal photographs that I am interested in.

The role of photographs in daily life seems incomparable to any other relationship with an object. Personal images bear a direct connection with something that is gone, either a time, place or person. They have the power to evoke strong emotional responses, trigger memories as well as aid in constructing new memories, and opening dialogs.

I am presenting a body of work though which I satisfy my own curiosity about the role of photography in the daily lives of the people around me. As my process, I propose the question, "what is your most important photograph?" to a variety of sitters and then photograph them with the photographic image of their choice in their home, held by their hands.

An array of responses has been found though this survey. Some images hold sentimental attachment while others were chosen for aesthetic appeal. Through this series I not only find out more about my subjects on a personal level, but also more about how the invention of photography has become a tool in our daily lives for capturing and keeping memories and ideas focused on to one small piece of light sensitive paper.

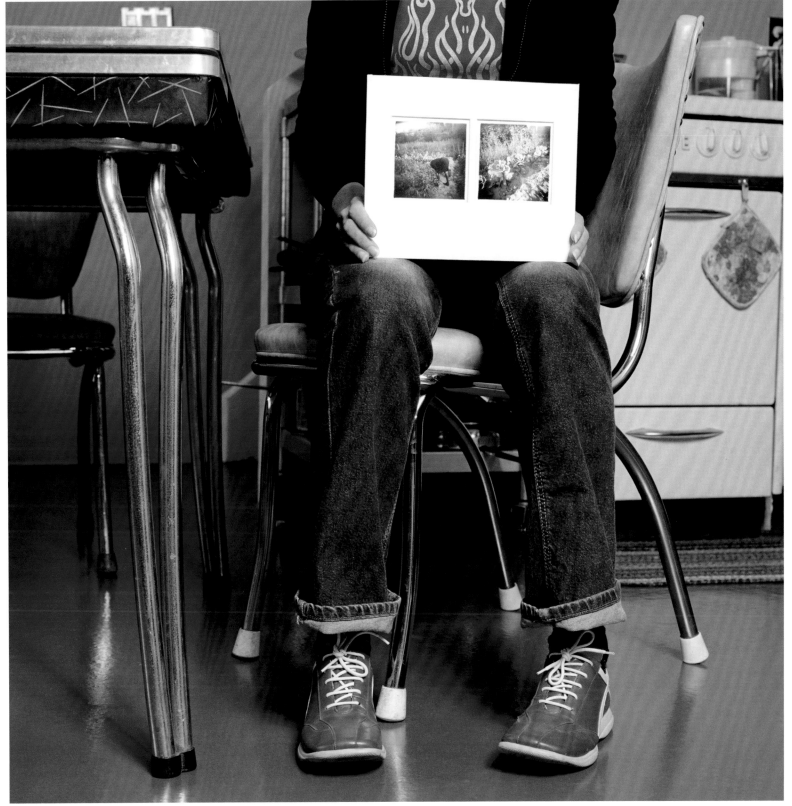

Raff, 2003

Rita Godlevskis

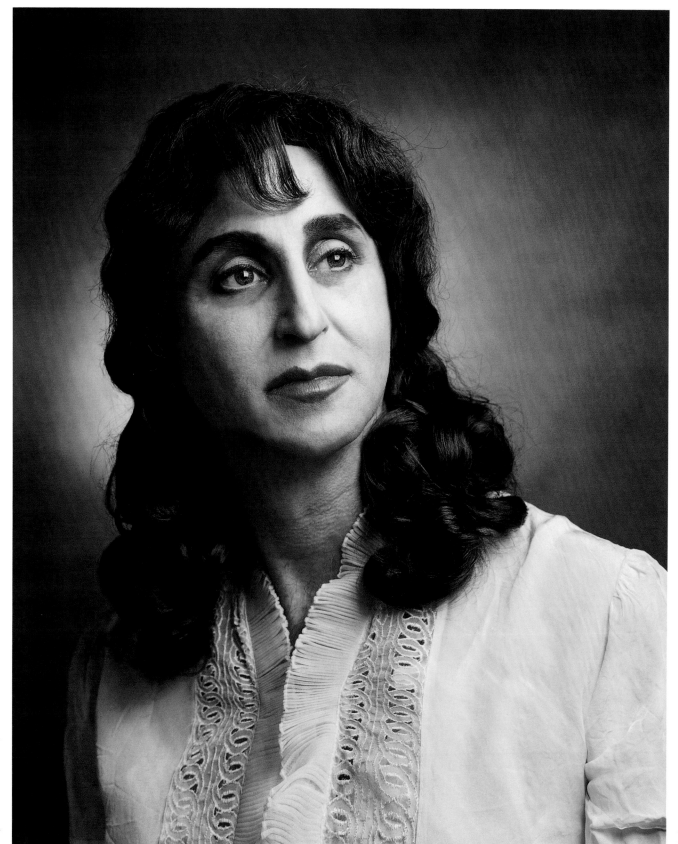

*Self-portrait as
Malka Ryten,
b. Lubliu,
Poland,1897,
d. Tel Aviv, Israel,
1974*

Raphael Goldchain

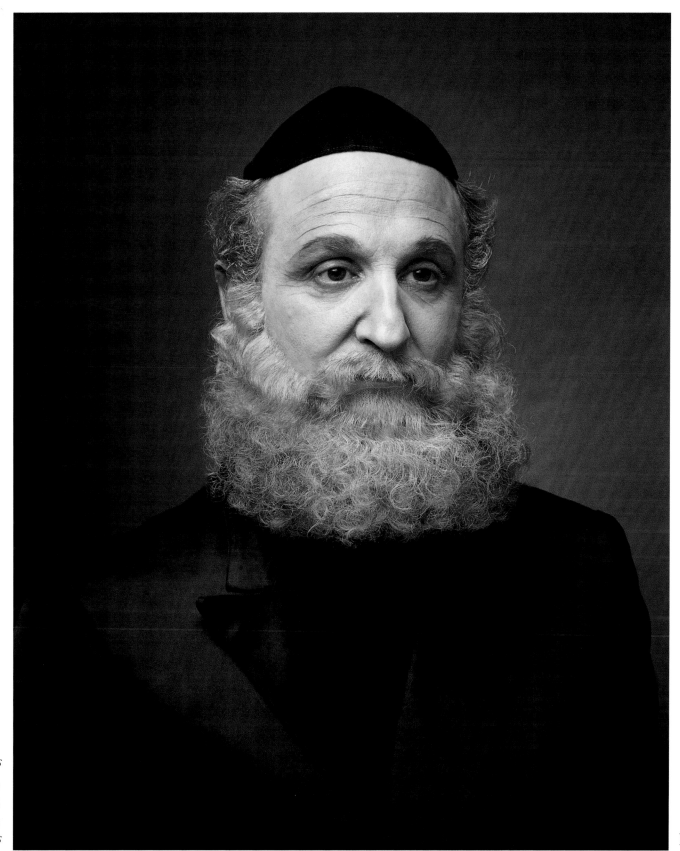

Self-portrait as
David Ryten,
b. Ustilug,
Ukraine,early 1900s,
d. Poland early 1940s

Raphael Goldchain

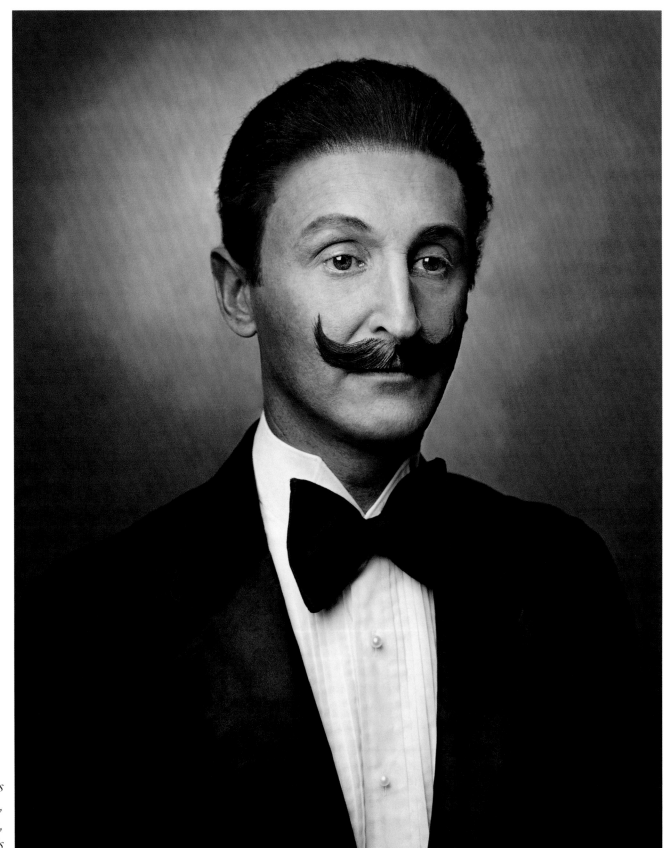

Self-portrait as
Mendl Golsszajn,
b. Poland 1890s,
d. Poland early 1940s

Raphael Goldchain

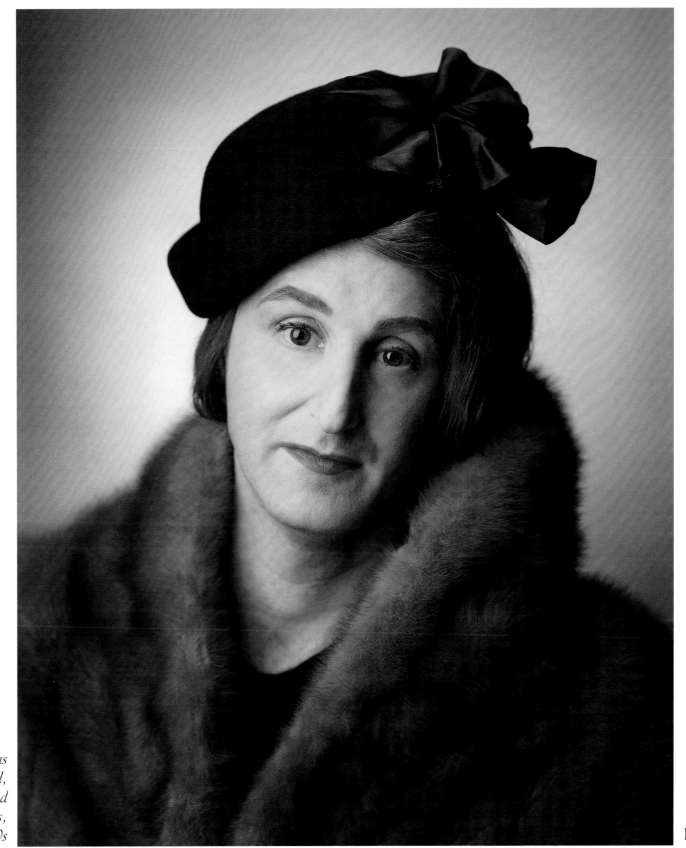

Self-portrait as
Pola Baumfeld,
b. Ostrowice, Poland
early 1900s,
d. Poland early 1940s

Raphael Goldchain

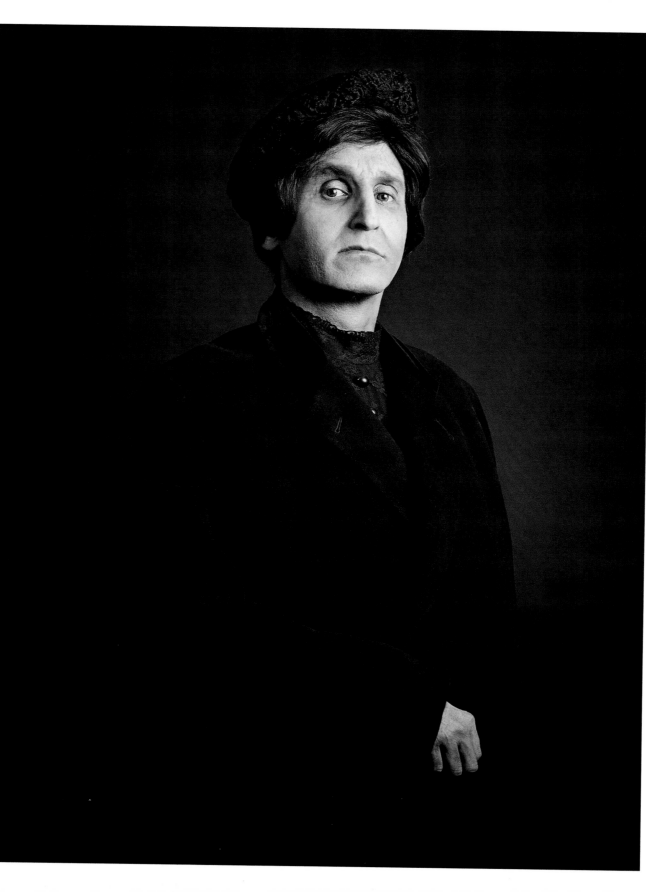

"I Am My Family" is an auto-biographical exhibition and book that features digitally altered self-portrait photographs. It suggests that grounding identity within a familial and cultural history subject to extinction, geographic displacements, and cultural dislocations entails mixing equal measures of fact and imagination. It involves a process of gathering and connecting scattered fragments of past familial history while acknowledging the impossibility of complete retrieval. It attempts to create an illusion of a whole family gathered while underlining its fragmentation and dispersal.

The self-portraits in "I Am My Family" are detailed reenactments of ancestral figures, and in their specificity can be understood as acts of "naming" linked to mourning and remembrance. "I Am My Family" proposes a language of mourning through self-portraiture and through the conventions of family portrait photography. In reenacting ancestral others through a genetic relationship of resemblance, and through the conventionality of the portrait photograph, the self-portraits in "I Am My Family" suggest that we look at family photographs in order to insert ourselves in them and recognize ourselves in the photographic trace left by the ancestral other.

"I Am My Family" is the product of a process that started several years ago when my son was small. I slowly realized that my role as parent included the responsibility to pass on to my son a familial and cultural inheritance, and

Self-portrait as Chaja Golda Precelman née Ryten, b. Ostrowice, Poland late 1800s, d. Poland early 1940s

that such inheritance would need to be gathered and delivered gradually in a manner appropriate to his age. My attempts at relating histories, familial and historical, made me acutely aware of how much I knew of the latter, and how little of the former. I thought of the many erasures that my family history was subjected to, and of the way in which my South American and Jewish educations privileged public histories. As I reached my middle years it became important to not only retrieve basic historical facts such as family names, dates, and genealogical relations, but also to attempt to know the world of my ancestors as a basic foundation of an identity that I could pass on to my son. While I could access the considerable existing stores of knowledge of Eastern European Jewish life, knowledge of the pre-Holocaust lives of my grandparents and their families only exists in fragments deeply buried within the memories of elderly relatives.

Using historical images and documents I insert myself into my familial history. Where there are only gaps I create, or invent that which can be thought to be lost forever. These gaps are the fuel of the imagination where invention responds to the need to bring the past to life and into the present. Some ancestors represented in the body of work are based on accurate documentation and living memory while others-in the absence of any information - were invented based on archival sources from the same period, and yet others were created in the studio based on the playful use of period clothing, makeup and hair pieces. In some cases the same ancestor was portrayed at various (imagined) stages of their life. The historical evolution and geograph-

Raphael Goldchain

ical displacement of the family is evident in hair and clothing styles and in image titles that show changes to name spelling and places of birth and death.

The effort to be precise both in characterization and in image titles is akin to the mournful and angry recitation of the names of disappeared fathers, husbands, and sons by the Mothers of the Plaza de Mayo in Argentina. But mourning and remembrance is not all that is required to underpin an identity fractured by extinction and scattering, by geographic and cultural displacement. Representations of ancestors are often used to bolster claims to social position and entitlement (definitely not my case,) or in other cases to settle old scores, although I must admit that a shade of satire and fun creeps in here and there.

My work explores the relations amongst family portraiture, mourning and remembrance, notions of history, memory, and of justice and inheritance. Just as I am the carrier of memories and ancestral history fragments through whom the familial past is brought up into the present (for my son to carry into the future), the self-portraits in "I Am My Family" visually articulate a process of identity representation through mourning and remembrance, whereby ancestral figures take on my visage as they emerge into visibility (while at the same time remaining concealed behind my features and behind the opacity of the portrait photograph) to serve as a reminder of the unavoidable work of inheritance. These images are the result of a reconstructive process that acknowledges its own limitations in that the construction of an image of the past unavoidably involves a mixture of fragmented memory, artifice, and invention, and that this mixture necessarily evolves as it is transmitted from generation to generation.

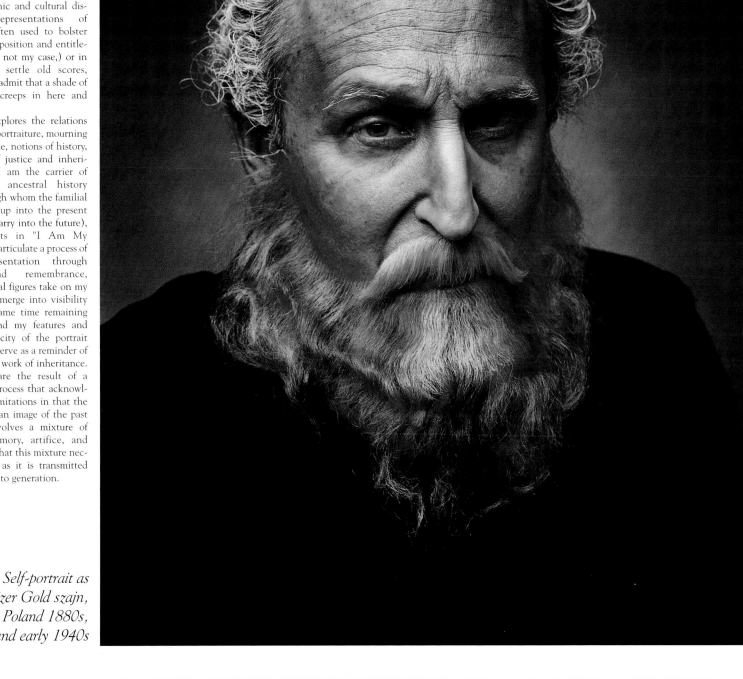

Self-portrait as
Leizer Gold szajn,
b. Poland 1880s,
d. Poland early 1940s

Raphael Goldchain

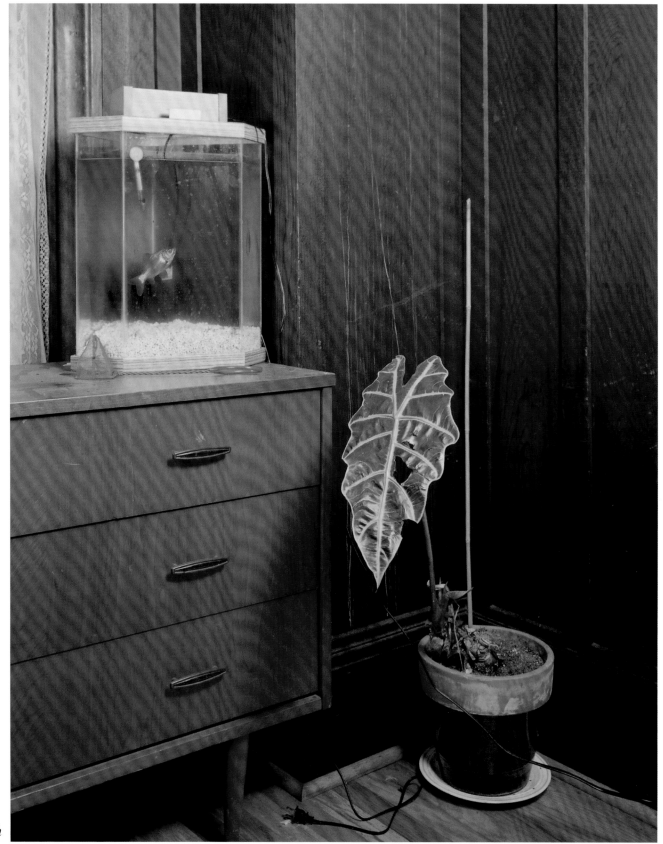

Goldfish

Nicole Jean Hill

Tank Nicole Jean Hill

Fire Eyes

Nicole Jean Hill

Chuck

Nicole Jean Hill

Huxley

Nicole Jean Hill

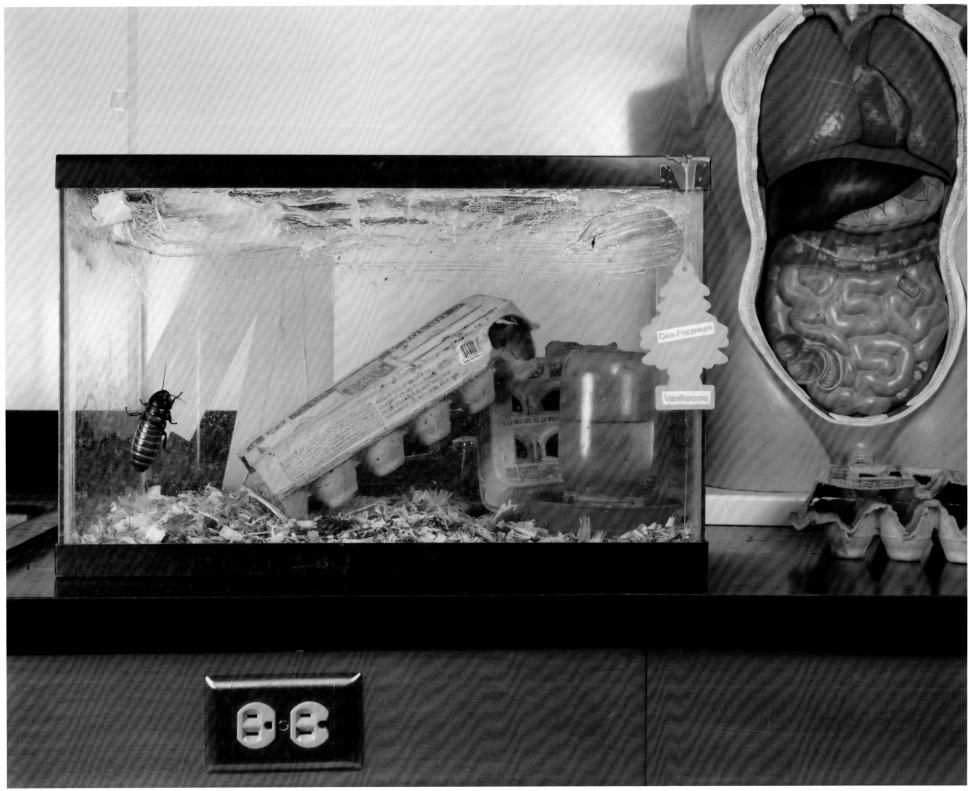

Hissing Cockroach

Nicole Jean Hill

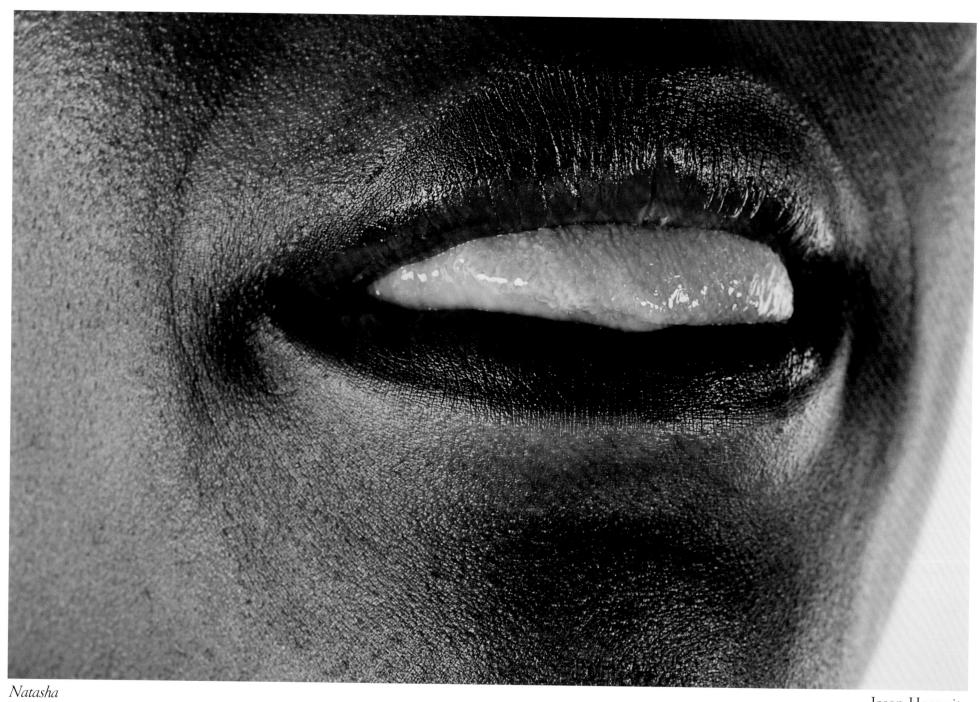

Natasha

Jason Horowitz

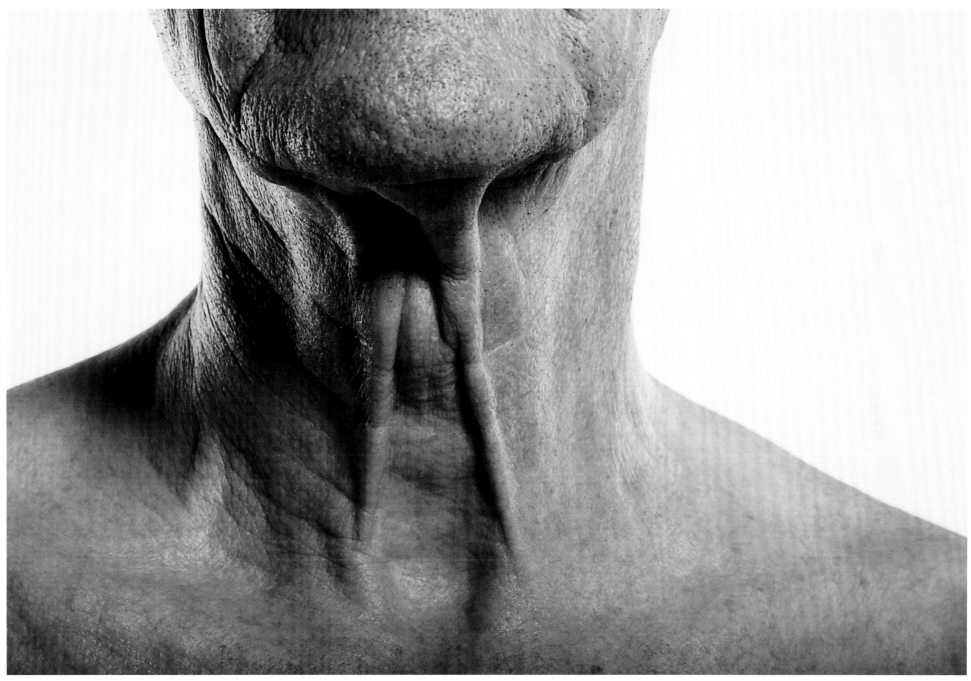

Wayne

Jason Horowitz

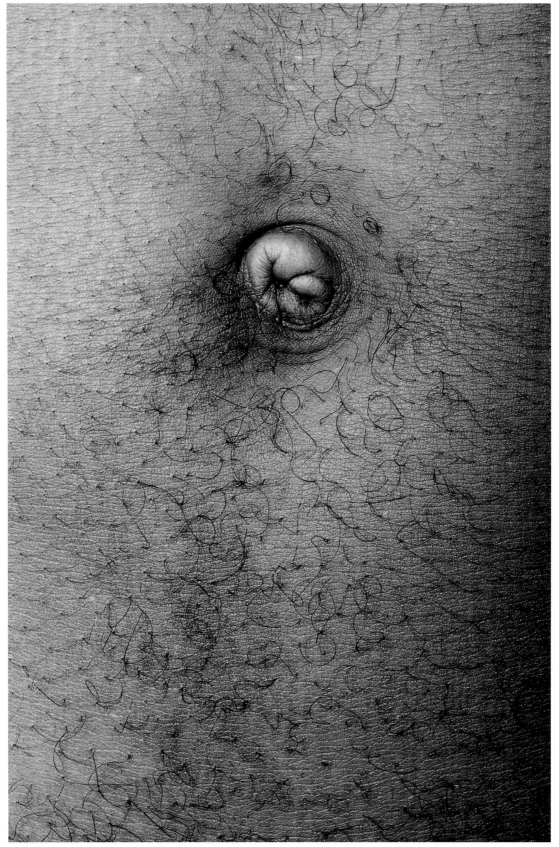

Bruce #2 Jason Horowitz

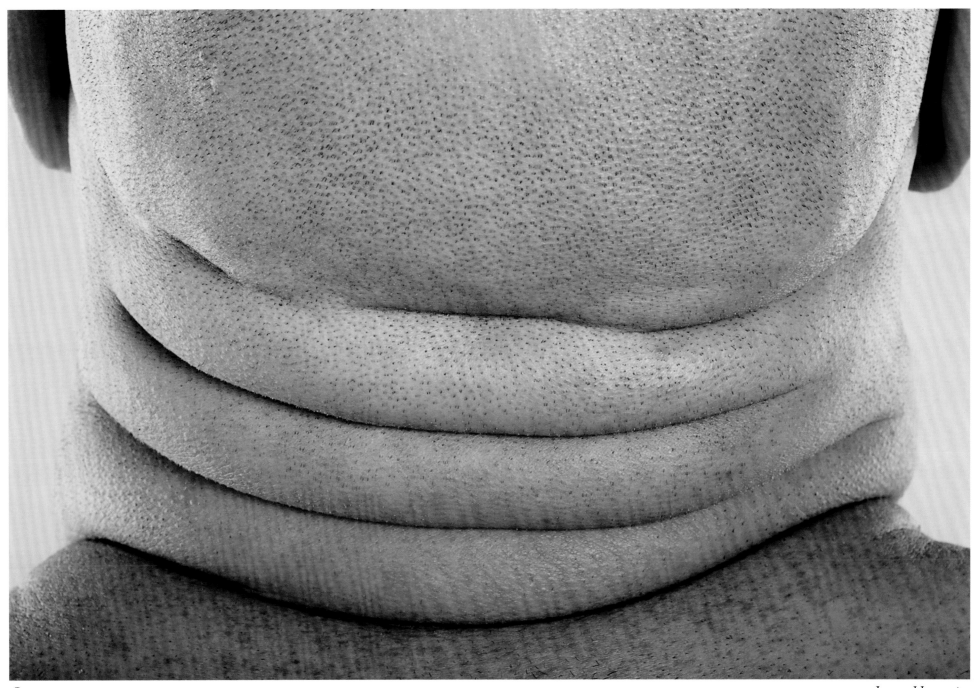

Scott

Jason Horowitz

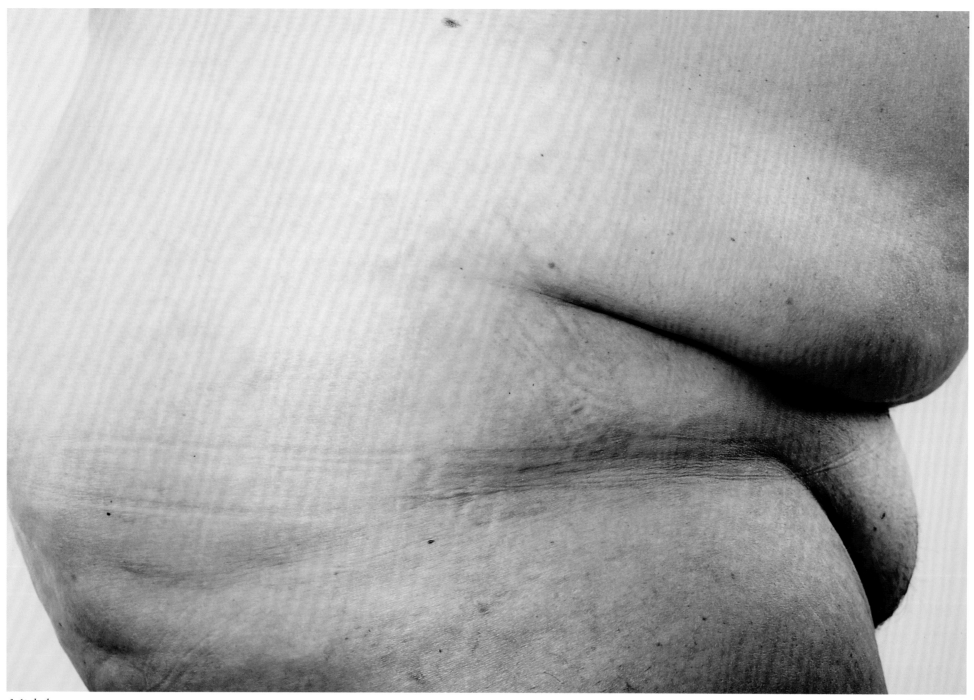

Michele

Jason Horowitz

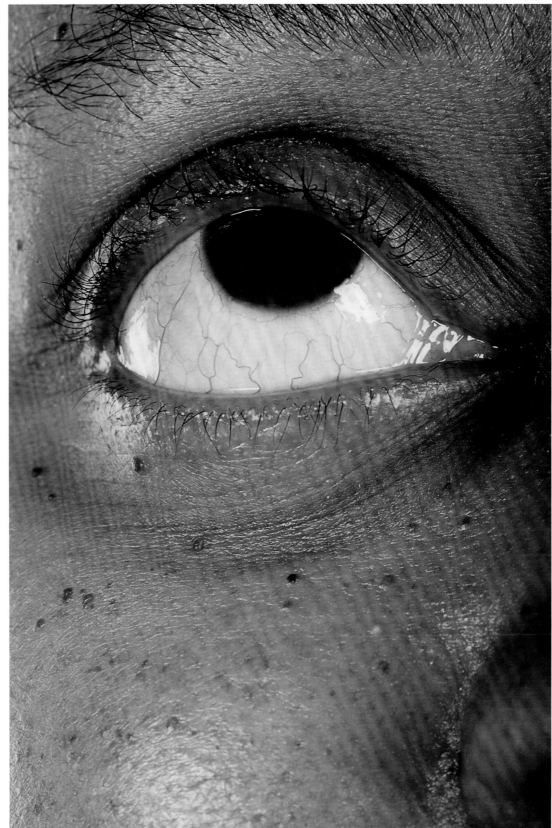

The images of the Corpus portfolio find new ground to explore about the human body. These large-scale photographs exist at the intersection of landscape and anonymous portraiture. By exploding scale, they reveal not only the fascinating visual terrain of the body but also challenge our own hidden or unspoken biases about beauty, ugliness, body-image, race, sexuality, aging, and the thresholds of exhibitionism. Playing with the tension between attraction and repulsion, the images reveal a hyper-realistic amount of detail about the subject and explore the relationship between photographic representation and painterly abstraction, the formal elements in tension with the emotional content of the subject matter. Their scientific/medical point-of-view is balanced by the intimate, personal, and sometime sensuous nature of the subject matter. Shot with the same "glamour" lighting set-up used for fashion images, these photographs subvert that process to look at what is real rather than ideal. Larger than life, these images become a vehicle for looking deeply at one's self and others.

Meredith

Jason Horowitz

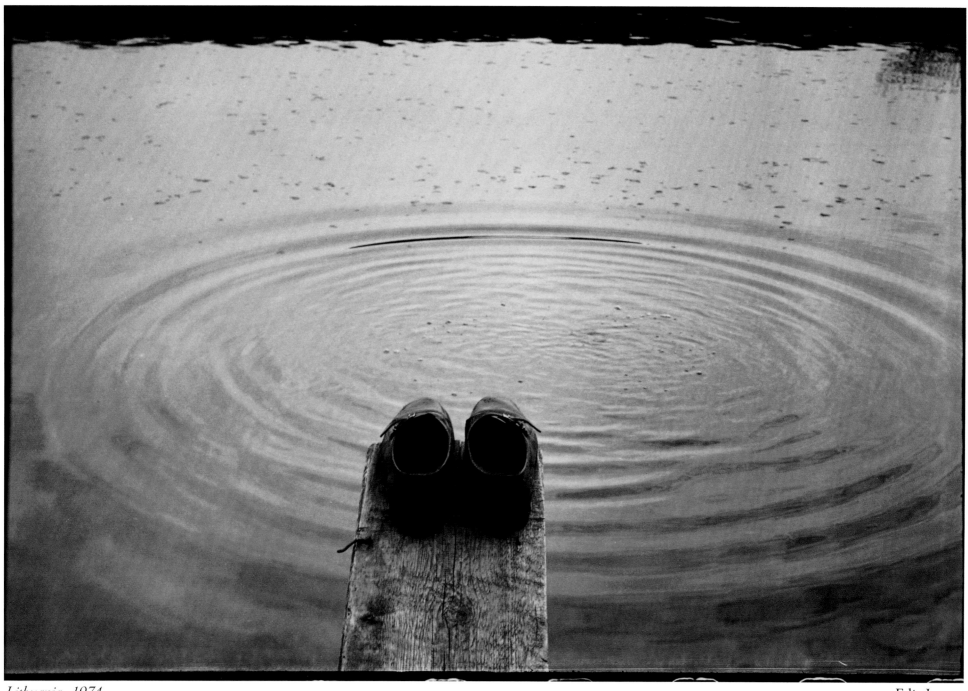

Lithuania, 1974

Edis Jurcys

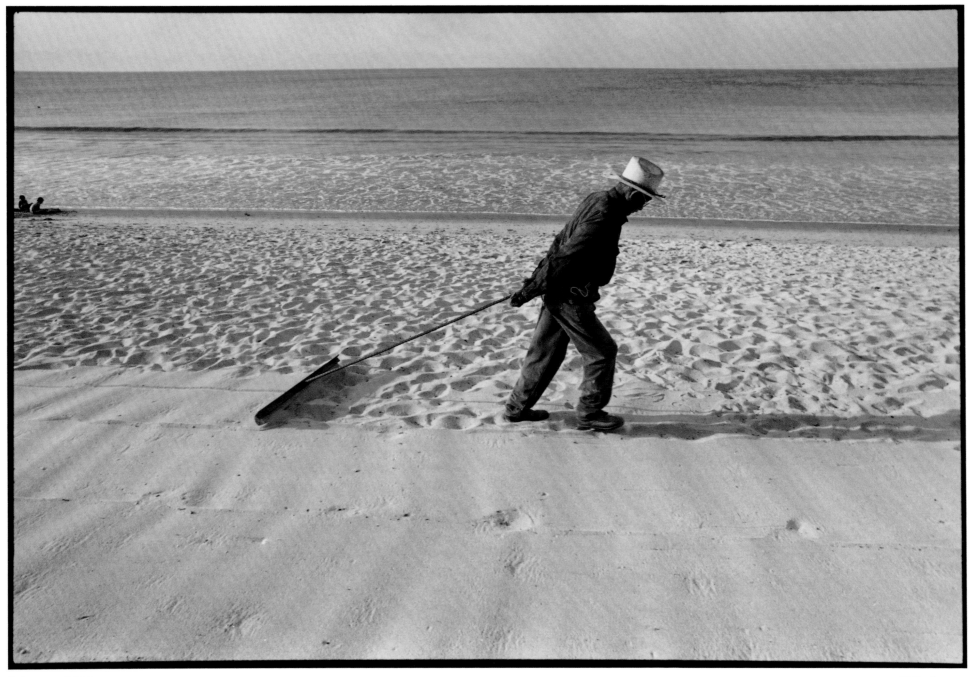

Mexico, 1999

Edis Jurcys

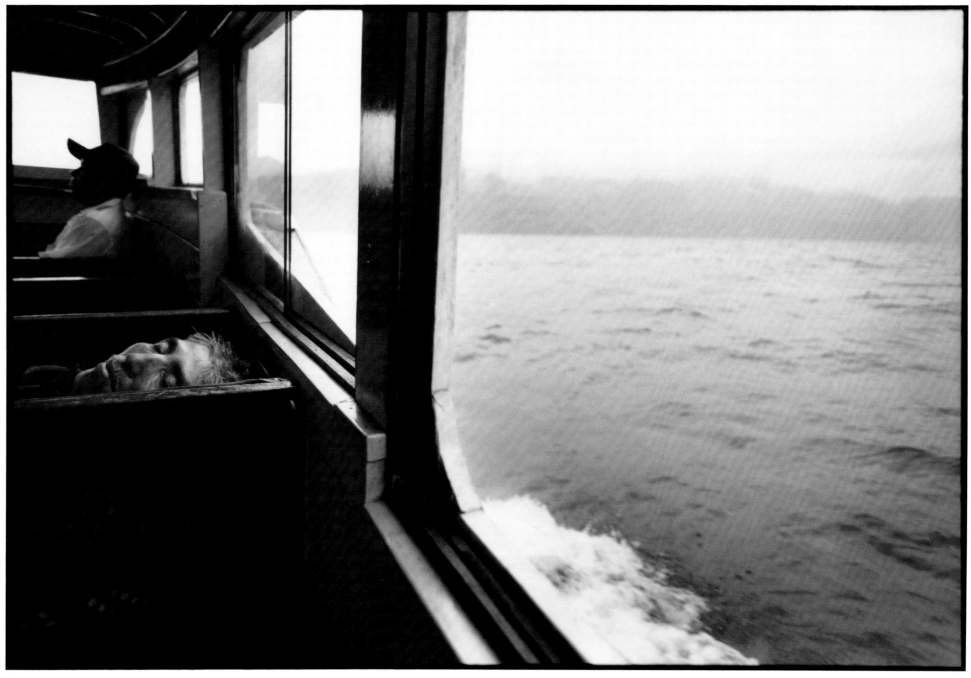

Ferry series, 2000 – 2004

Edis Jurcys

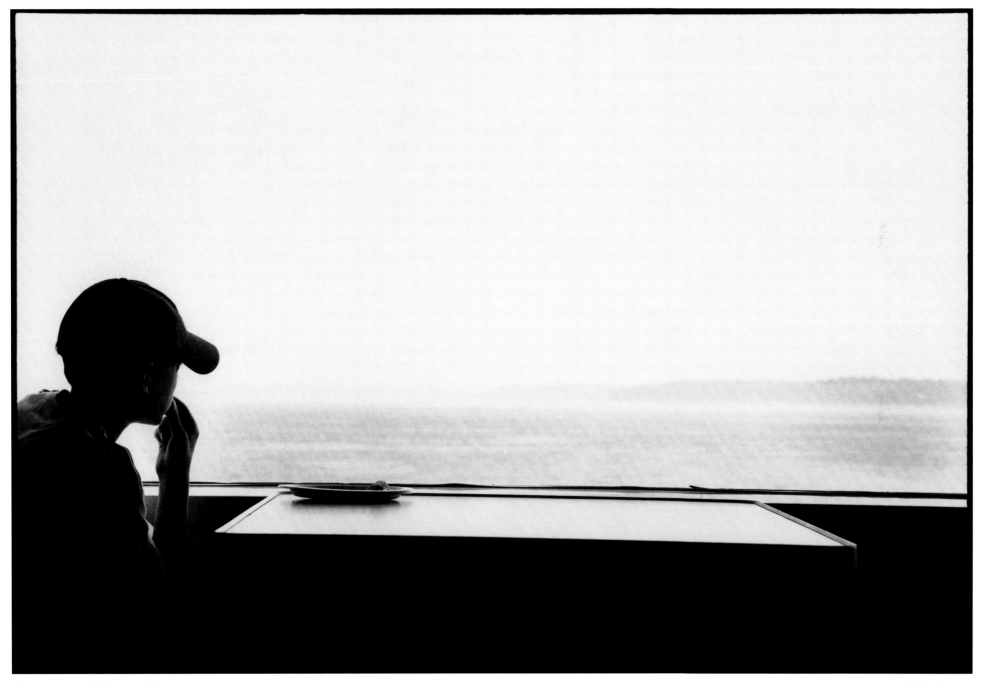

Ferry series, 2000 – 2004

Edis Jurcys

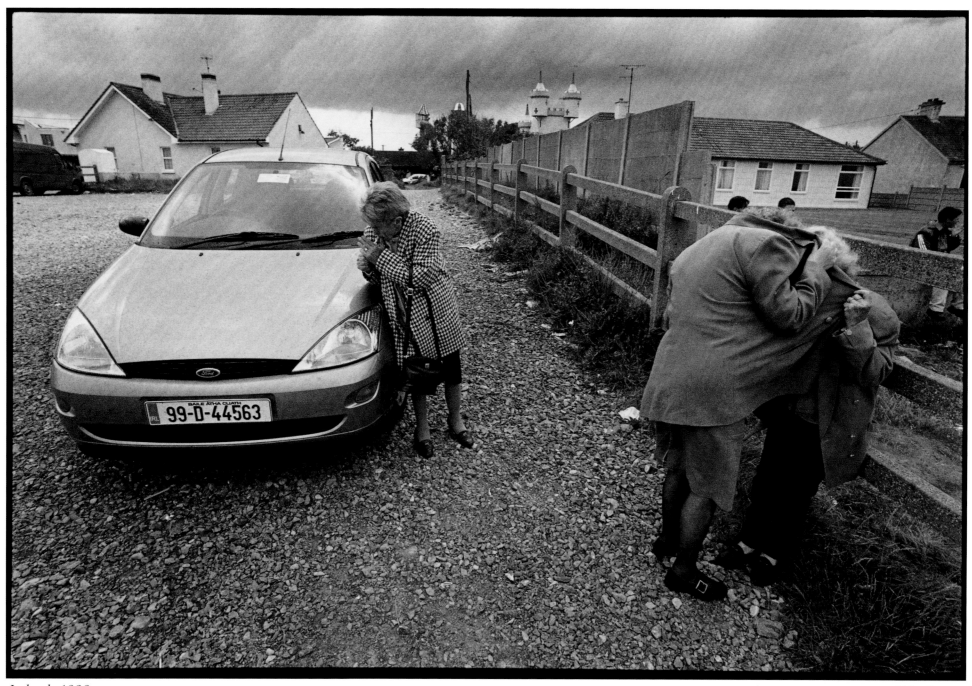

Ireland, 1998

Edis Jurcys

My images are wide ranging and eclectic, everything from homeless people with their pets to lovers, ferry boat travelers, the humor in a $5 hair salon or different cultures.

I observe people with depth, sensitivity and originality. One important element of my work is surprise, my ability to lift a moment out of its ordinary existence and elevate it to my particular artistic perception. I avoid staging images. I want to see and feel the real flow of people, time, and behavior. I aim to magnify both sacred and trivial things, giving them dignity and respect while capturing honest feelings.

Some of my photographs are mystical, seeing reflections of reflections, as if we lived in the kingdom of mirrors - in a world where images represent images that imagine themselves.

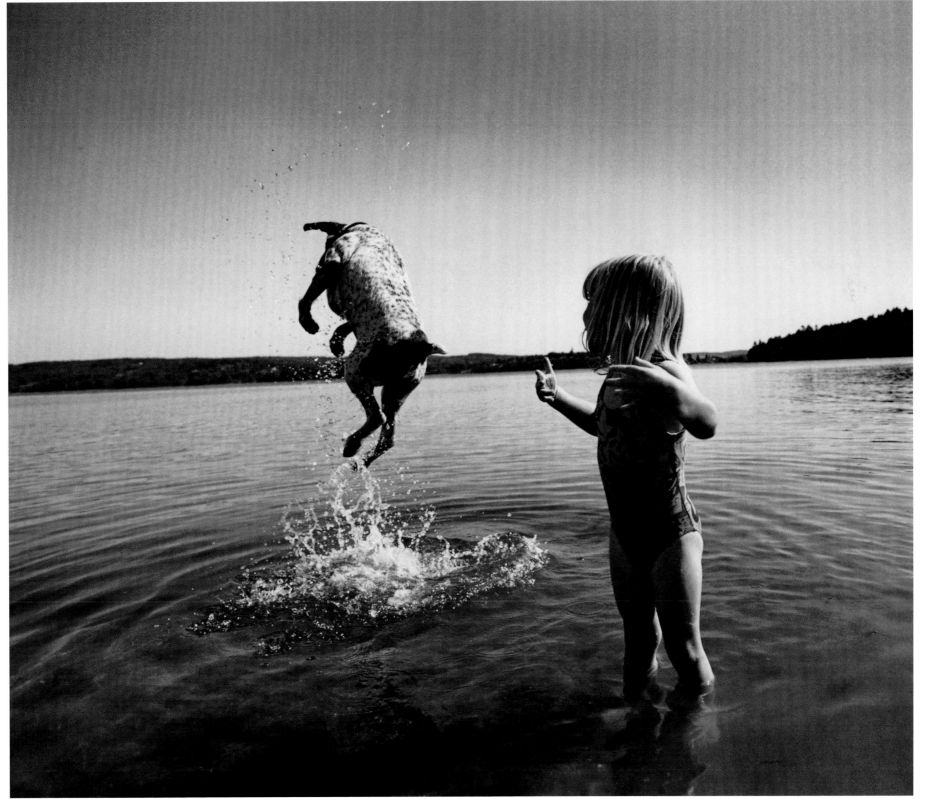

Seattle, 1997

Edis Jurcys

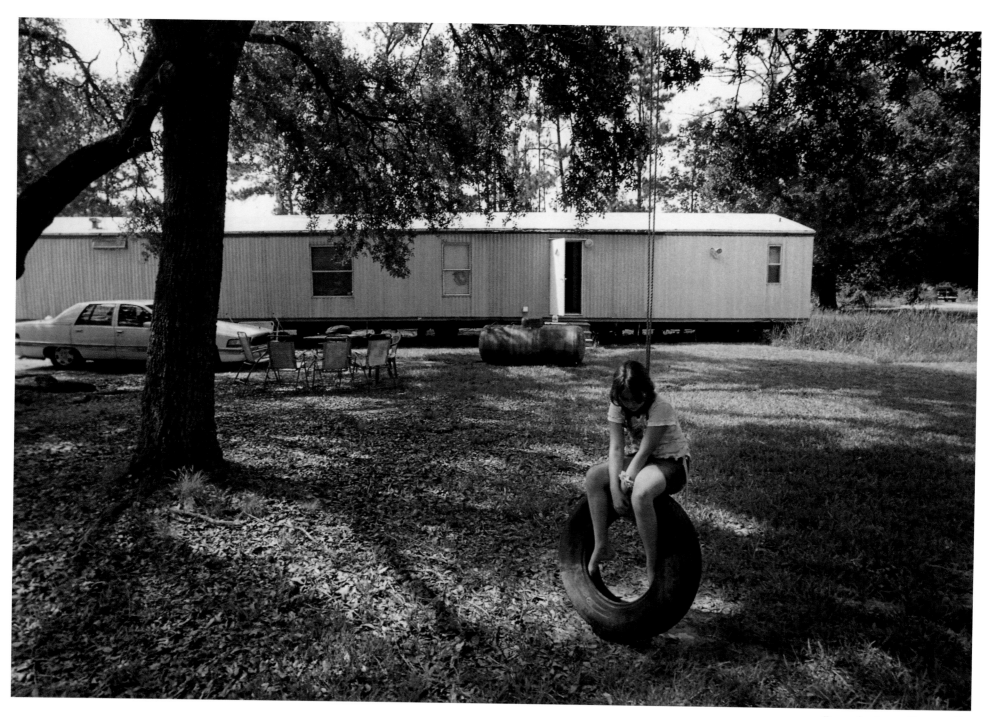

Brenda Ann Kenneally

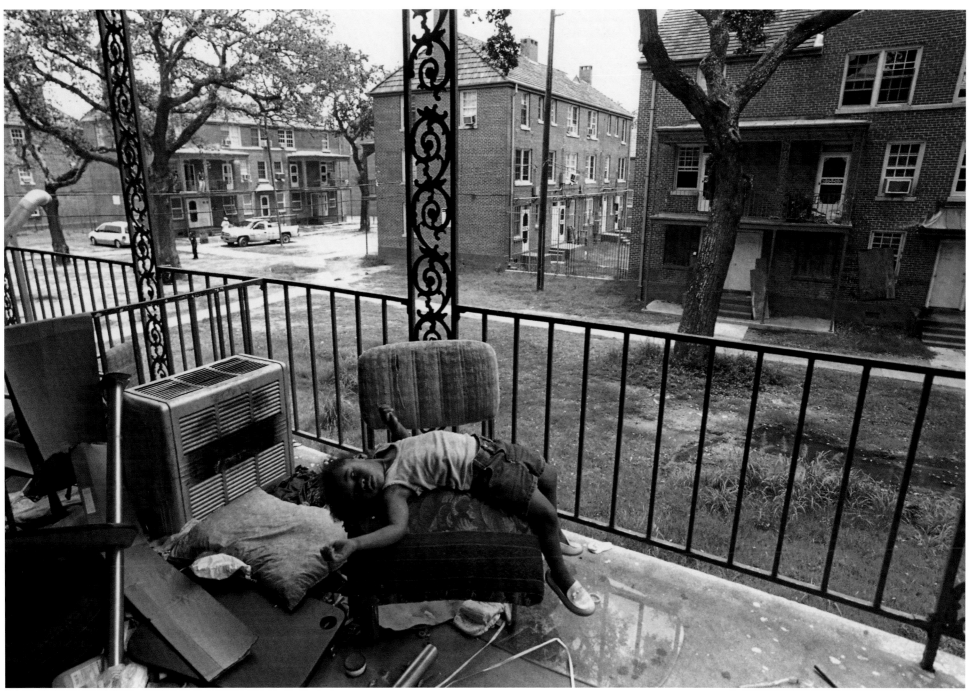

Brenda Ann Kenneally

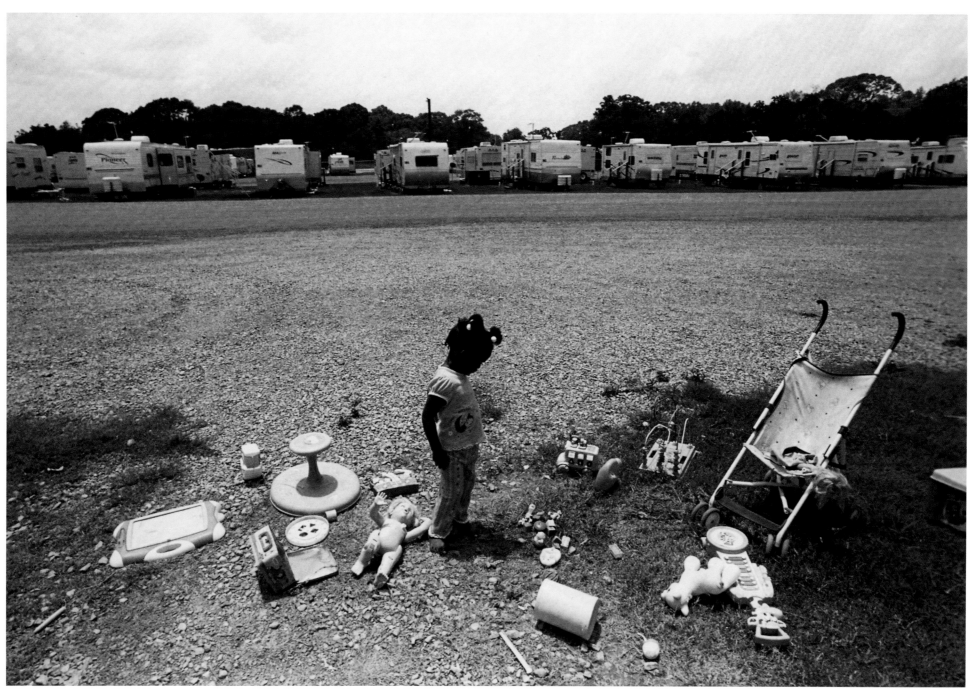

Brenda Ann Kenneally

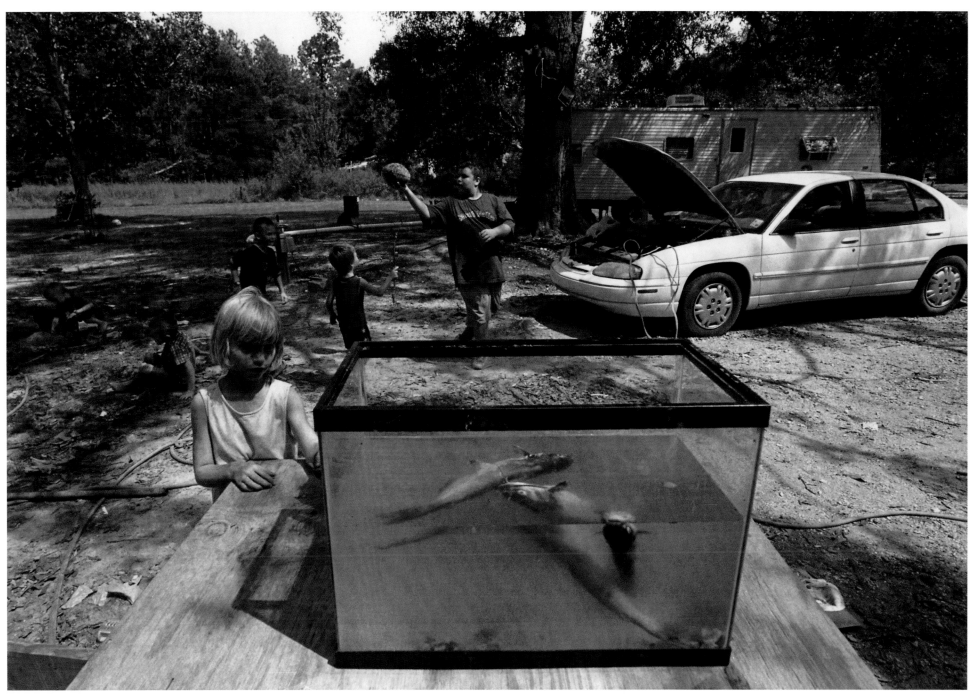

Brenda Ann Kenneally

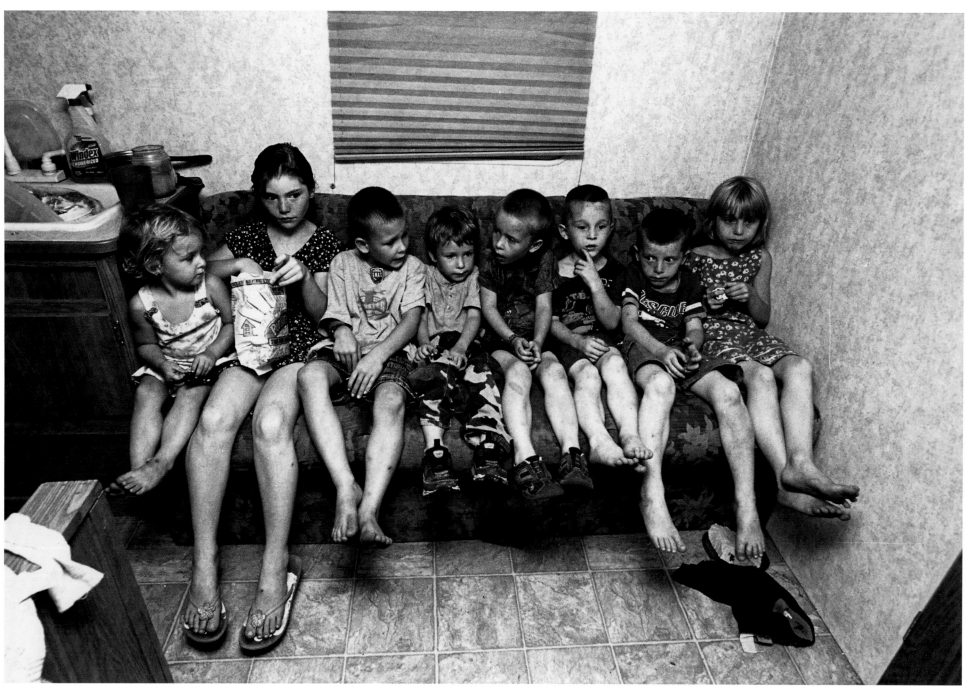

Brenda Ann Kenneally

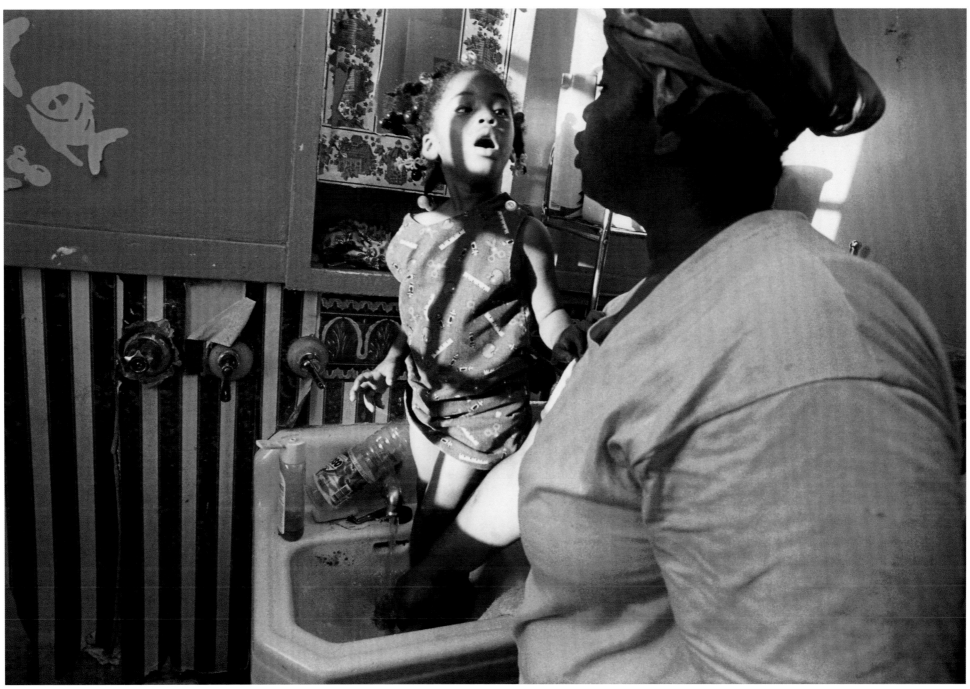

Two years after Hurricane Katrina hit Louisiana on August 29, 2005, the story is no longer about leaving. It's about coming home. For many, that process has not been easy. Tens of thousands of houses still remain empty, a majority of them belonging to the poor. In New Orleans alone, most of the 77,000 rental units have not been rebuilt.

As staggering as the numbers are, though, they cannot do justice to the emotional turmoil left in the hurricane's wake. Just what does it take for a family to start over? How does one survive not only the loss of a house, but the very real economic hardships of paltry insurance payments and lack of jobs, housing, and so many basic needs.

Brenda Ann Kenneally

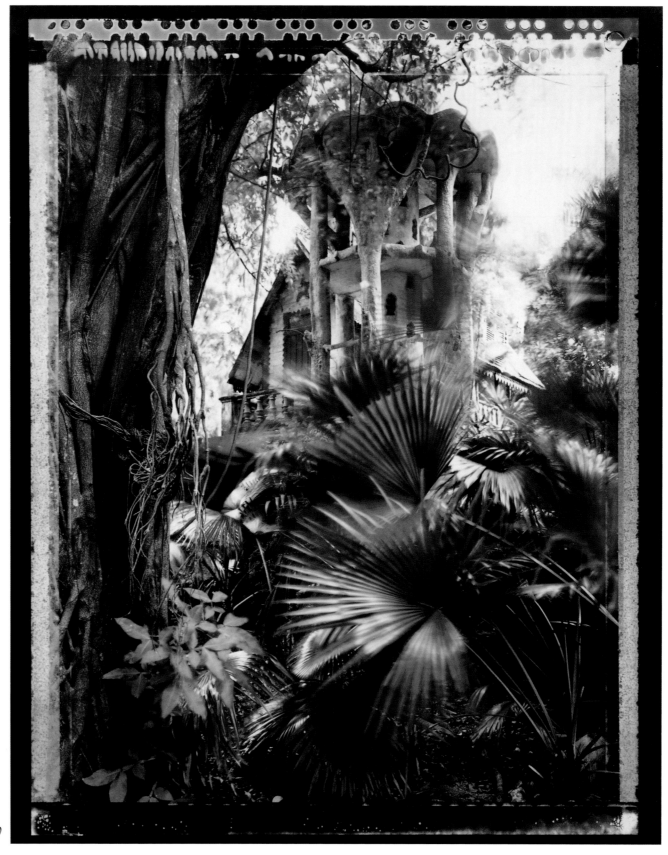

Garden fantasy, Havana, 2000

Elaine Ling

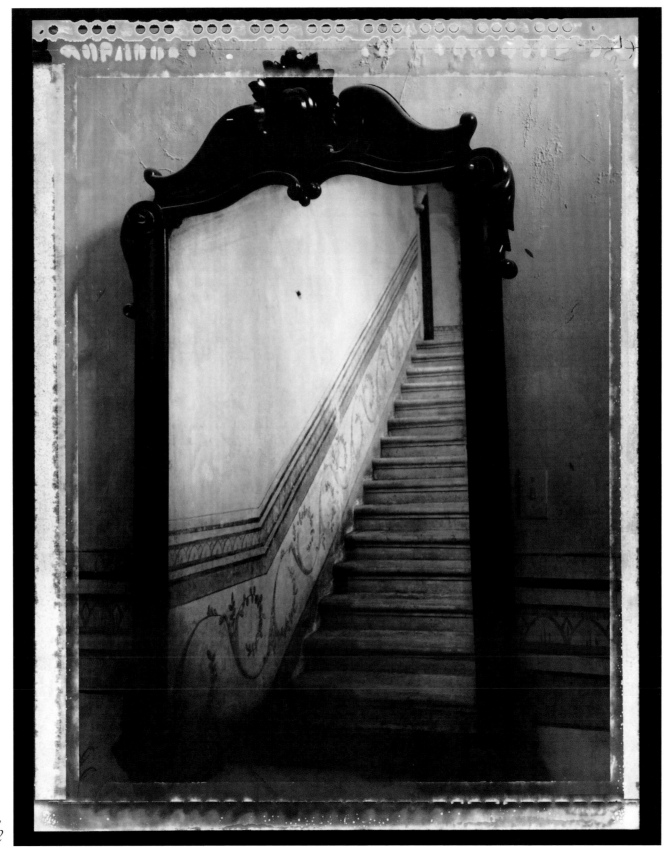

Grand staircase mirror,
Havana, 2002

Elaine Ling

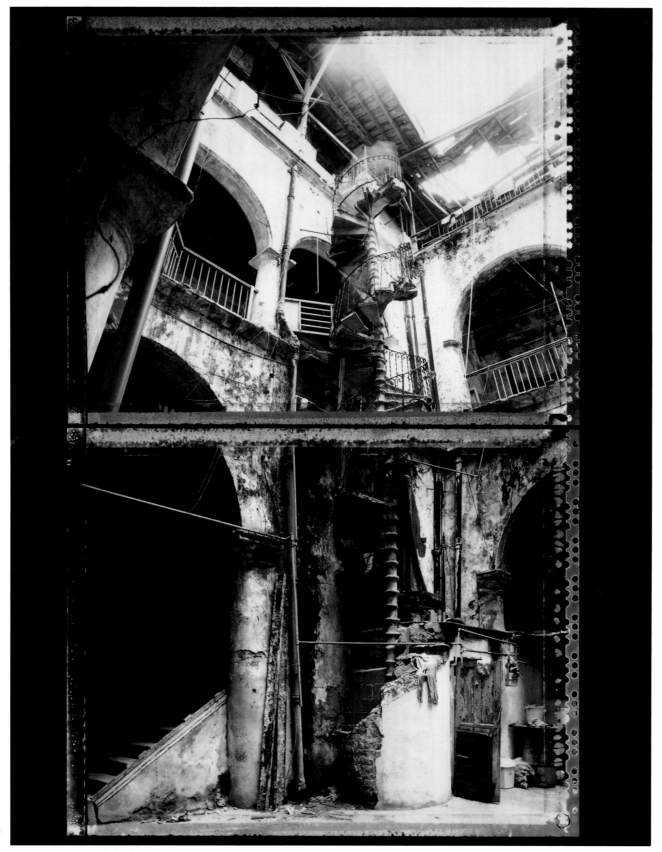

Lady in white dress, Havana, 2000

Elaine Ling

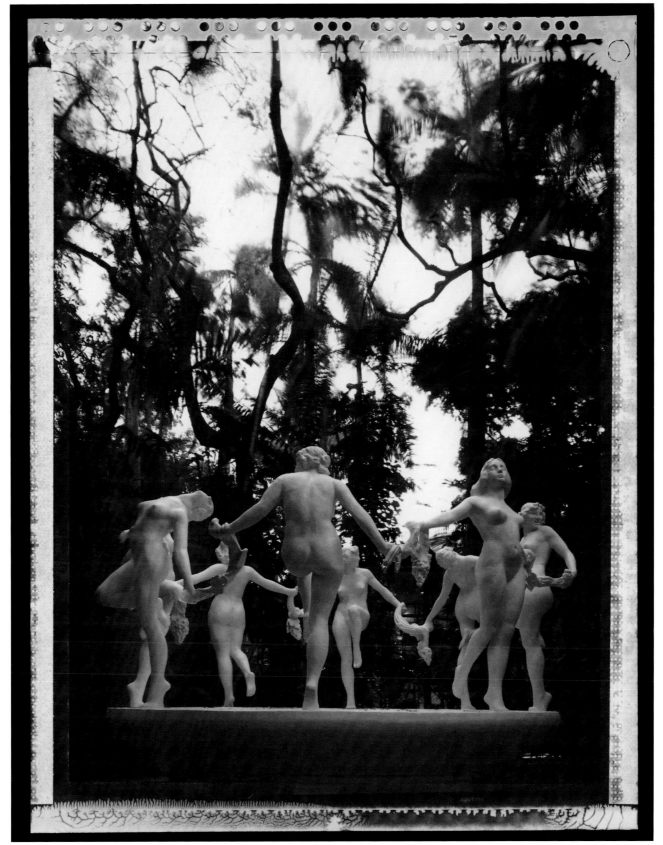

Tropicana, Havana, Elaine Ling

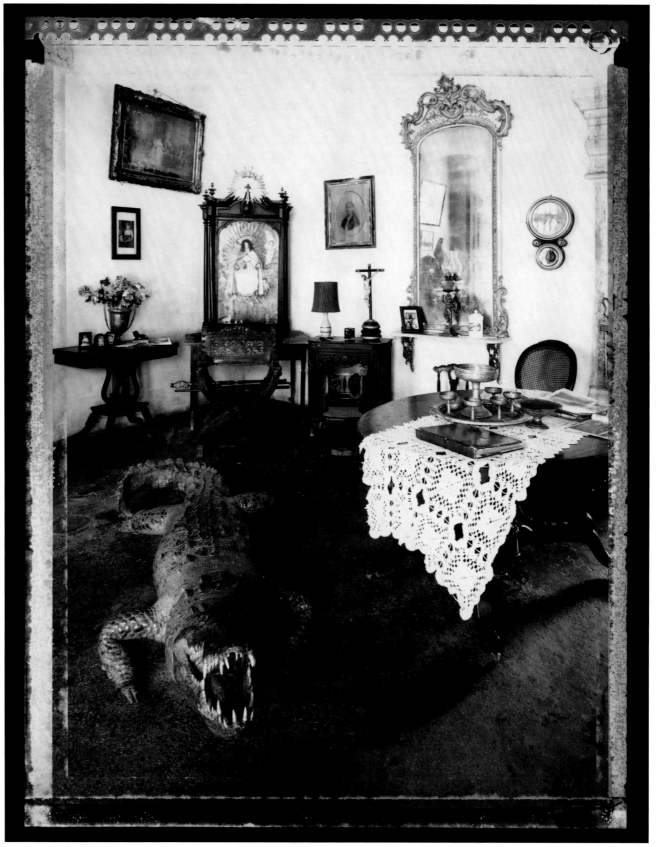

Family room, Trinidad, Elaine Ling

Cuba Chronicles

In Cuba, an island caught between the grandeur of old world glory and the decay of the immediate epoch, I found an urban landscape that reflects a struggle between daily life and the slow forces of Nature and a religion that has superimposed the old world African demigods onto the new world Roman Catholic saints.

Havana echoes the architecture of a decadent and multicultural past. In the vestigial remains of a one street Chinatown are found 13 casinos or clubs, each a center for the few old members of that clan to share their morning teatime. Trinidad echoes the interior grandeur of the colonial homes, each displaying a family's eclectic possessions. Santiago de Cuba echoes the deeply entrenched religions of Santería, Congo, Spiritus and Catholicism. Household shrines often honor all aspects of these beliefs.

Santería, the religion of saint worship, was used in Cuba to refer to the "pagan" religion of the Yoruba and Bantu slaves. Although the slaves had been baptized in the Roman Catholic Church upon arrival in Cuba, with their native practices suppressed by the slave owners, they developed a novel way of keeping their old beliefs alive by equating the santos of their traditional religions with corresponding Christian saints. The slaves cloaked their gods in Catholic clothes and prayed to them. Gods change name and sometimes sex at midnight. The daytime Santa Barbara changes at night to Chango, god of war, fire, thunder and lightning. The house of a santero or santera is open to all. People go there to get help in resolving a problem, usually something to do with health. Strongly, seventy per cent of Cubans believe in santería and observe its rites.

I came to work on this portfolio through shouted invitations to visit people's homes as I wander down the streets carrying my 4x5 camera on a tripod. Each home lead to the neighboring home and each one-room casa holds stored-away treasures of gold trimmed porcelain, doll collections, photos of Ché and Fidel when they were young men and memorabilia of a widow of his wife. Despite the cramped conditions of a whole family living in a small space, there is always an entire room reserved for the altar of the family patron saint. One pays tribute by shaking the rattle and placing an offering in front of the santos.

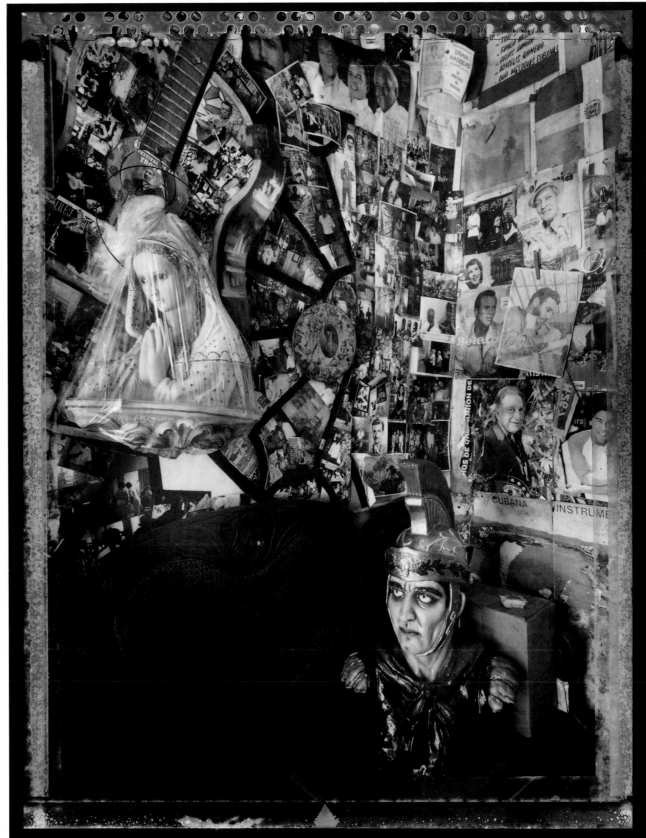

Bookstore, Santiago de Cuba, 2002

Elaine Ling

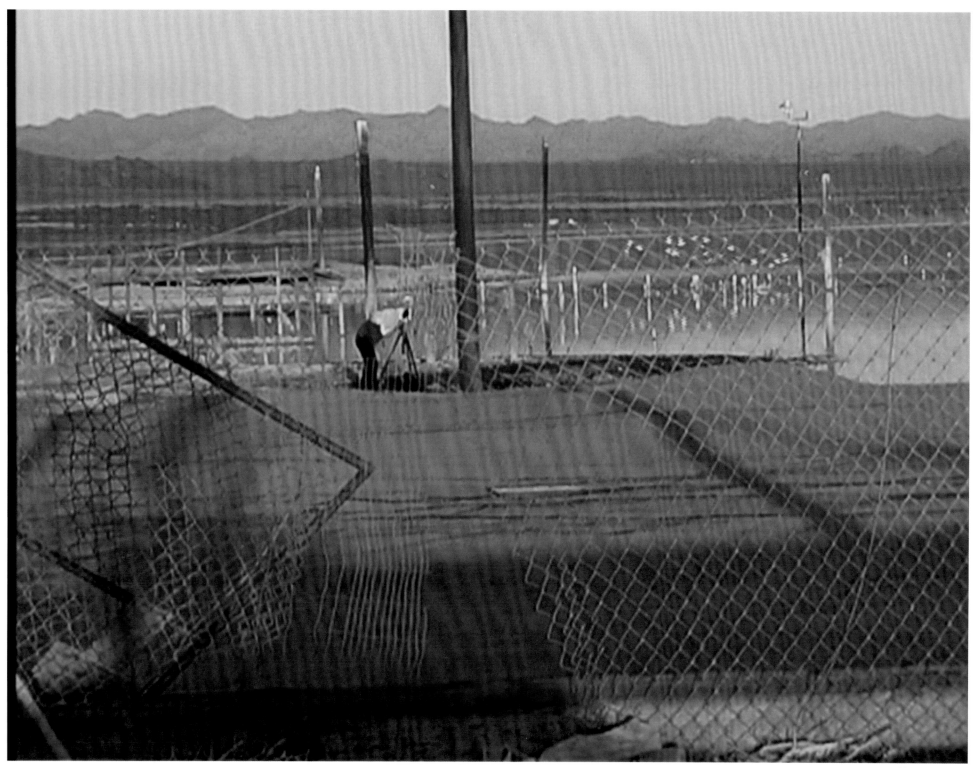

Danielle Mericle

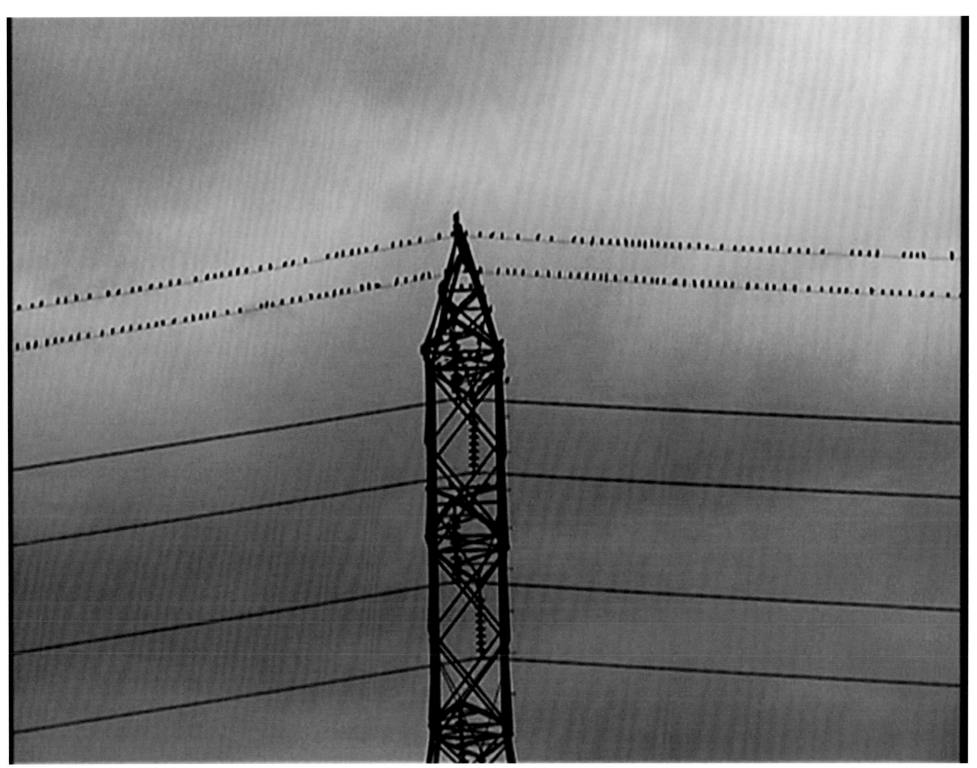

Danielle Mericle

Danielle Mericle

Danielle Mericle

Danielle Mericle

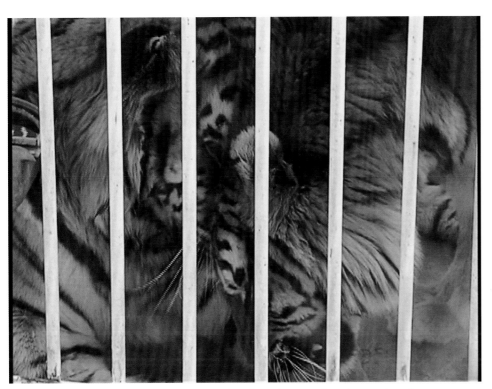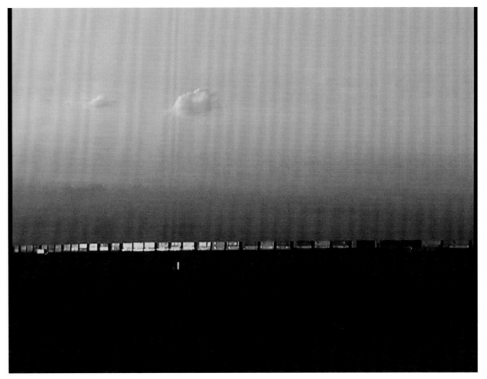

Things that Happen consists of a series of videos that take a phenomenological approach to the contemporary landscape. These videos simply observe how we operate within our everyday reality. Meditative yet humorous, this work reveals the strange, coincidental, and beautiful happenings that occur in our seemingly banal and everyday world.

Danielle Mericle

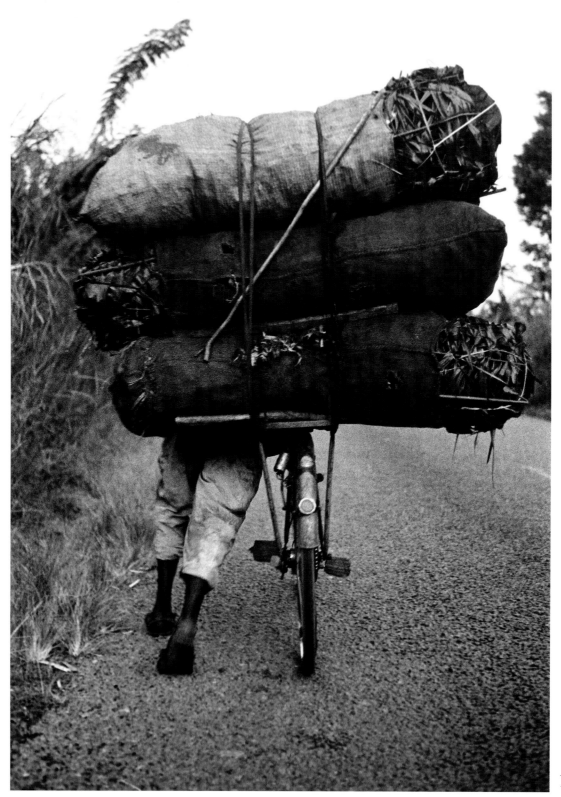

Ntare Guma Mbaho Mwine

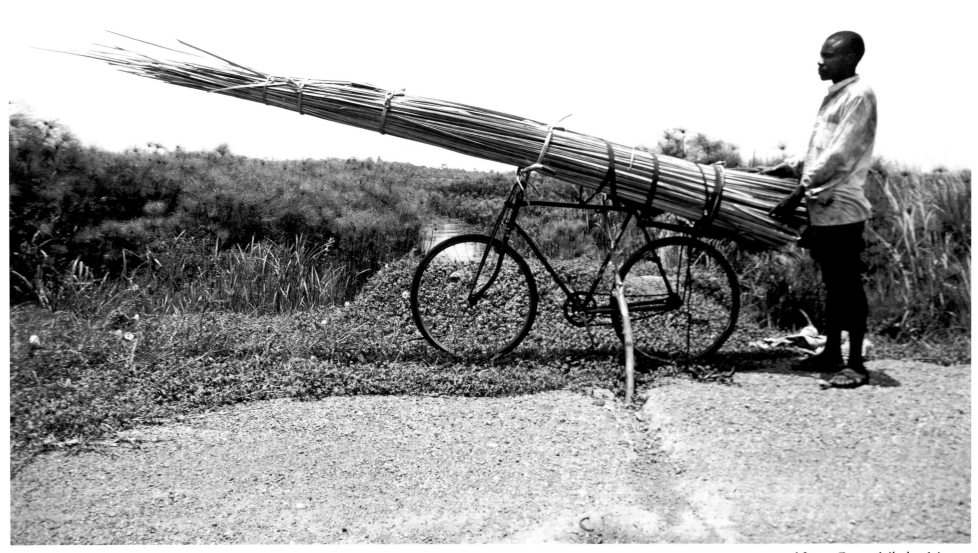

Ntare Guma Mbaho Mwine

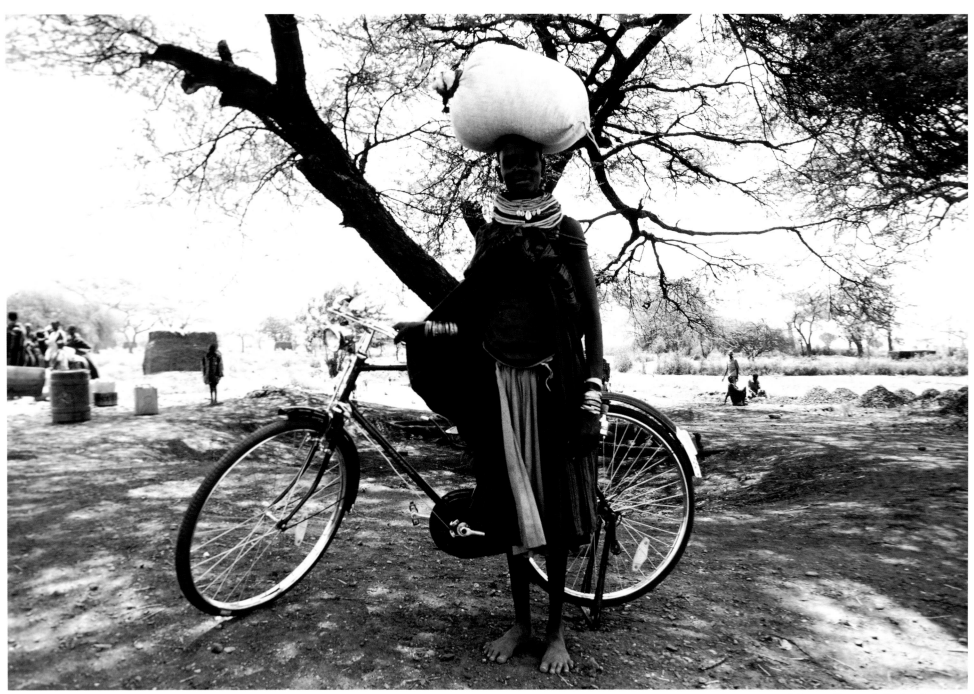

Ntare Guma Mbaho Mwine

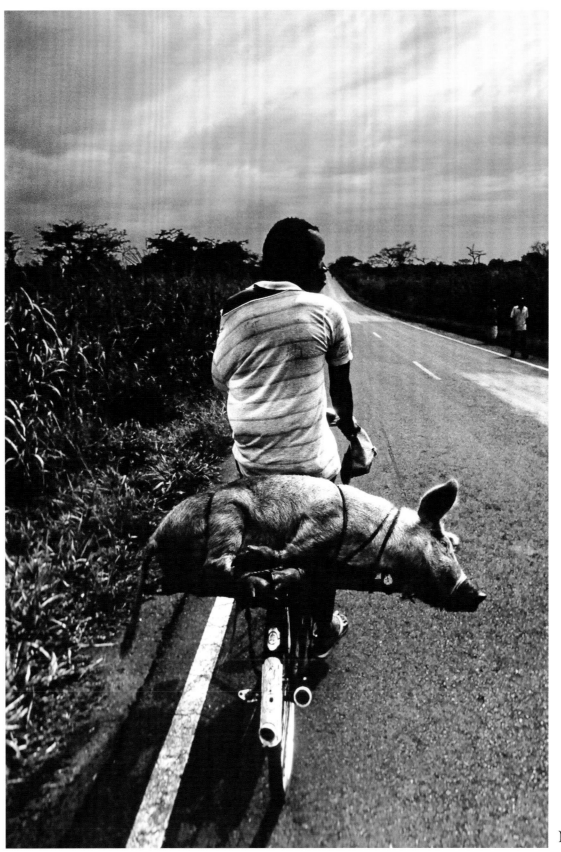

Ntare Guma Mbaho Mwine

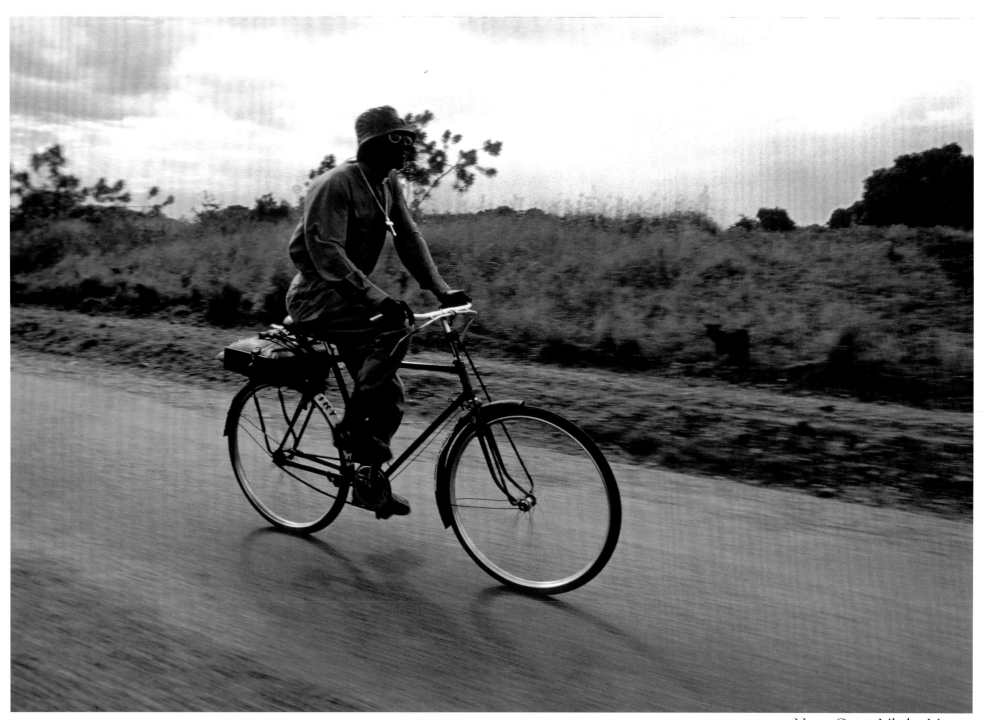

Ntare Guma Mbaho Mwine

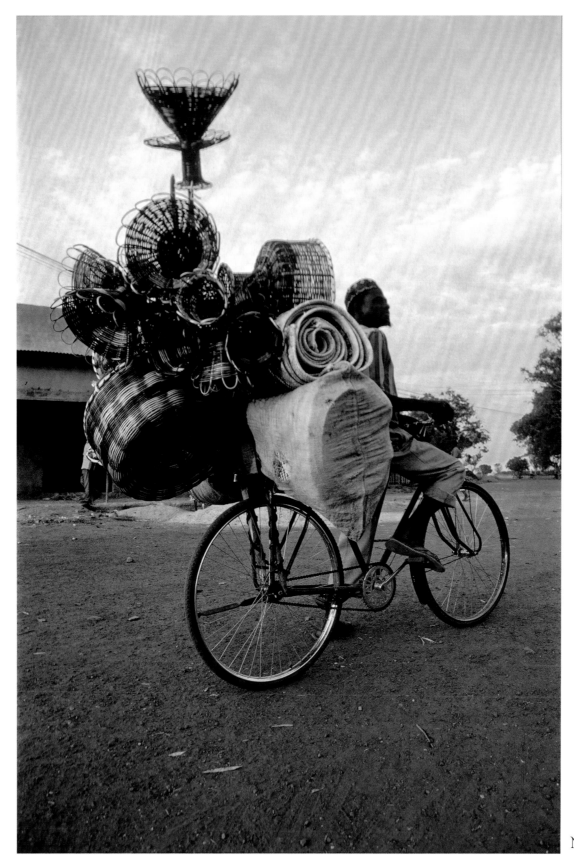

In the passenger seat of my father's car traversing his native homeland of Uganda, I took photos. On business or pleasure on marram or tarmaced roads our conversation inevitably turned to the boda boda's; the bicycle men and the fantastical parade of services, goods and people they transported. It is our wonder at their amazing courage, skill and madness that inspired this series titled "Boda boda."

My father purchased a 35 mm Pentax Asahi camera to take pictures of me when I was born. I shot the images featured in this series with this same camera.

Ntare Guma Mbaho Mwine

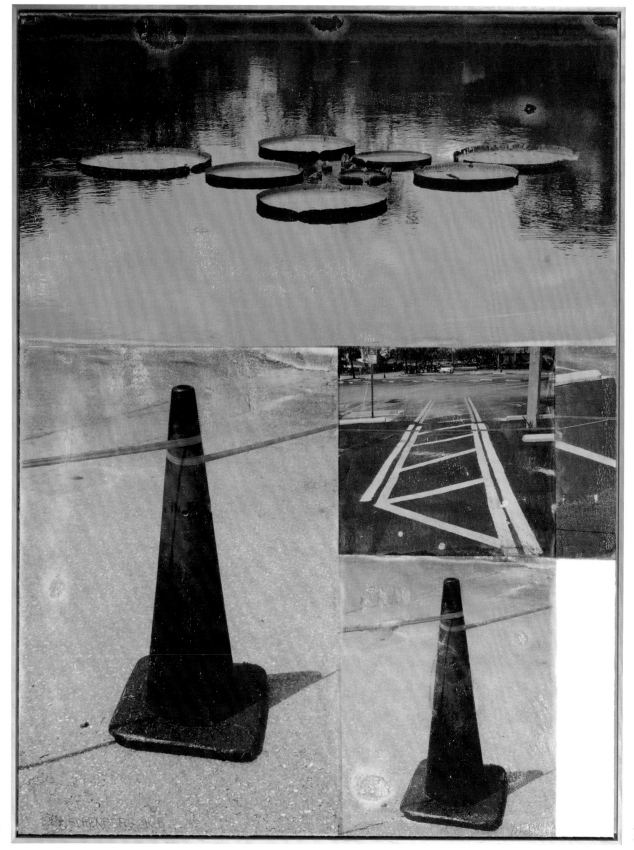

Lotus Bed 1 Robert Rauschenberg

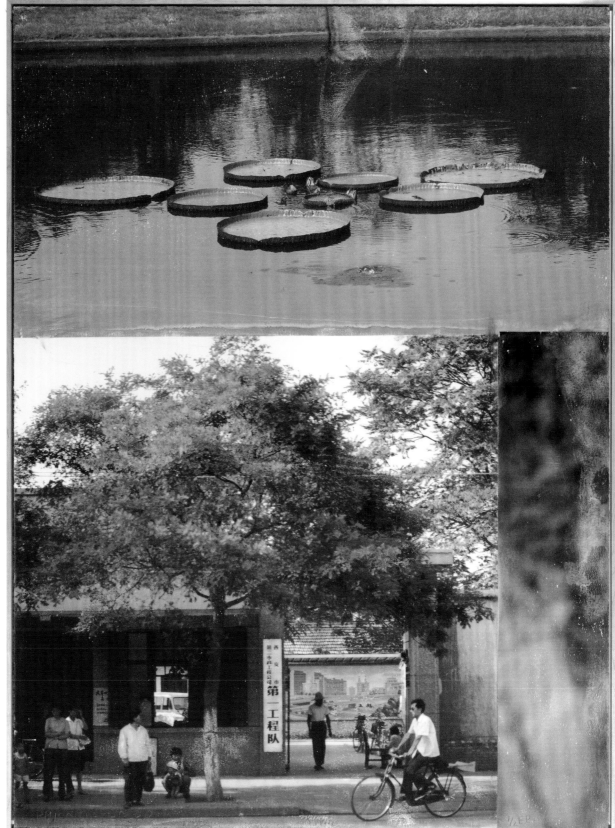

Robert Rauschenberg travelled to China in 1982 and made hundreds of photographs (fifty-two of which were collaged into the 100-foot-long photograph *Chinese Summerhall*). He returned to China in 1985 and made photographs as part of the Rauschenberg Overseas Cultural Interchange. Many of these images from Rauschenberg's trips to China remained unused until this past year, when Rauschenberg put them to work in this series of 12 prints made with longtime collaborator Bill Goldston of Universal Limited Art Editions.

Rauschenberg died on May 12th at age 82 with a painting in progress in his studio, these prints rolling off the presses, and an undiminished and unequalled curiosity and love of life.

Lotus Bed 2

Robert Rauschenberg

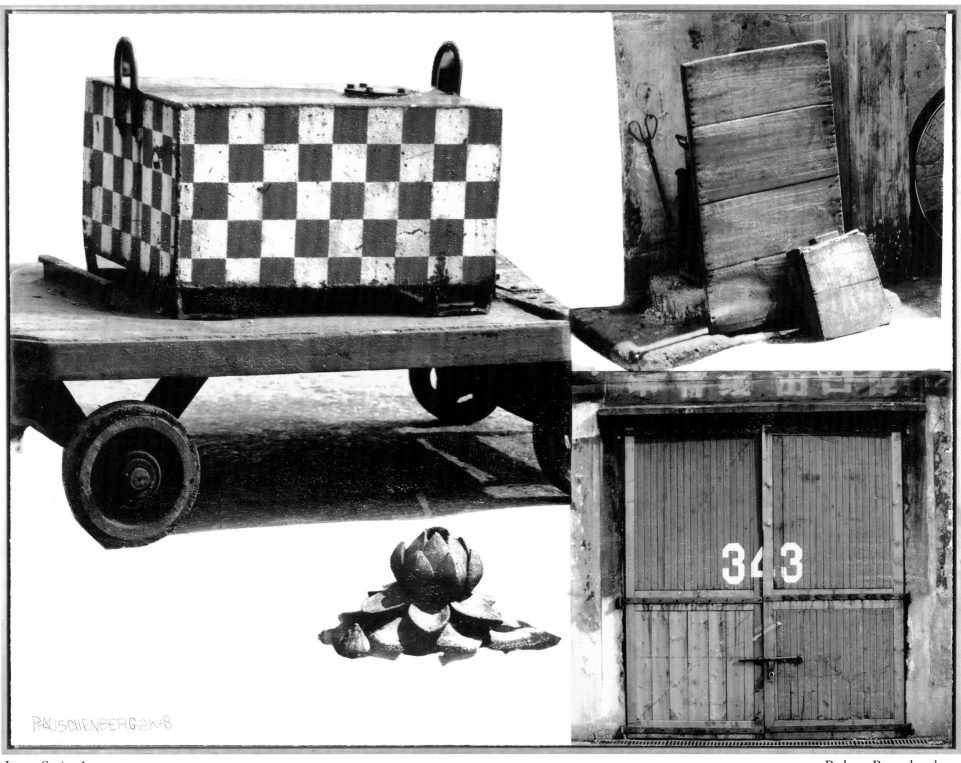

Lotus Series 1

Robert Rauschenberg

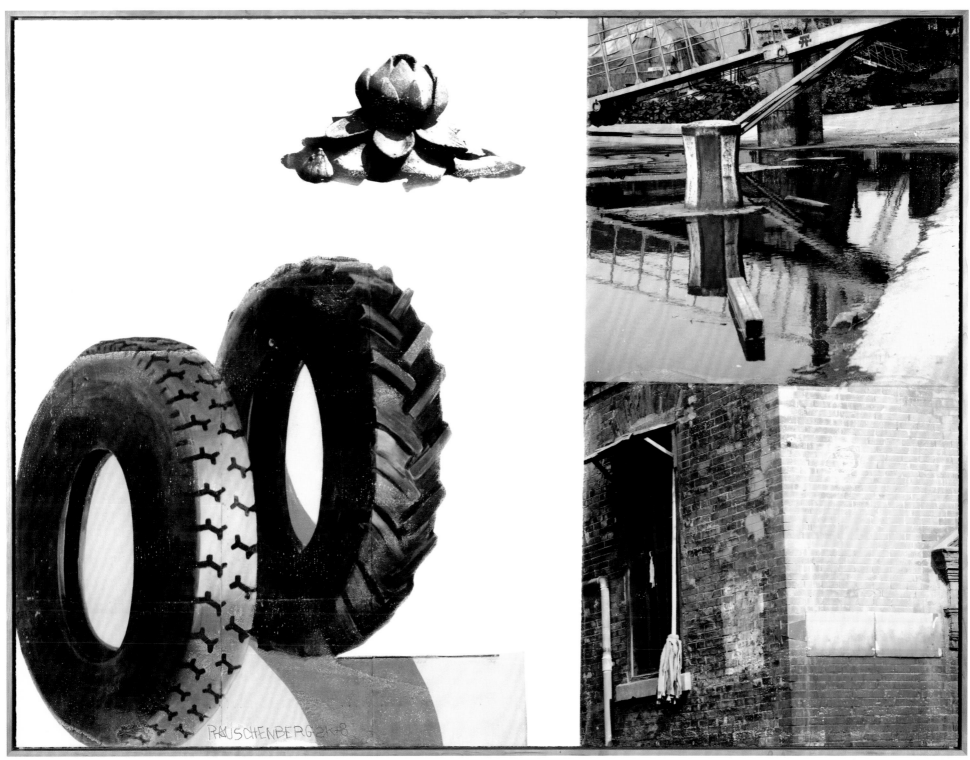

Lotus Series 2

Robert Rauschenberg

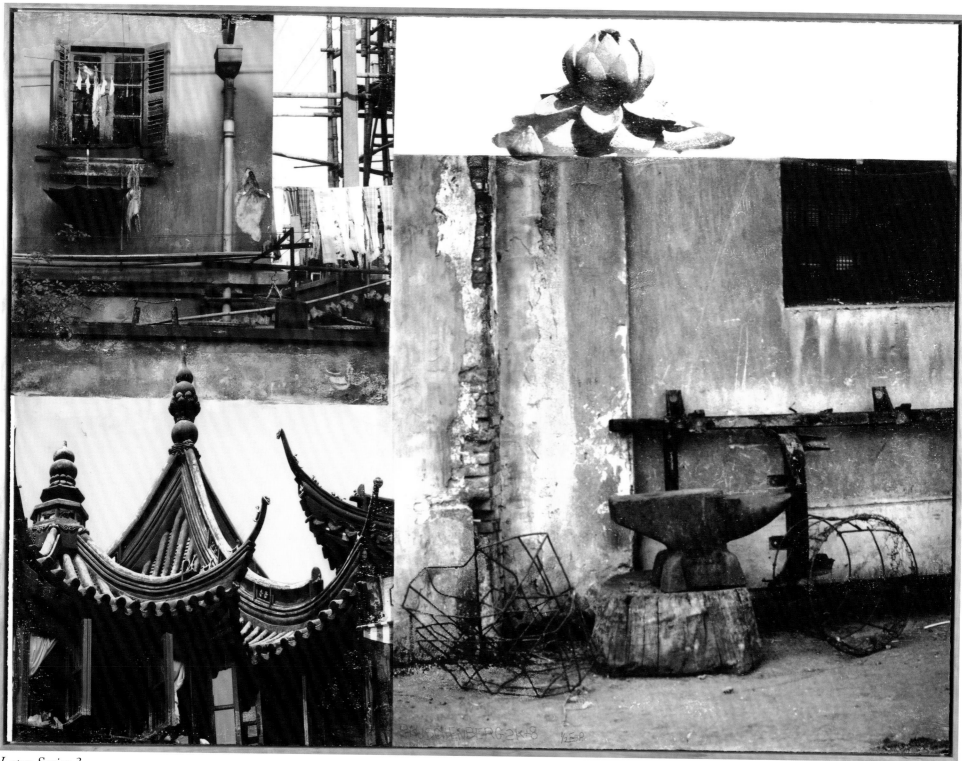

Lotus Series 3

Robert Rauschenberg

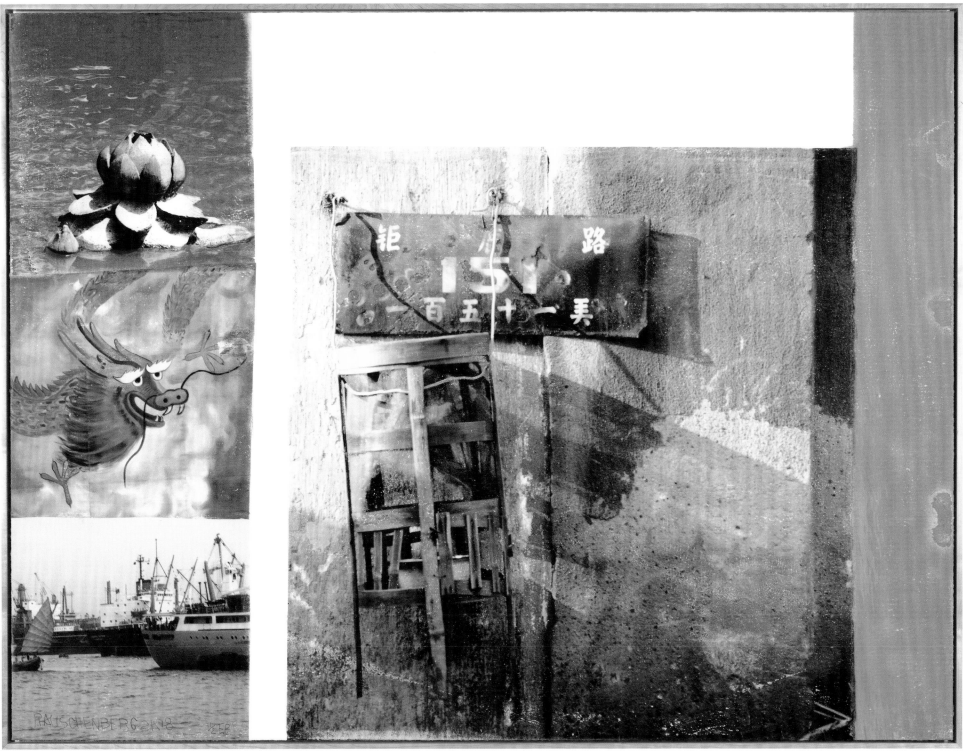

Lotus Series 4

Robert Rauschenberg

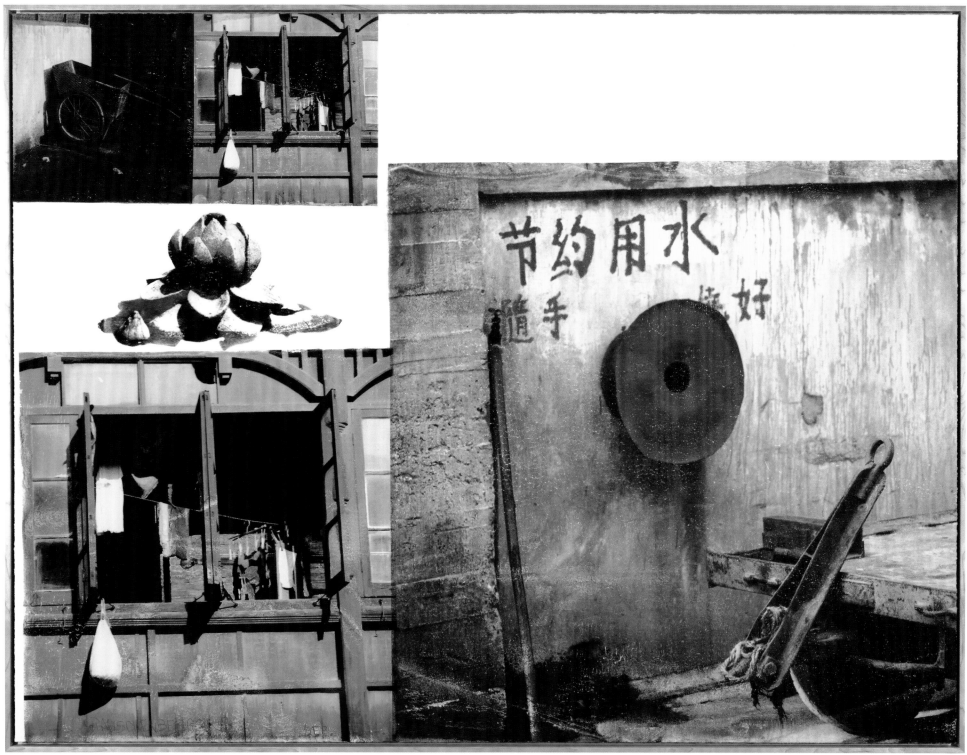

Lotus Series 5 Robert Rauschenberg

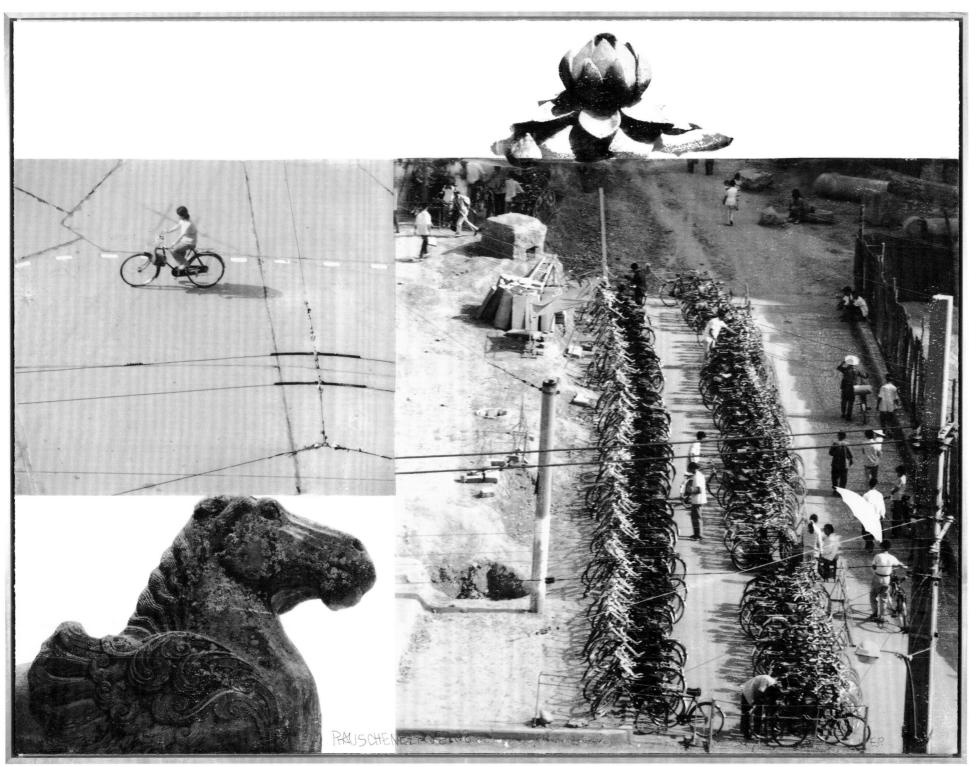

Lotus Series 6

Robert Rauschenberg

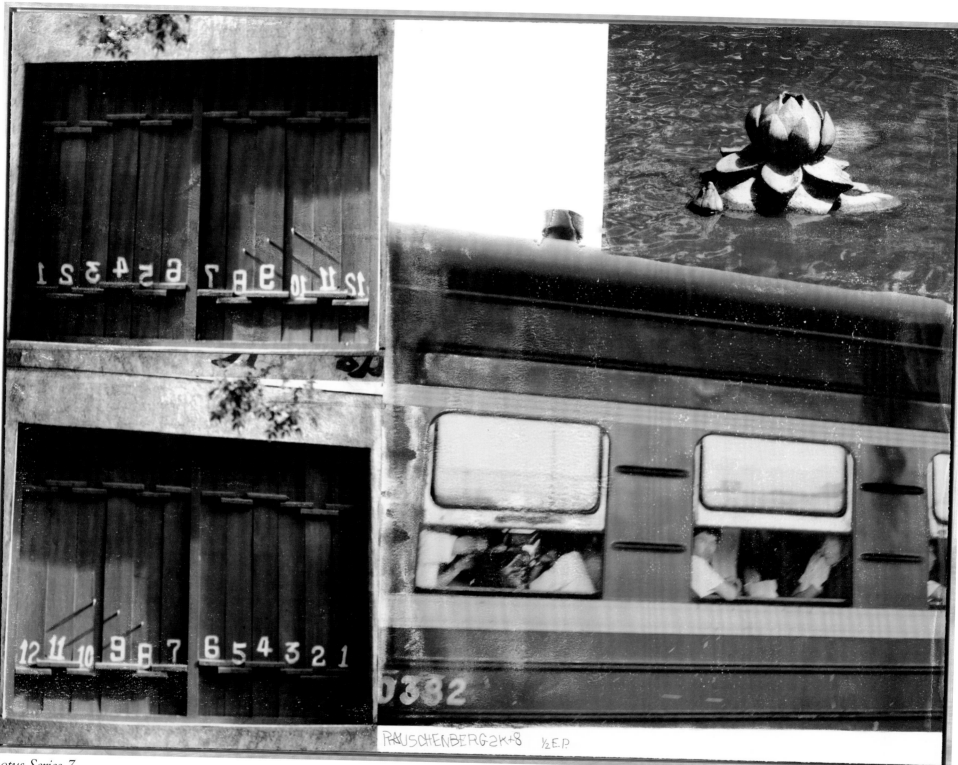

Lotus Series 7

Robert Rauschenberg

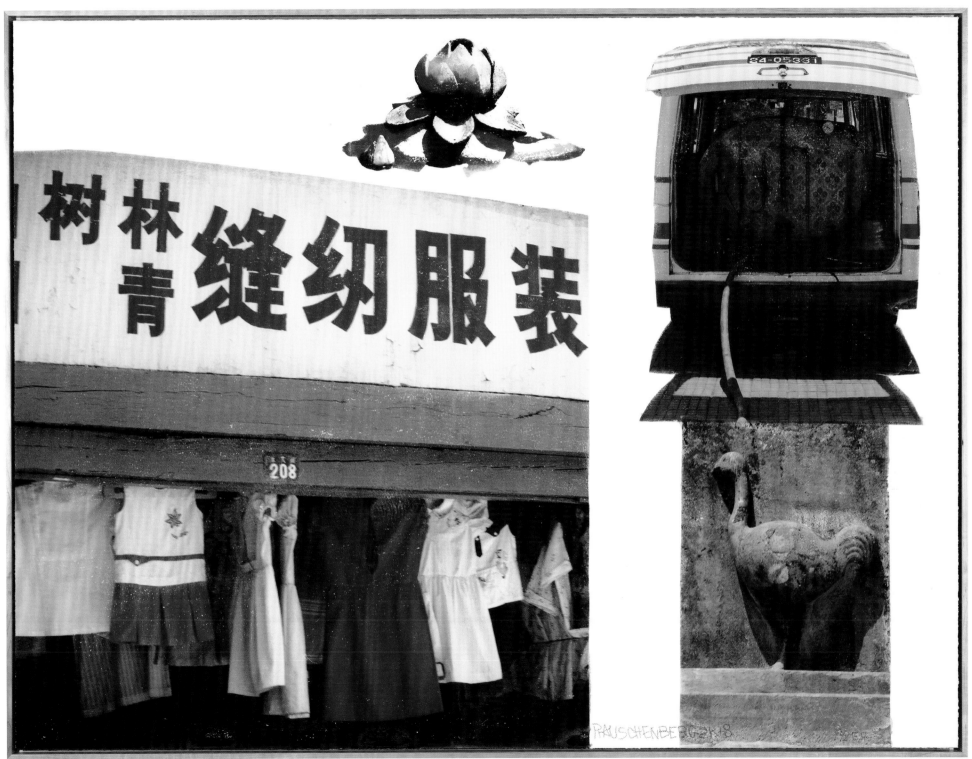

Lotus Series 8

Robert Rauschenberg

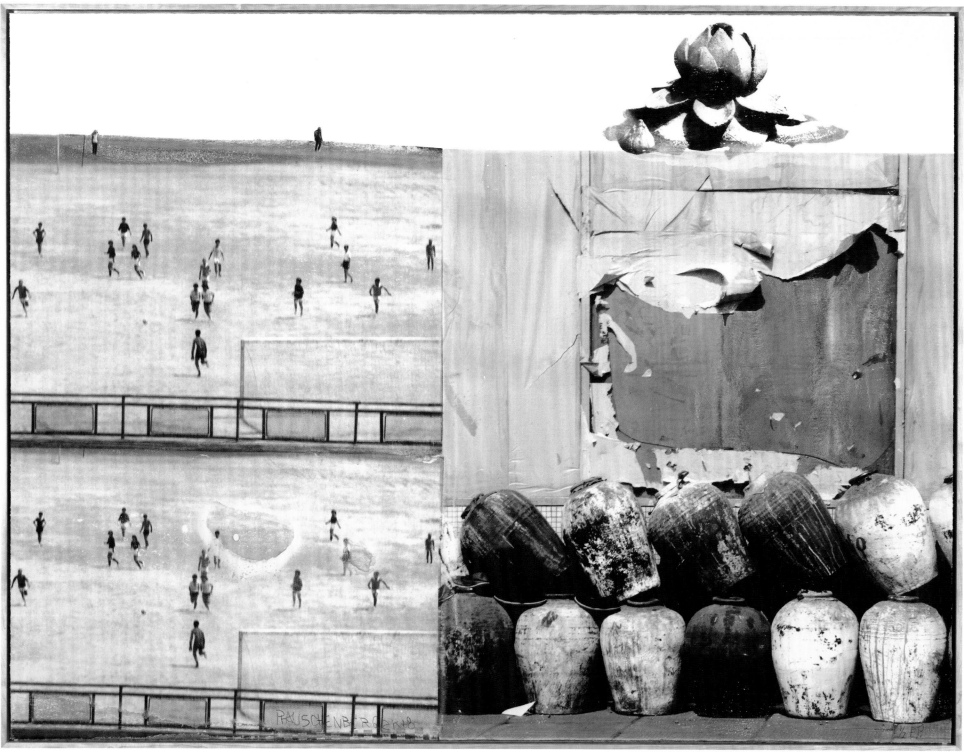

Lotus Series 9

Robert Rauschenberg

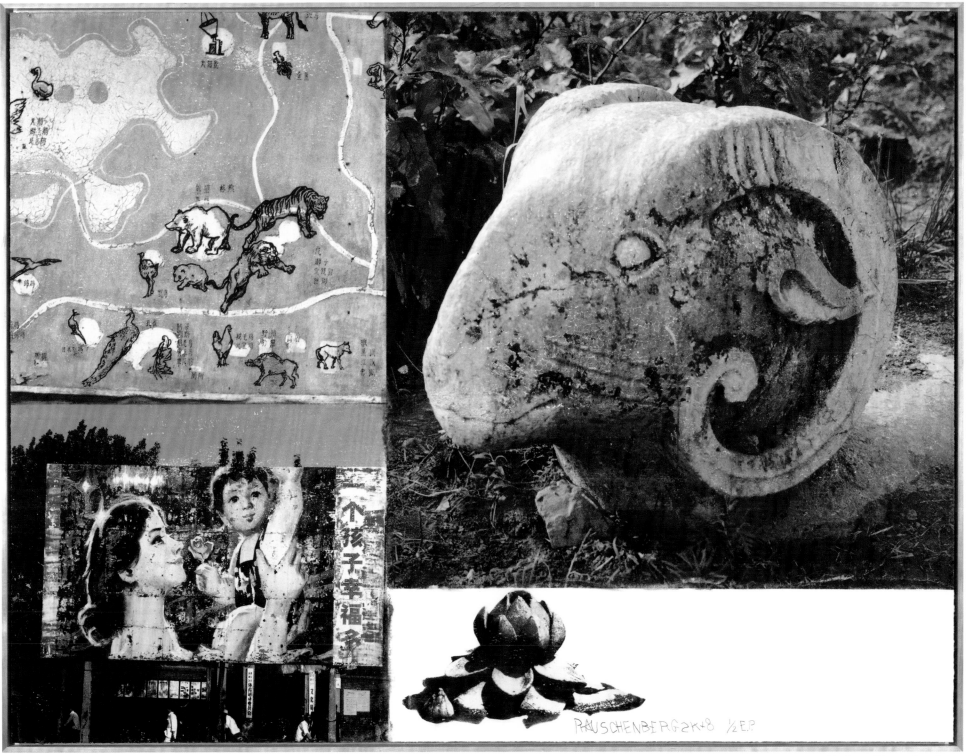

Lotus Series 10

Robert Rauschenberg

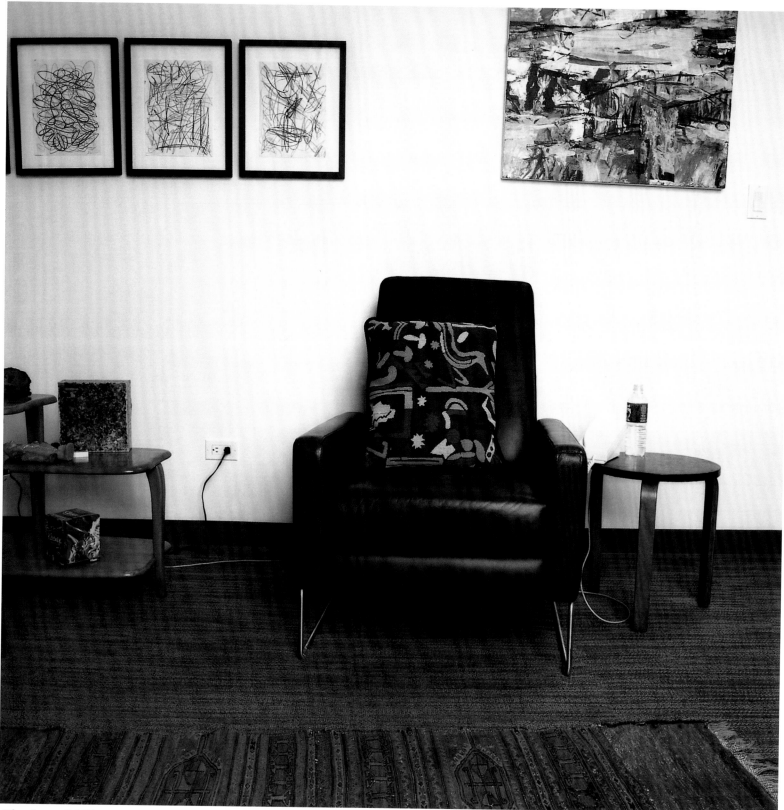

Flat Iron, 2007

Saul Robbins

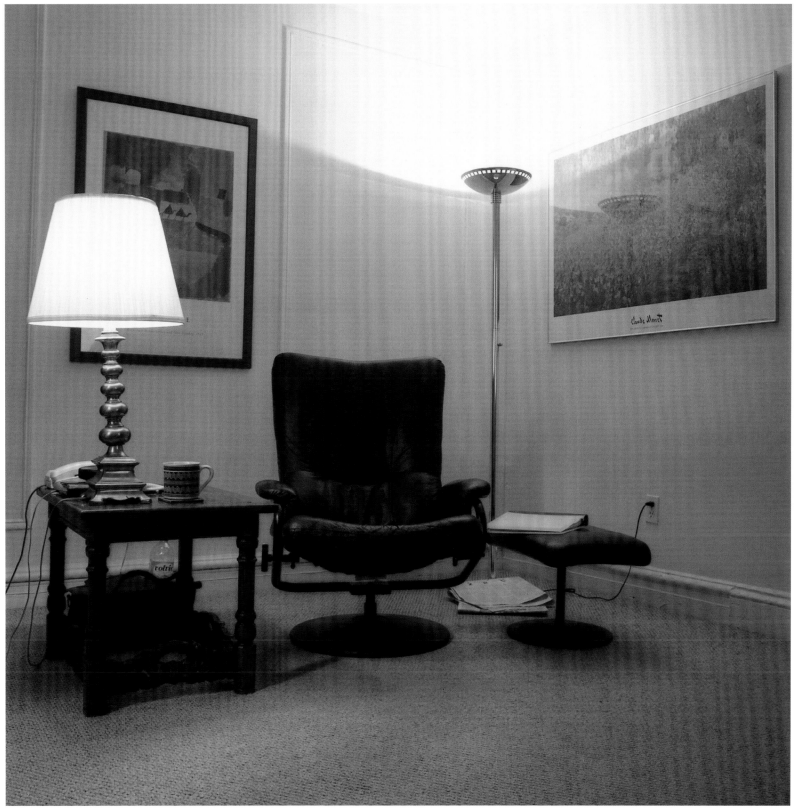

Upper West Side, 2004 Saul Robbins

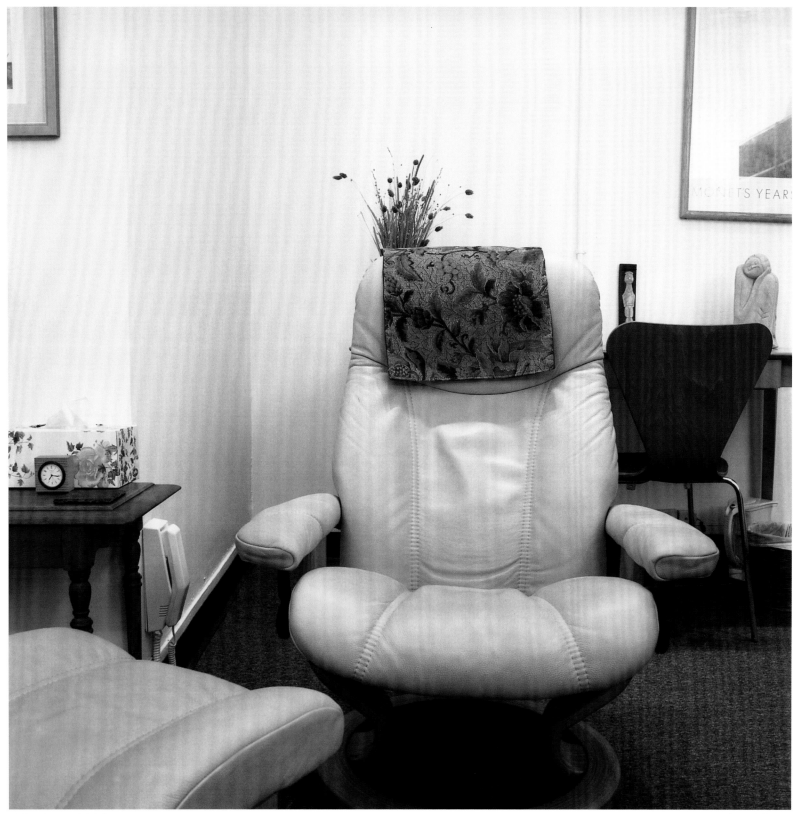

Flat Iron, 2005

Saul Robbins

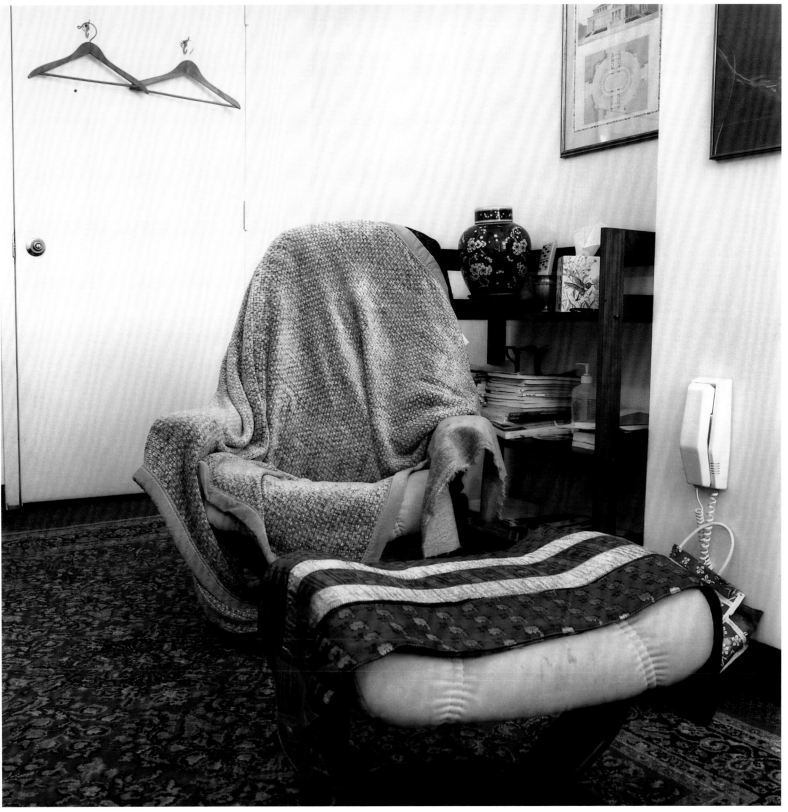

Union Square, 2005

Saul Robbins

Columbus Circle, 2006 Saul Robbins

Initial Intake

This ongoing body of work examines the chair and office surroundings of New York based psychotherapists from the point of view of their clients. It is from this vantage point that I wish to reference the perceptions, associations, and responses to this very private environment, and the work that takes place there.

For many, the role of the psychotherapist holds significant weight, and the importance given to her / him is one of profound influence in many people's lives. By examining the empty therapist's chair, viewers are encouraged to consider both the personality inherent in each image and the place of power it holds, quite literally, across from them, on a regular basis.

This work stems from a life-long interest in psychology. My immediate family is made up of psychotherapists, and my own interest in self-inquiry and understanding has always leaned towards the intra- and inter-personal. My interest in the dynamic process of self-discovery has found that the camera and photograph continue to provide an accessible and appropriate venue for the exploration and expression of my ideas. The results reveal a deep desire to better understand and communicate with others and the world in which we live.

Upper East Side, 2004

Saul Robbins

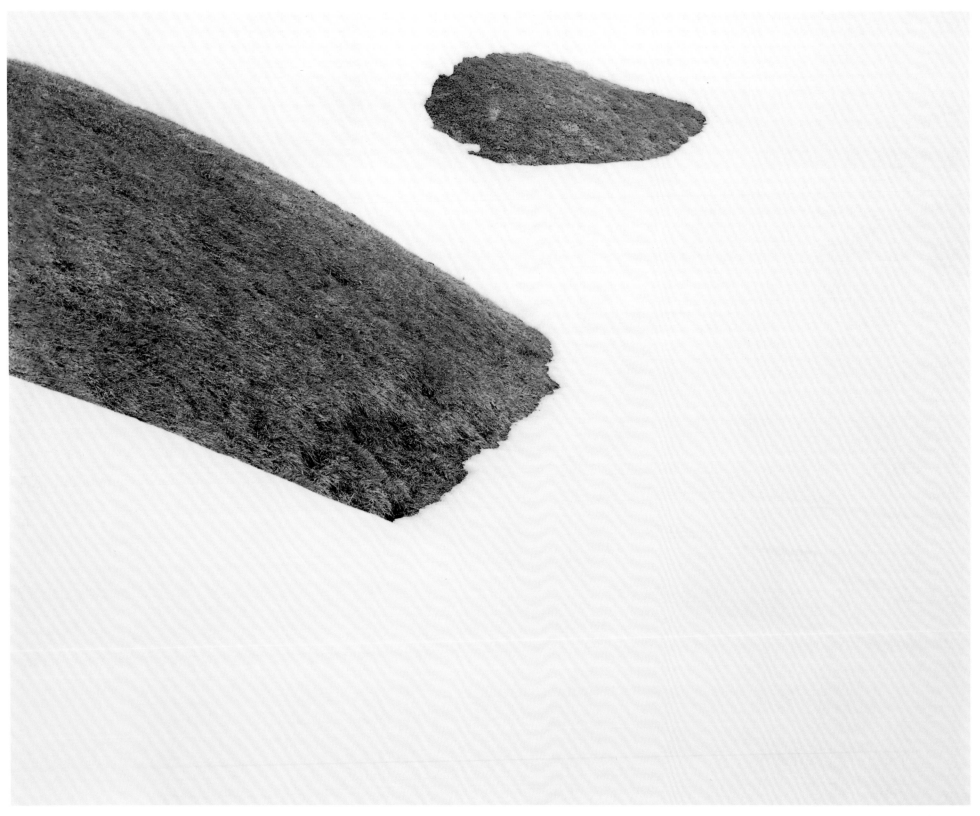

Lisa Robinson

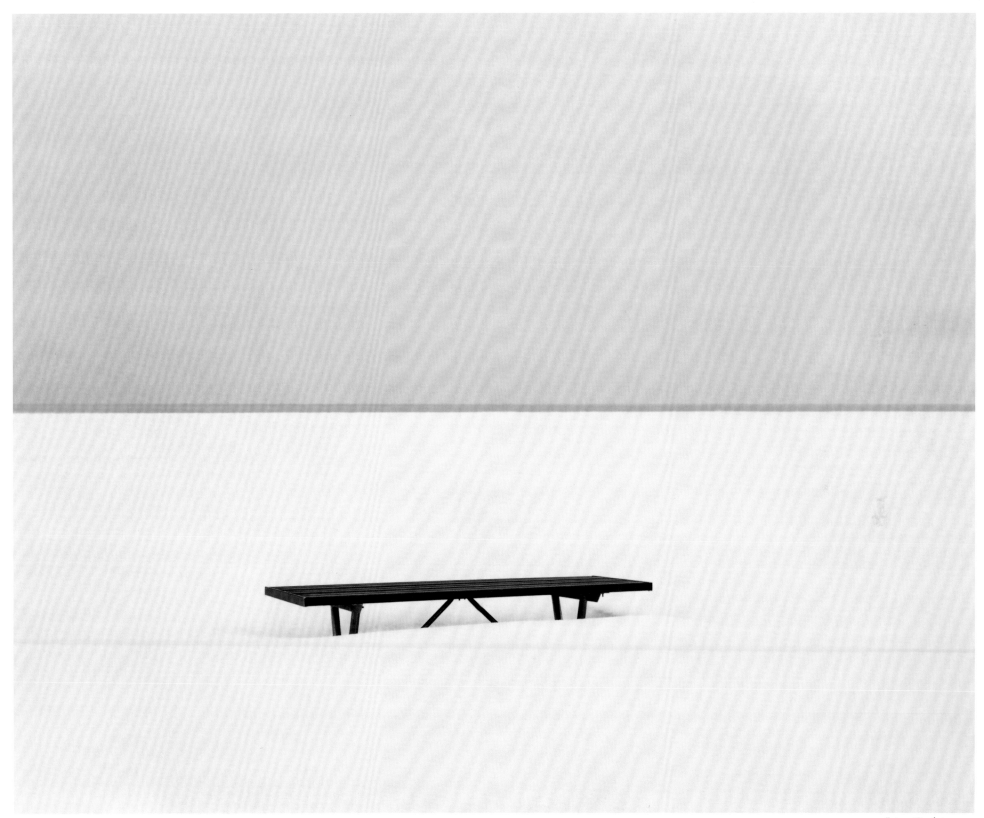

Lisa Robinson

Lisa Robinson

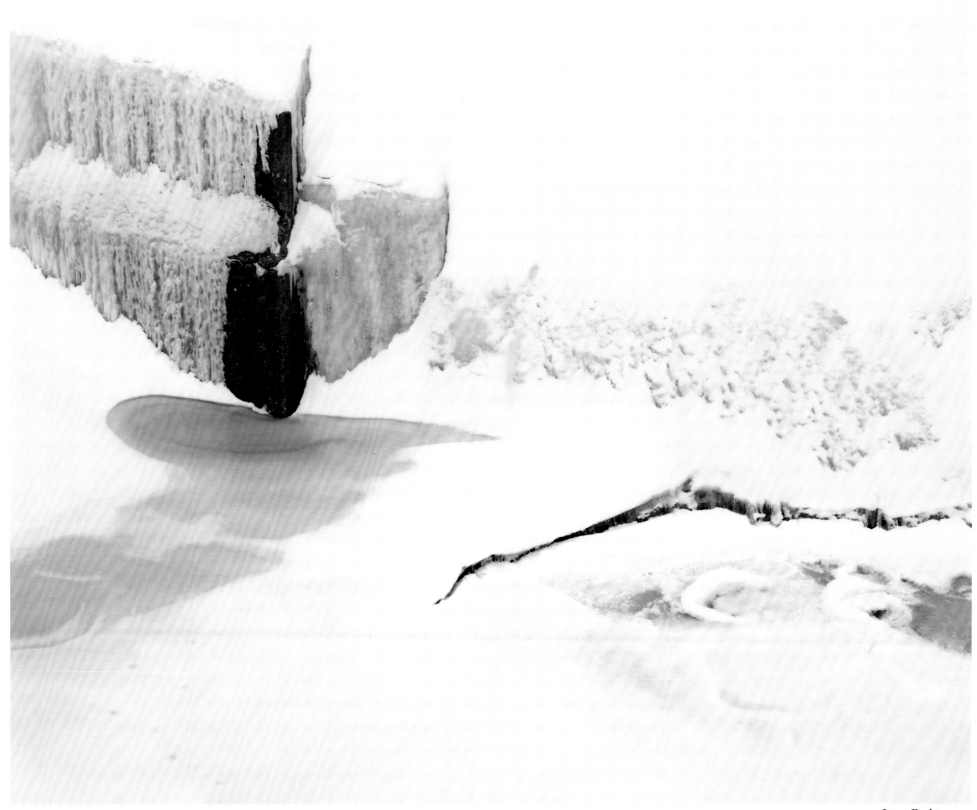

Lisa Robinson

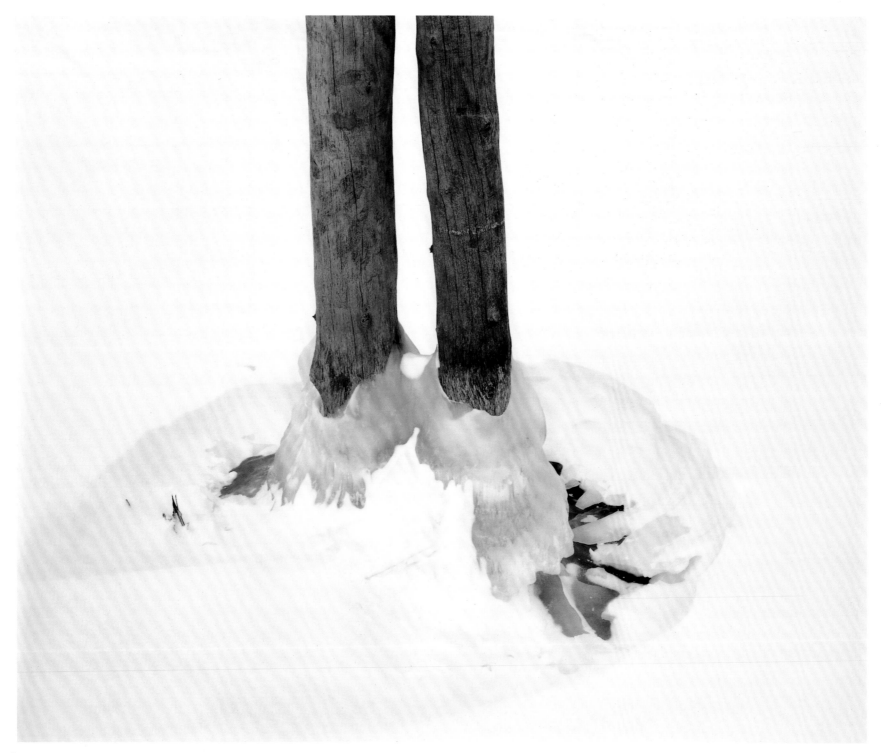

Snowbound

For the past five years, I have been making photographs in the snow and ice. I am interested in metaphor, and have sought to comprehend our human place in this world.

On the surface, these images are quite beautiful. They appear elegantly simple and accessible, evoking, perhaps, the silent tranquility that one might feel after a fresh snowfall. Beneath the surface, however, there is a subtle tension. Like fine haiku, each image quietly references another season, a time of life or activity that has already passed, and may come again. Throughout the series run the leitmotifs of poles and ropes and a palette of man-made

color. The relationship between the human and the natural world becomes more tightly intertwined as the series progresses, and the cycles of life and death and transformation fold inward.

This interest in time passage and life cycles becomes distilled in explorations of water itself. Ice, snow, fog and water embody the liminal states of a primary element. At times, the multiple forms exist simultaneously. It is as though the thing itself possesses its own counterpoint – and transformation is a constant condition, despite seeming moments of stillness.

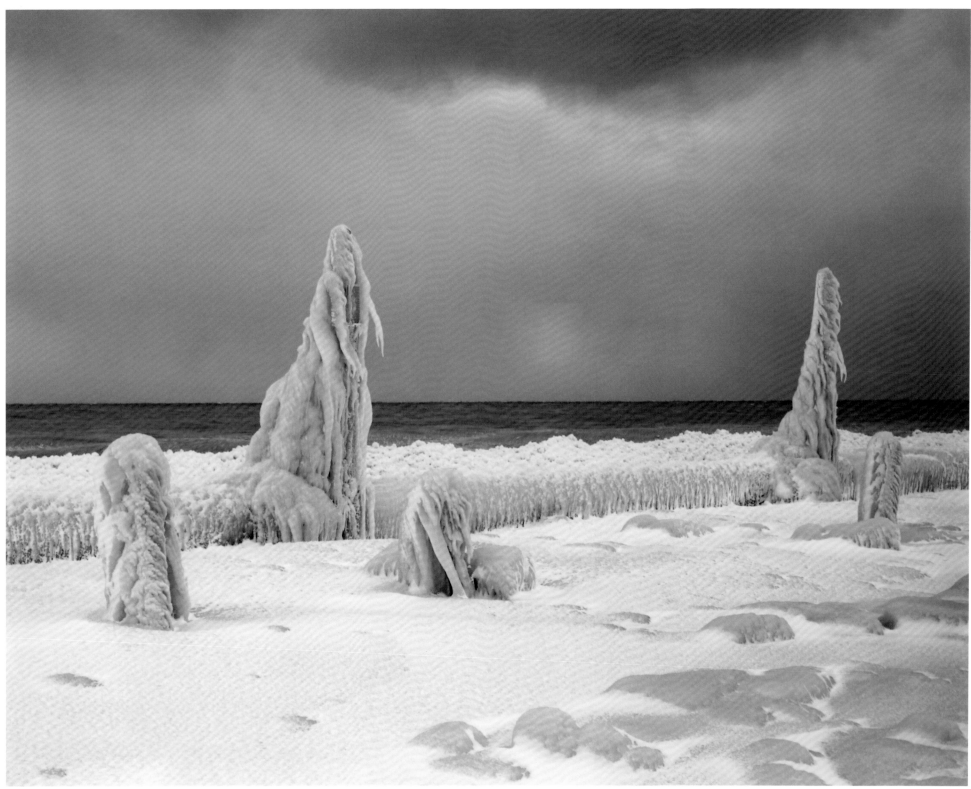

Lisa Robinson

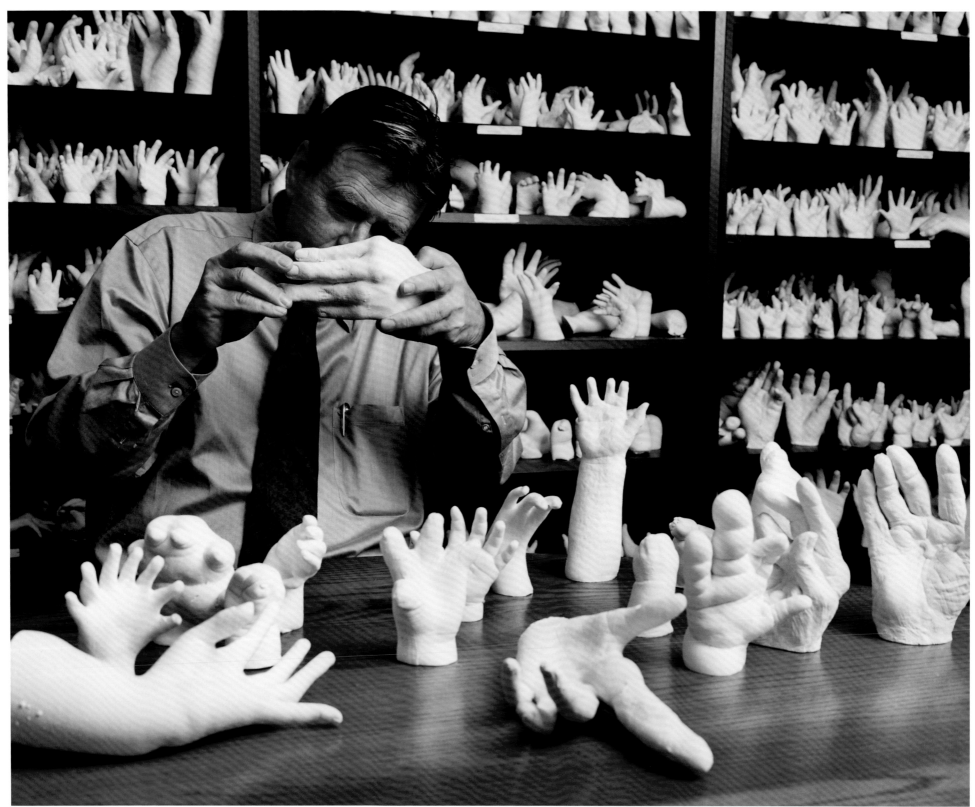

Surgeon with molds of hands he has repaired, Brookline, MA, 2002

Sage Sohier

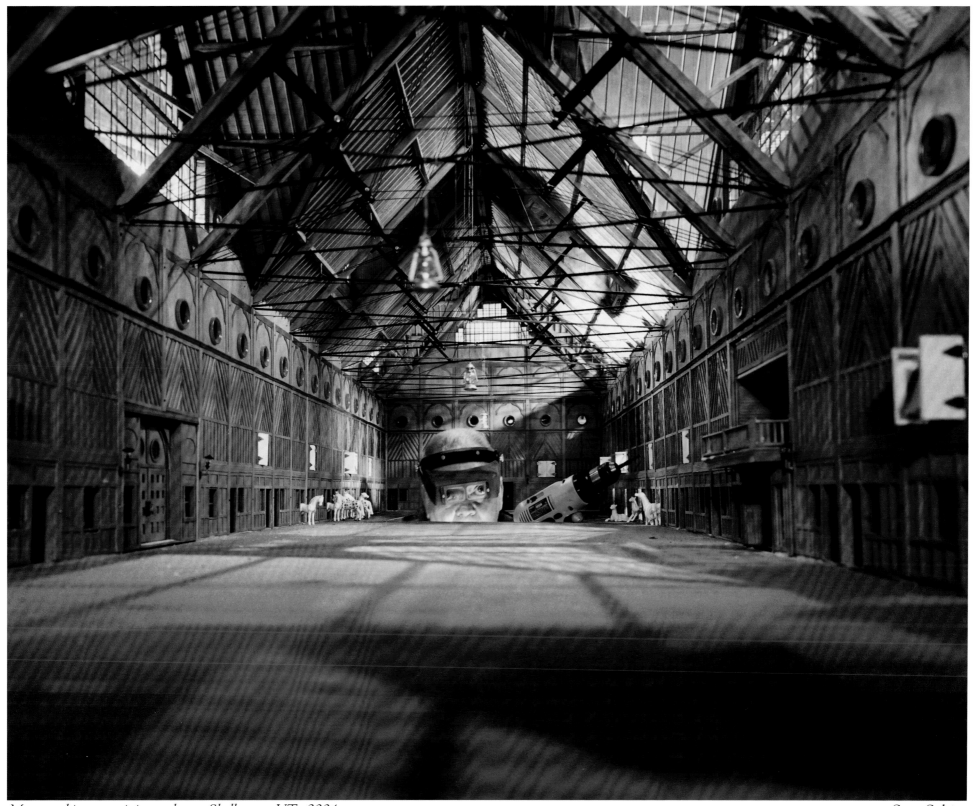

Man working on miniature barn, Shelburne, VT, 2004

Sage Sohier

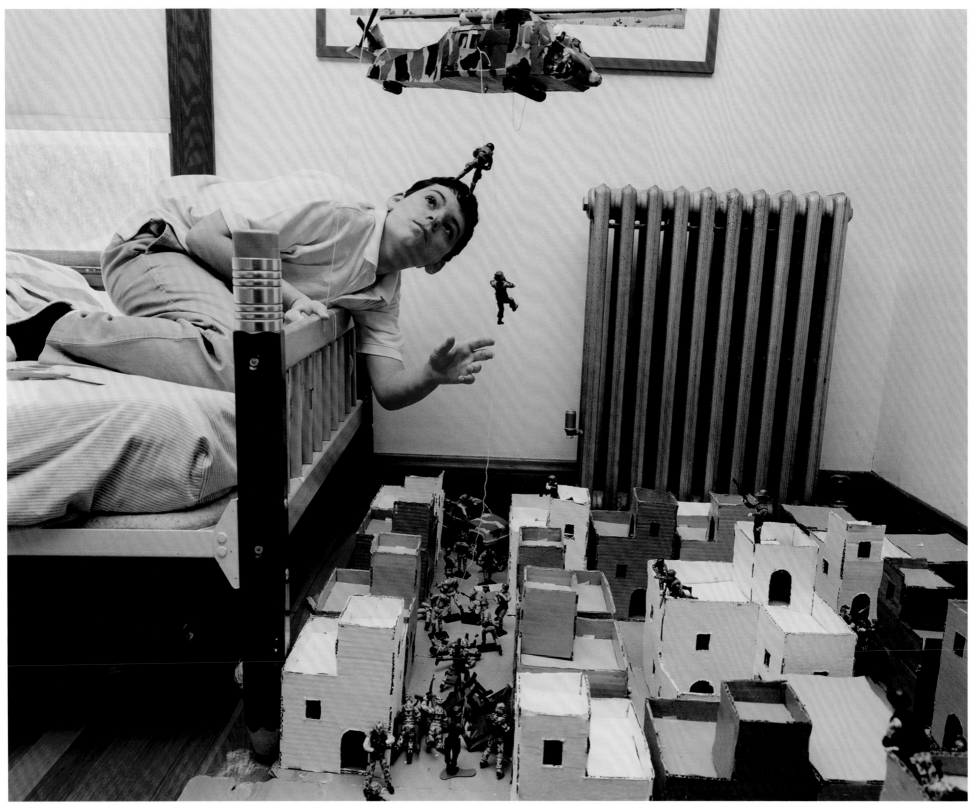

Boy in his bedroom with model of Kandahar, Afghanistan, Watertown, MA, 2001

Sage Sohier

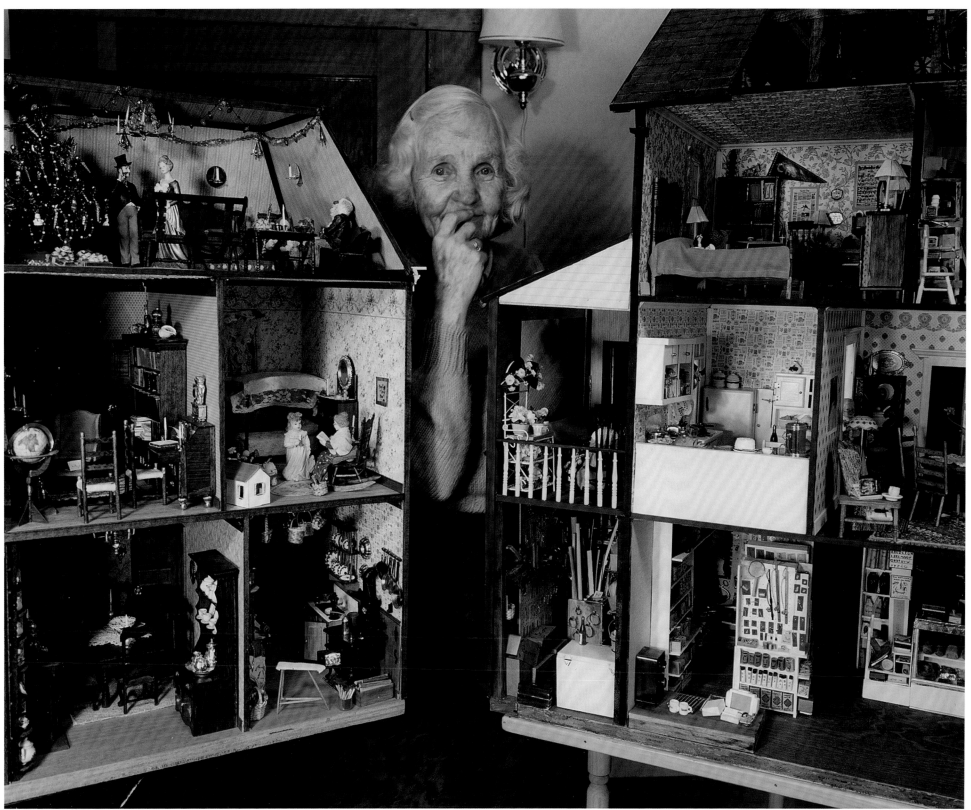

Woman with dollhouse interiors, Charlemont, MA, 2002

Sage Sohier

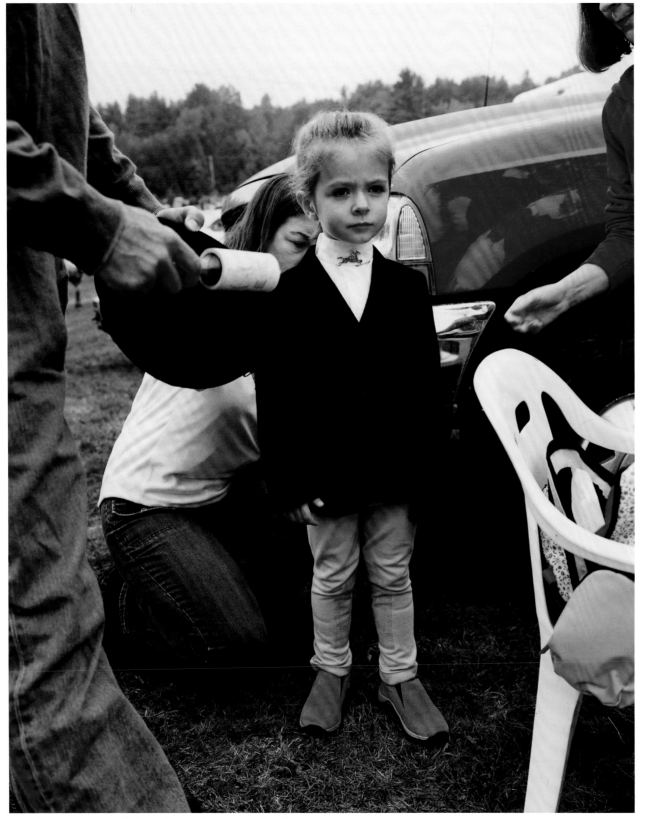

Girl being prepared for a horse show, Sandwich, NH, 2004

Perfectible Worlds is about people's private passions and obsessions. Begun soon after 9/11/01, the series portrays people transported into worlds and activities over which they have near-total control. The photographs, made from medium-format negatives, range from portraits of some who make extravagant miniature worlds, to others who have extraordinary collections or who immerse themselves in unusual pursuits. Each photograph is the discovery of a particular world an individual has found or created for himself - a private world that few are privileged to see.

The series began with a picture I took of a friend working on his model railroad. Expanding over the twenty years he has owned his house, his railroad has taken over the entire basement. When he goes down to work on it, he leaves behind both his professional and family life. He need satisfy only himself, and exercises complete control over what he has made. This kind of absorption – what we do in an imperfect world to console ourselves – struck me as a subject worthy of exploration.

We're all fascinated with other people's passions – what they do in their spare time to satisfy an inner need. These constructions, collections, or activities are quirky, often beautiful, and almost always ends in themselves. My ambition has been to reveal the particularity and intensity of these acts and creations, and also to capture individuals' engagement in the midst of them. Their worlds – for a fleeting instant, and through their generosity – become mine...and now, perhaps, yours.

Sage Sohier

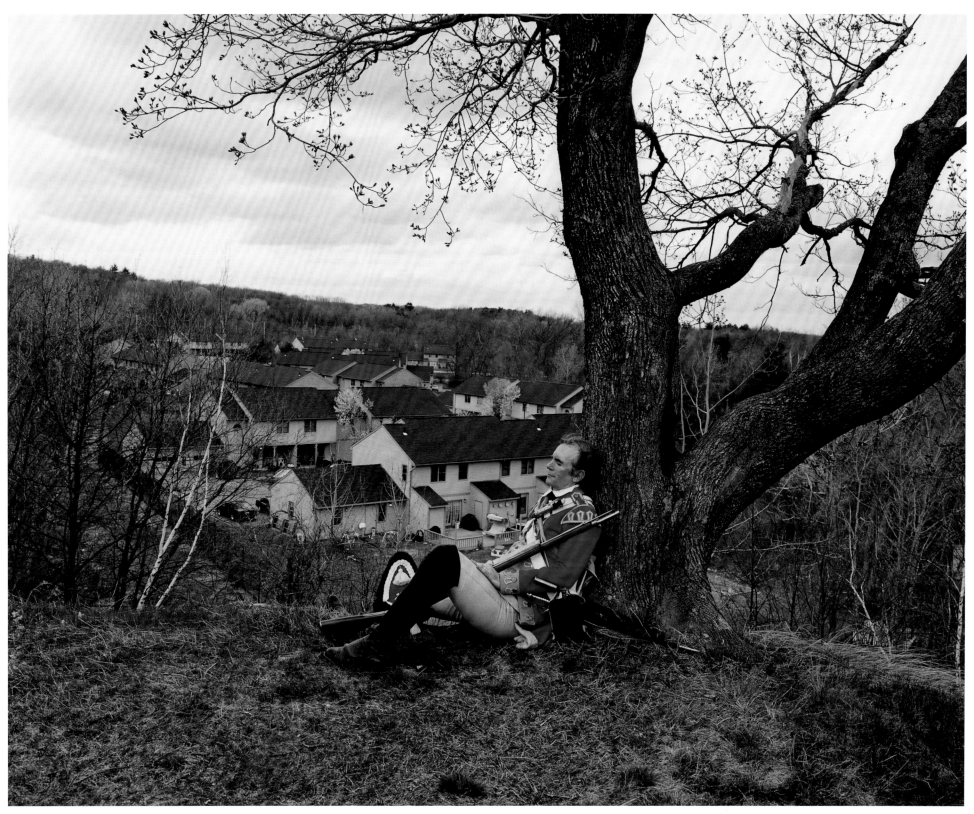

British Redcoat re-enactor, Battle of Concord and Lexington, Lexington, MA, 2002 Sage Sohier

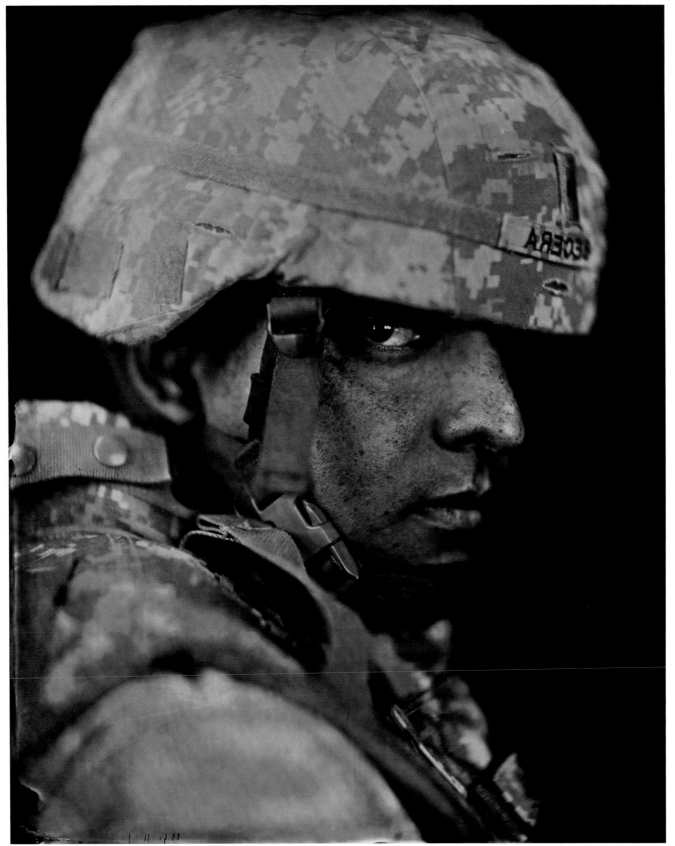

WO1 Ignacio Becera, 2007

Ellen Susan

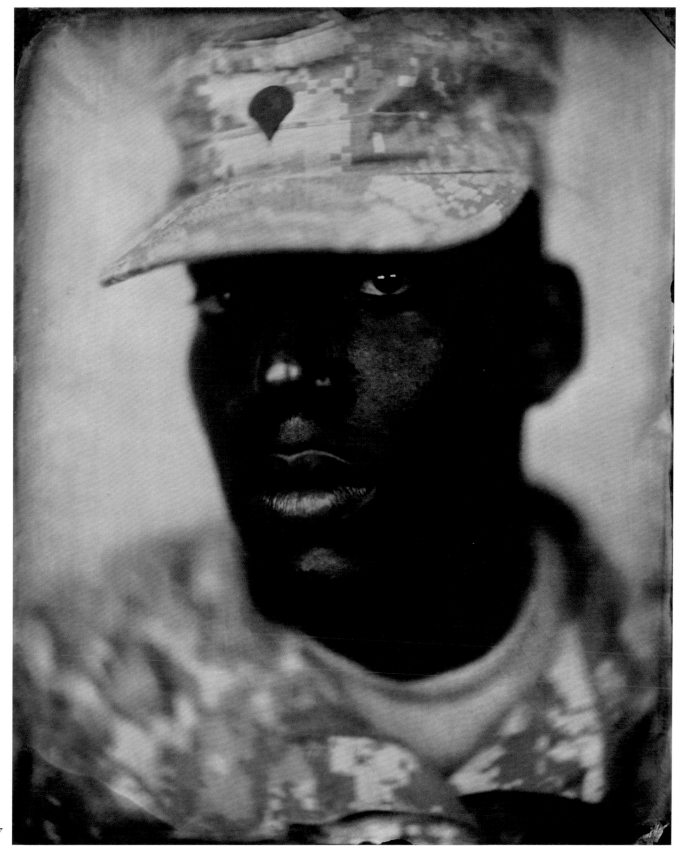

SPC Melvin Moore, 2007

Ellen Susan

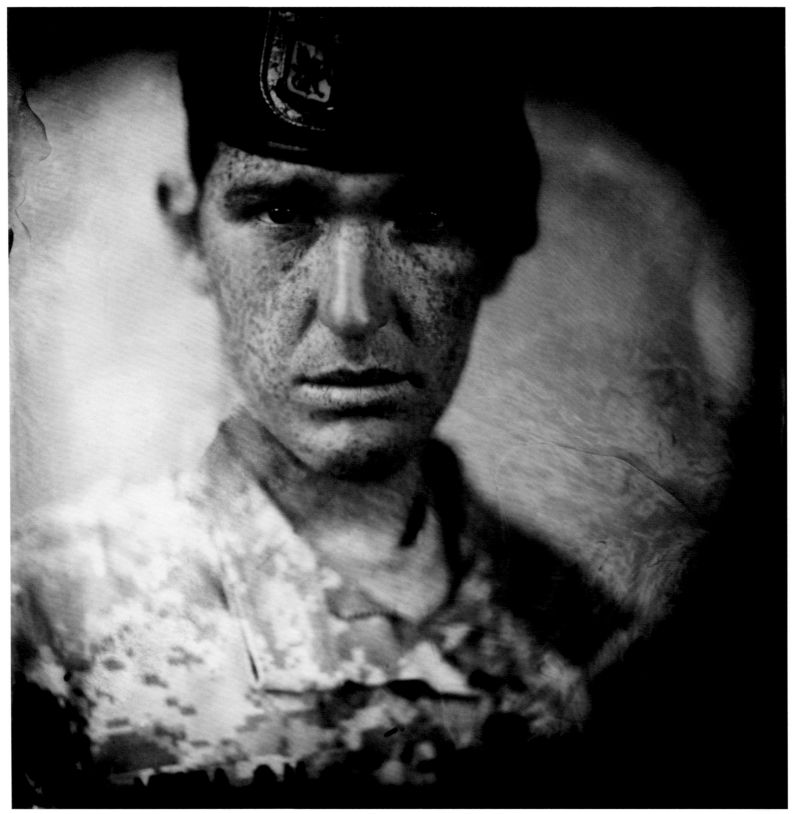

PFC William Burnett, 2007

Ellen Susan

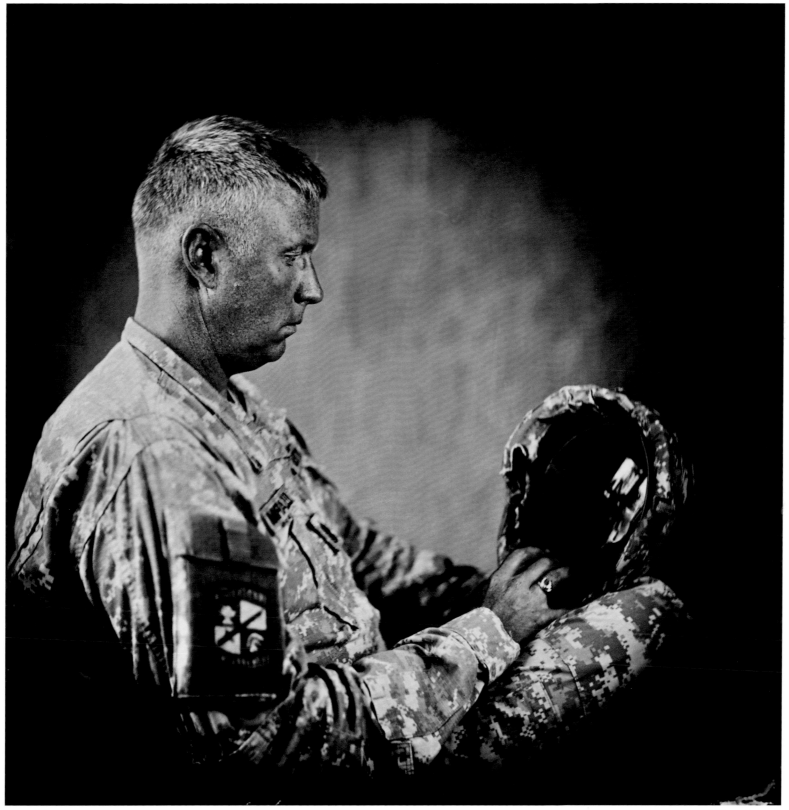

MAJ Steven Watts, 2008 Ellen Susan

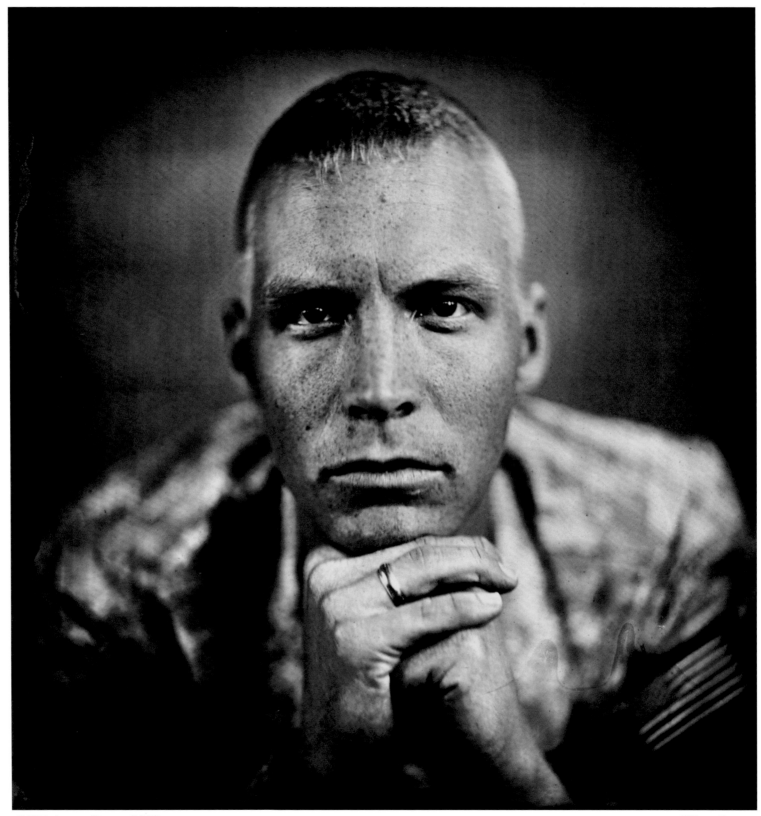

CPT Aaron Price, 2008

Ellen Susan

The Soldier Portraits series consists of unique collodion positives produced on glass and aluminum plates. The wet collodion process was the primary photographic method from the 1850s through the 1880s, encompassing the dates of the American Civil War. The people photographed are soldiers of the U.S. Army based in Southeast Georgia. The majority of them have deployed to Iraq one to three times since 2003. Many are in Iraq now.

This work is a result of my relocation to Savannah, Georgia, which is near two major army installations. I started seeing soldiers in uniform at the grocery store, the gas station, everywhere. I'd never really given soldiers much thought, because I rarely encountered them. I began to read in the local newspaper that many members of the local division were being deployed to Iraq for the third time. Looking into the impossibly fresh, young face of the uniformed kid in front of me at Home Depot and connecting that face to what happens in Iraq was a big shift for me in the way I thought about soldiers.

There is a contemporary point of view (which is by no means universal) that process is irrelevant to the content of an image. In this instance the process is integral to the images' message. I felt that the the 150 year old collodion process could be a meaningful way to photograph contemporary soldiers, to provide a counterpoint to the anonymous representations of soldiers seen in newspapers and on television. The necessarily long exposures of this slow process often result in an intensity of gaze that asks the viewer to look longer, and the grainless, highly detailed surface brings out minute details of each individual. Because the direct positive produces a reversed image, a viewer may also consider the concept of themselves "mirrored" by a soldier. And the military history of the process – the vast majority of civil war images were made with this technique – brings up other considerations. The appearance reflects back on our cultural memory of images of war.

Thousands of wet collodion plates – ambrotypes on glass and tintypes on metal – from the civil war era survive today. It is one of the most archival of the photographic processes. The inherent flaws that appear on the plates of this very hands-on technique also serve to remind us that the object (plate) being viewed was in the room with the subject and handled by the photographer at the time of the exposure.

In the end, I wanted to produce physically enduring, visually arresting images of people who are being sent repeatedly into a war zone with no apparent end in sight.

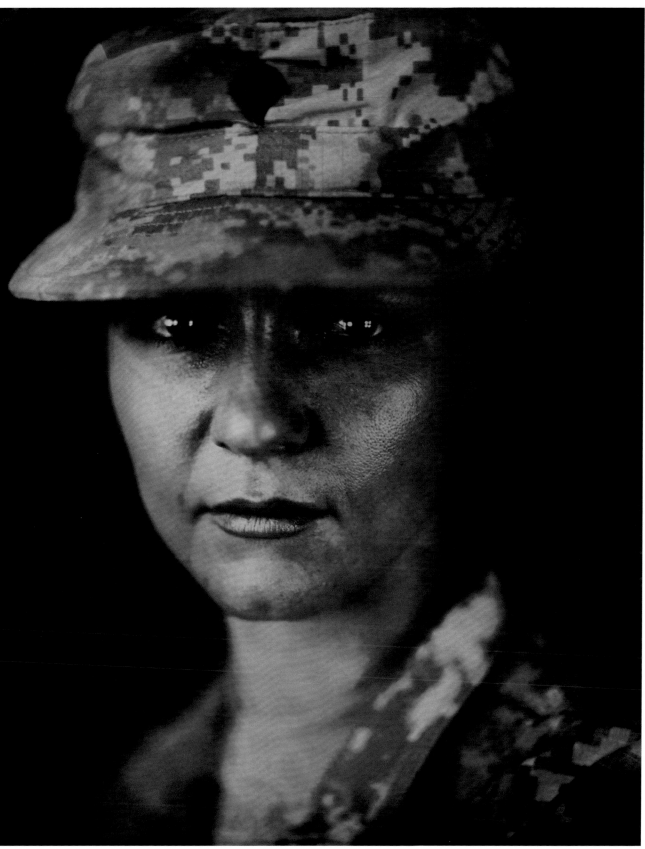

SPC Brandilynn Corntassel, 2007

Ellen Susan

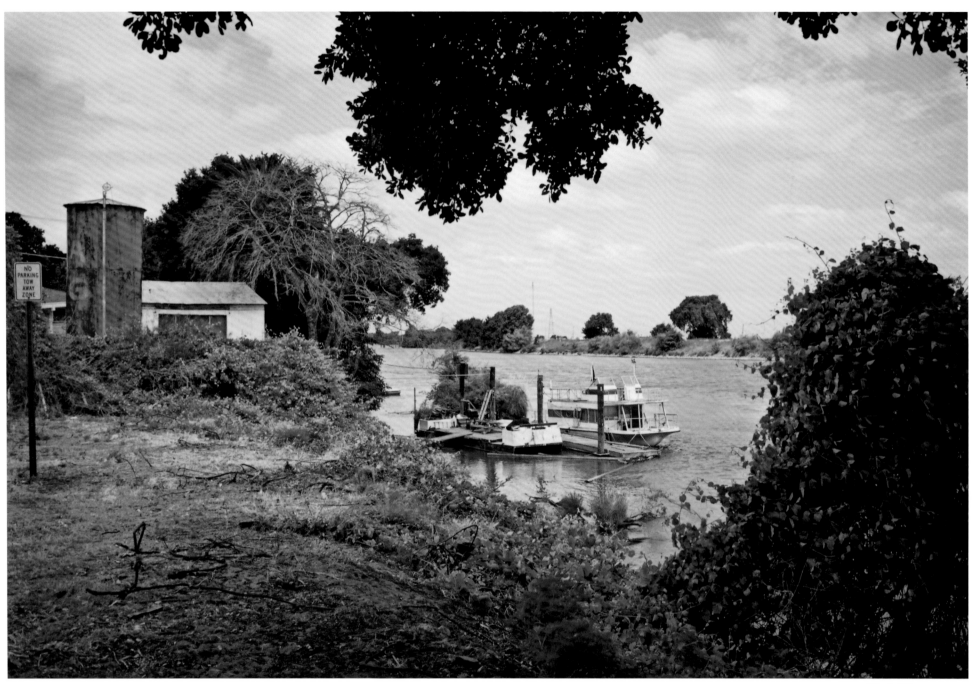

Kirk Thompson

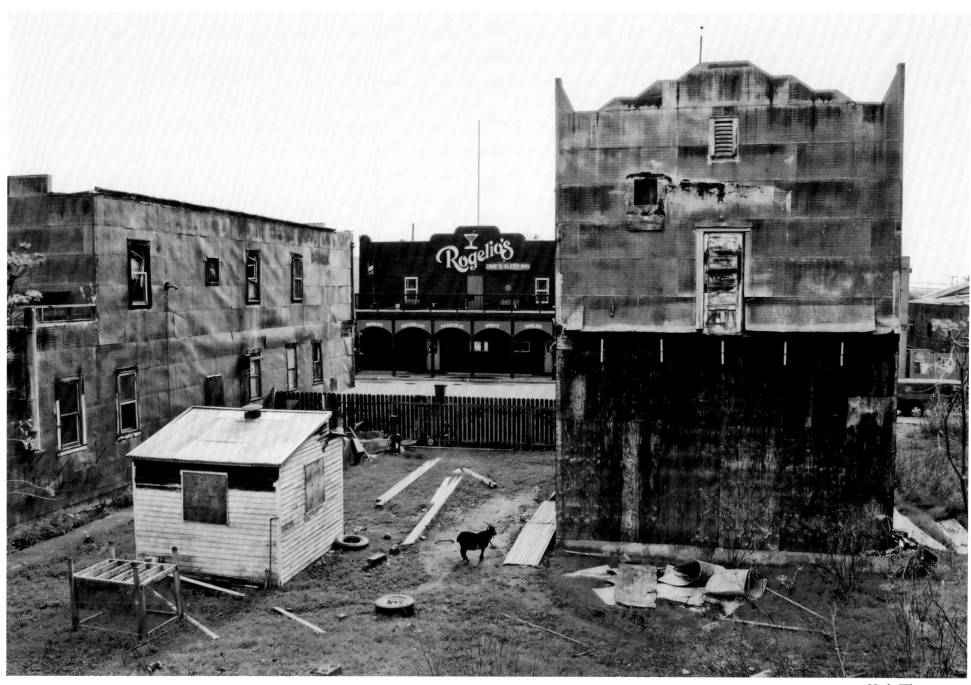

Kirk Thompson

Kirk Thompson

Kirk Thompson

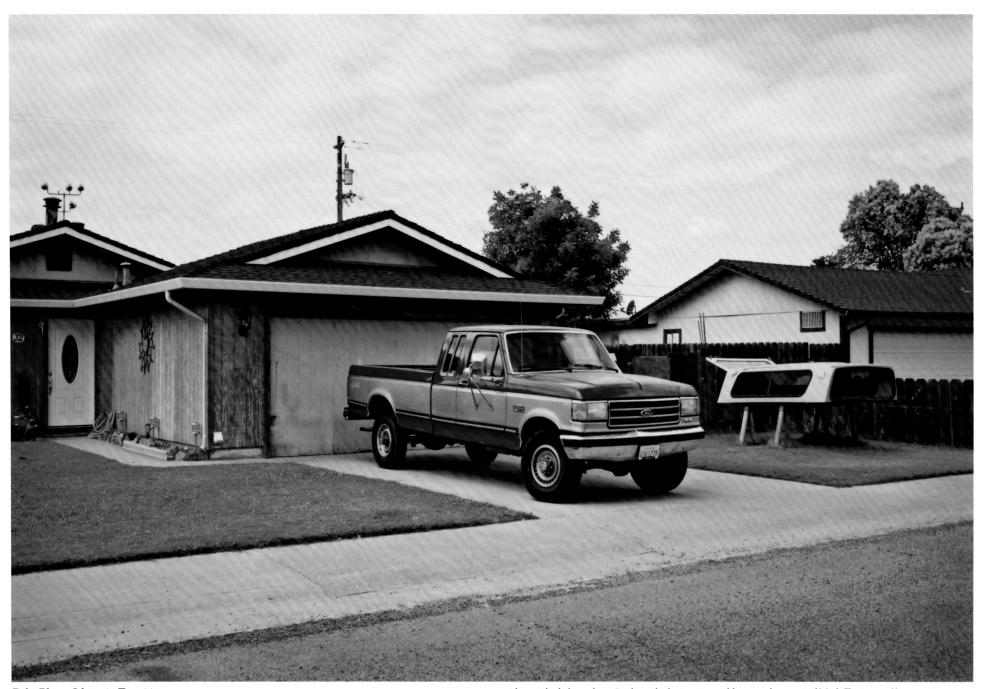

Delta Blues: Isleton in Transition

These photographs depict the town of Isleton, California, "the Crawfish Capital of the World," as it stood in 2004-2007. In that period it tottered on the brink of real estate development. I hope the series will be what Walker Evans called an "evocative document" and will stand as a portrayal, both historical and nostalgic, of an environment and a way of life that aren't likely to endure.

Isleton in 2004 was a town of the previous century. It rested quietly – except during the big annual crawdad festival – behind one of the many dikes of the Sacramento River Delta. In the words of Steve Calvert, a long-time

resident, it had always been "a classic little river town, like something out of Mark Twain. . . . You can sit on your houseboat with a beer at sunset and catch a catfish, listen to the birds."

But town leaders have hopes of revitalizing the all-too-peaceful economy. In 2004 the town approved a 40-acre real estate development and 650 more homes, with more to come. Entrepreneurs and owners of commercial buildings began turning the old main street and its "Chinatown" Historic District into a string of tourist-attracting boutiques. The town's historical society, promised a new museum, went along with plans that would extend the main street into a shopping district with a historic architectural motif. Overexpansion of the mortgage market

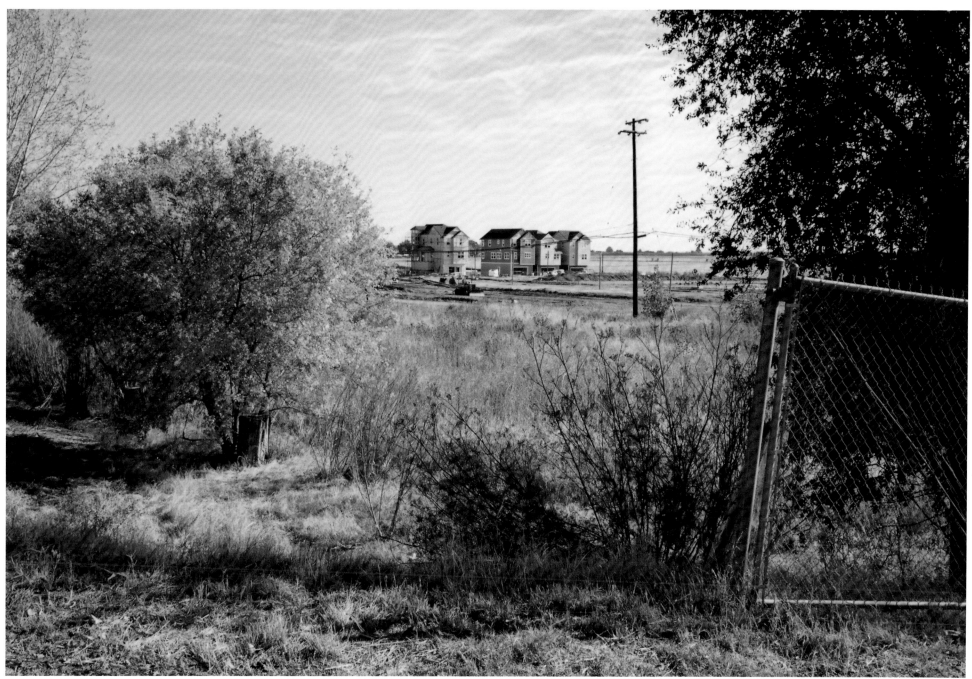

may slow, but probably won't turn, this developmental tide.

Isleton has become the focus of broader environmental concerns. The Sacramento River's Delta region is a honeycomb of islands and dikes, and both environmentalists and state officials have serious doubts that the aging dike system can protect the region's residents, homes, and agriculture from floods. This has become a 'big deal' in the politics of Northern California.

The little river towns of the Delta, for example Rio Vista, Isleton, Walnut Grove, Locke, and Courtland, are threatened culturally as well as environmentally. They're living museums of the subcultures of Anglos, Asian

Americans, and Latinos who lived, worked, and retired in the area in the 19th and 20th centuries. But as the San Francisco Bay Area, Sacramento, and the Northern Central Valley of California increase in population, the small towns and their nostalgic yesteryears come closer and closer to inclusion in the suburban perimeter.

So my "artist's statement" – in a sentence – is that I'd like to make a small contribution to the tradition of Atget, Evans, and all other photographers whose evocative documents have blended photography with history, leaving us a lingering – though never recoverable – sense of era and locale.

Kirk Thompson

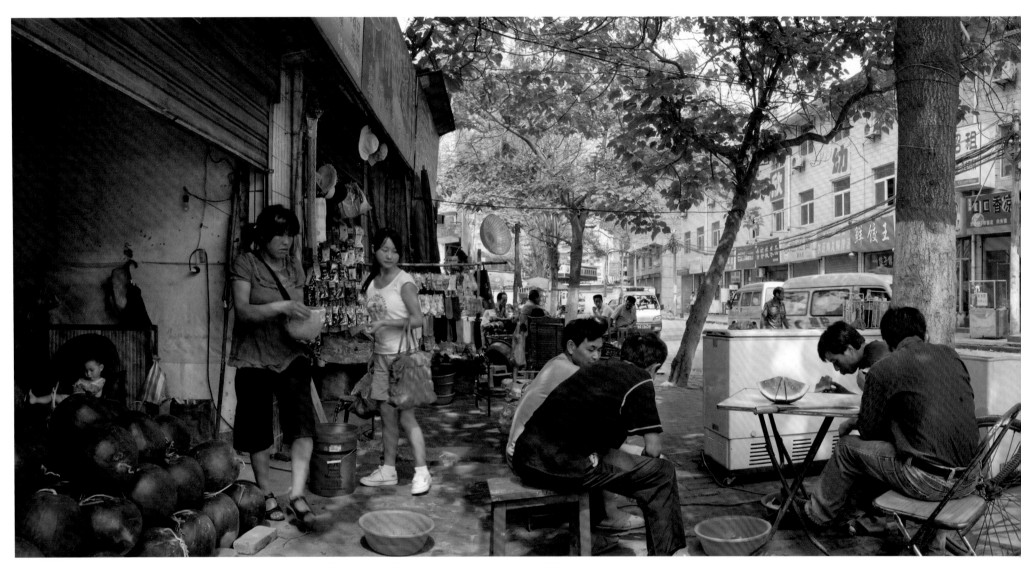

Ducklings and watermelon for sale on a street of Sha Jing Cun, Xi'an, Shaanxi Province, 2007

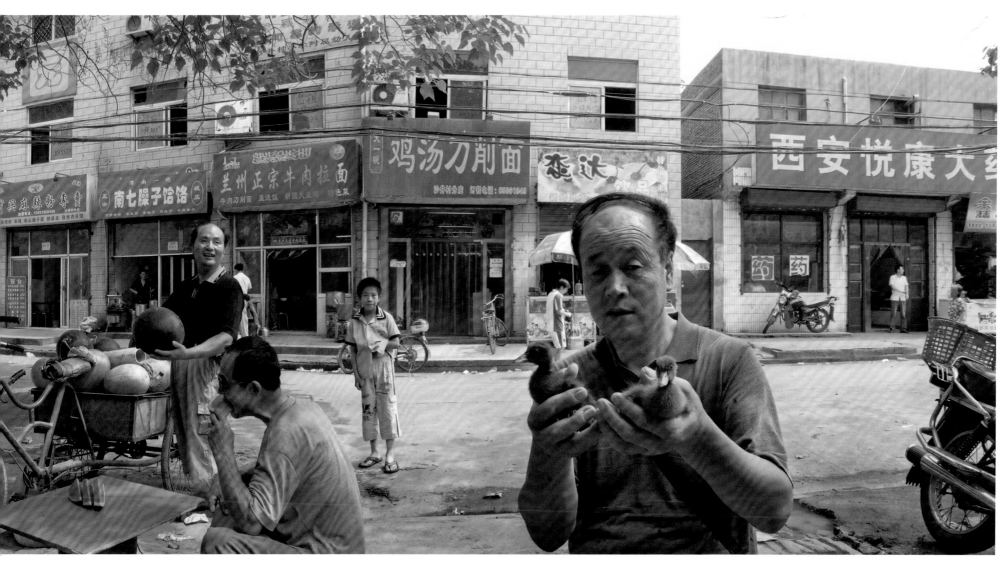

Joseph Vitone

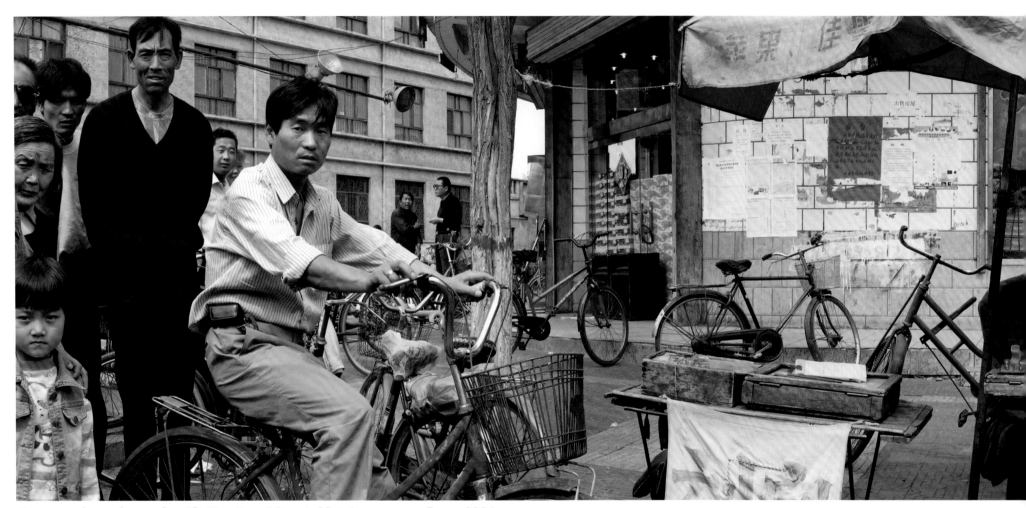

Street vendor and passerby, Shi Tan Jing, Ningxia Hui Autonomous Zone, 2006

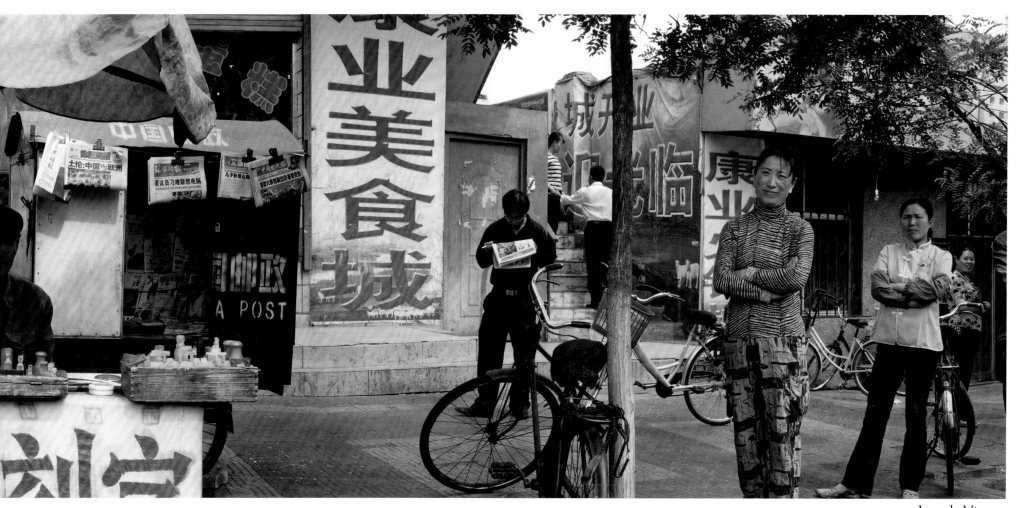

Joseph Vitone

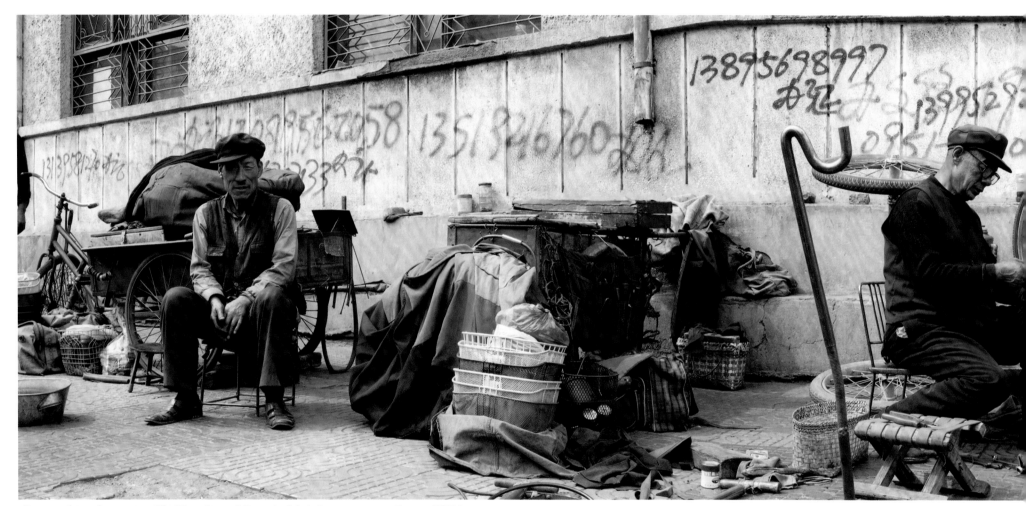

Corner bicycle repair, Shi Tan Jing, Ningxia Hui Autonomous Zone, 2006

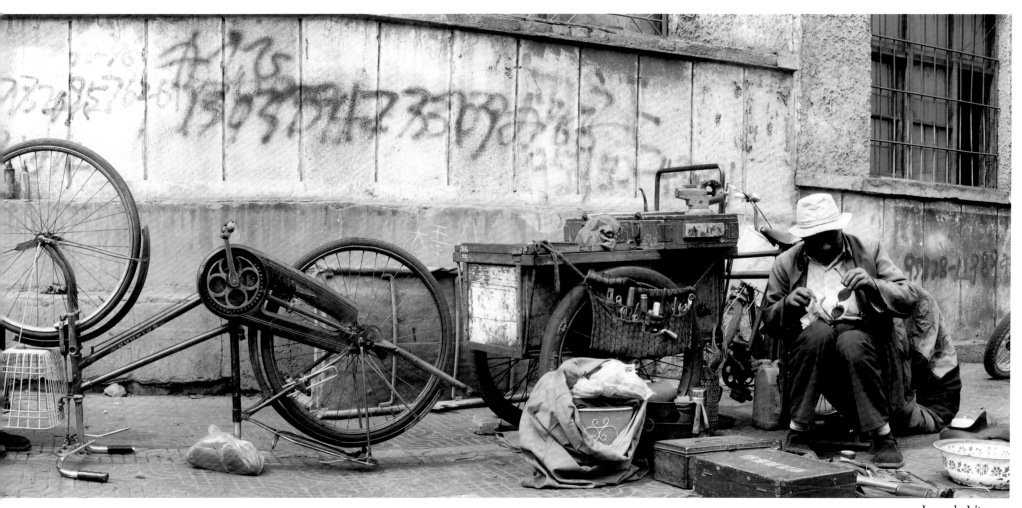

Joseph Vitone

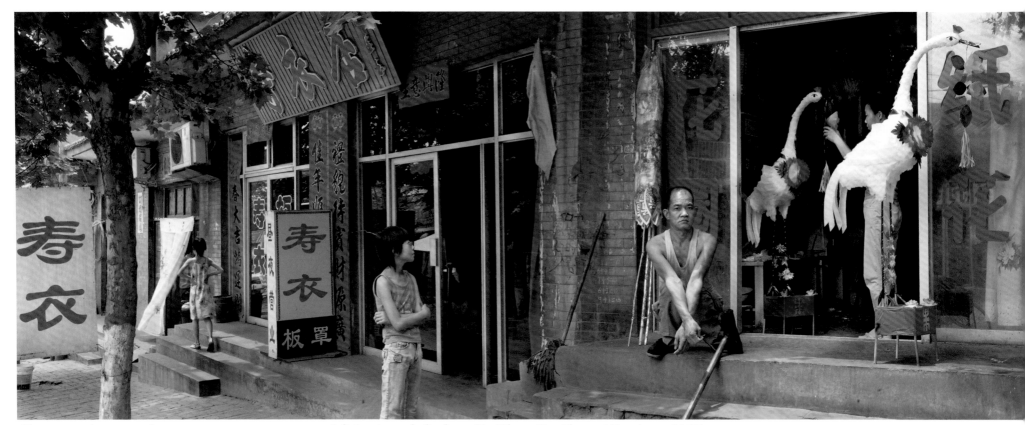

Shop preparing paper funerary cranes on a street specializing in such displays, Jin Cheng Jie, Shaanxi Province, 2007

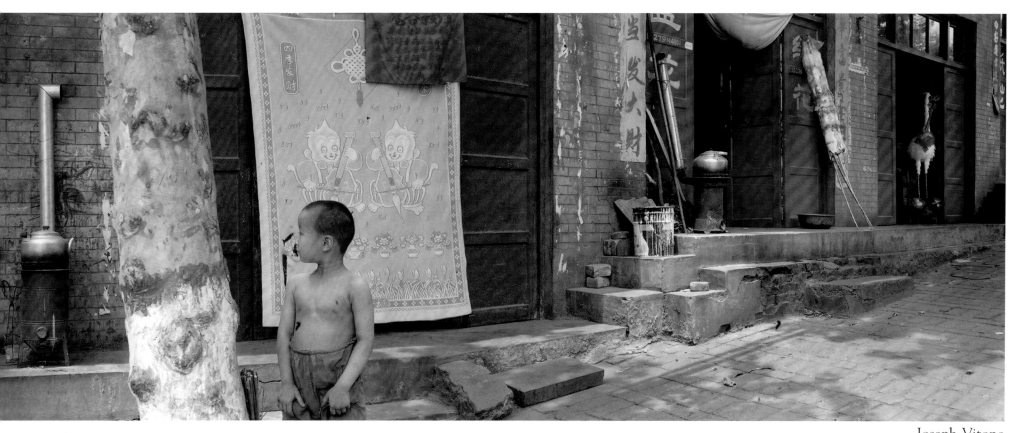

Joseph Vitone

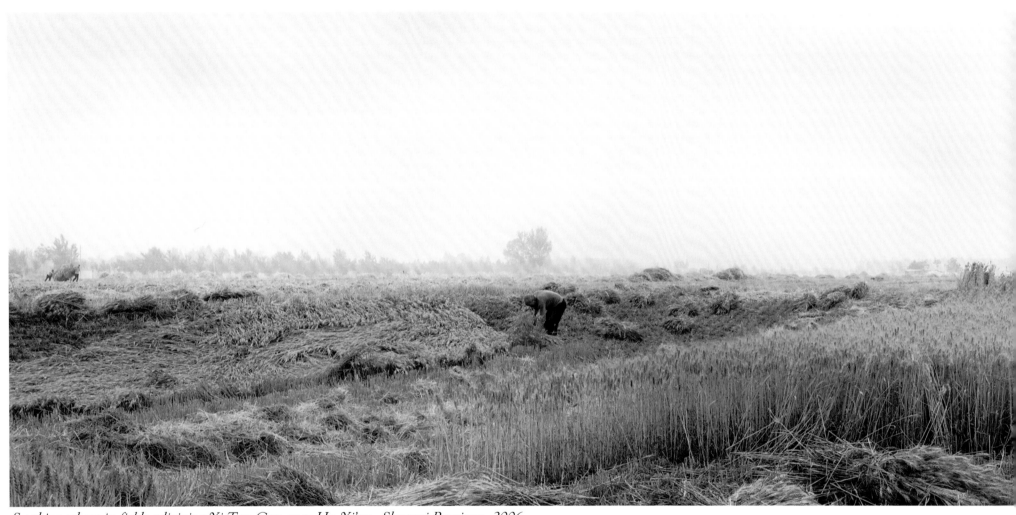

Scything wheat in fields adjoining Xi Tan Cun near Hu Xi'an, Shaanxi Province, 2006

Color Notes on a Wide Field

These panoramas were made within the past couple of years in Western China in the Ningxia Hui Autonomous Zone, an area that pushes into Inner Mongolia, and in Shaanxi Province, home to the Terra Cotta Warriors. While the pictures evidence discovery by the photographer of these areas, it is hoped the photographs also may carry to their viewers the beauty and humanity of this great nation.

There is often a cinematic quality to these pictures – an unfolding of events readable in the choreography of the people through areas depicted. The streets of urban China are dense with life and the activities of commerce. The cadence of rural life continues unchanged in many aspects from a countryside many generations past. The long frame provides a field for unfolding of interactions between the portrait subjects surrounded by their day to day activities. The scenes are presented in such a way as to eschew exoticism and understand the places and characters as approachable and knowable – citizens of a country whose density of population and long history of rural lifestyle have engendered a sense of ease with lack of personal space and acceptance of others as members of a great extended family.

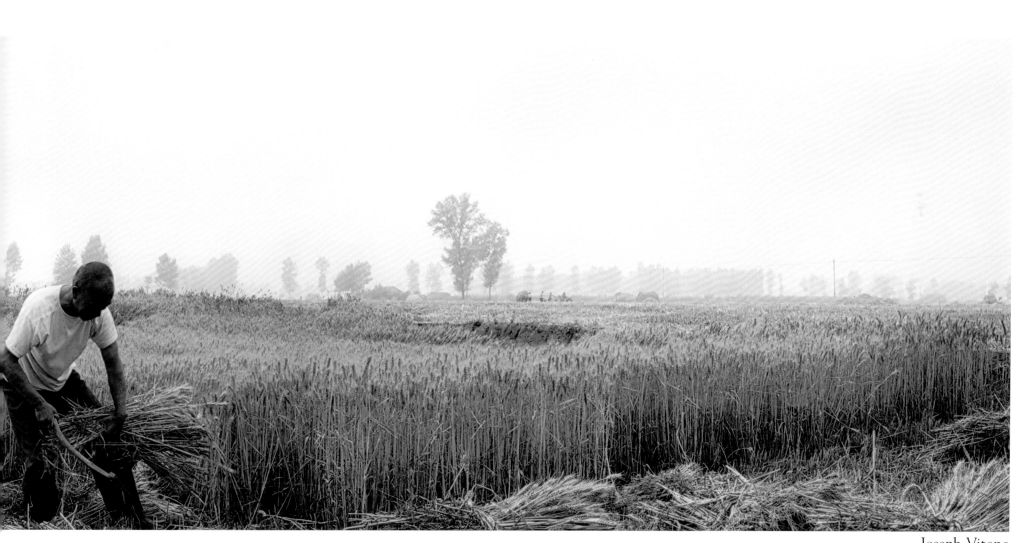

Joseph Vitone

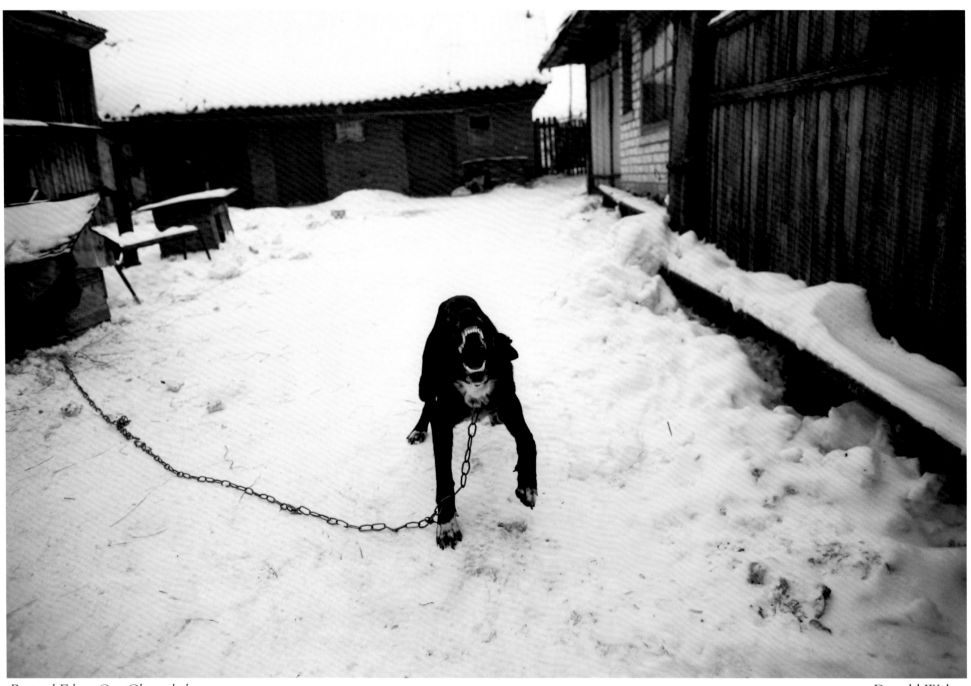

Bastard Eden, Our Chernobyl

Donald Weber

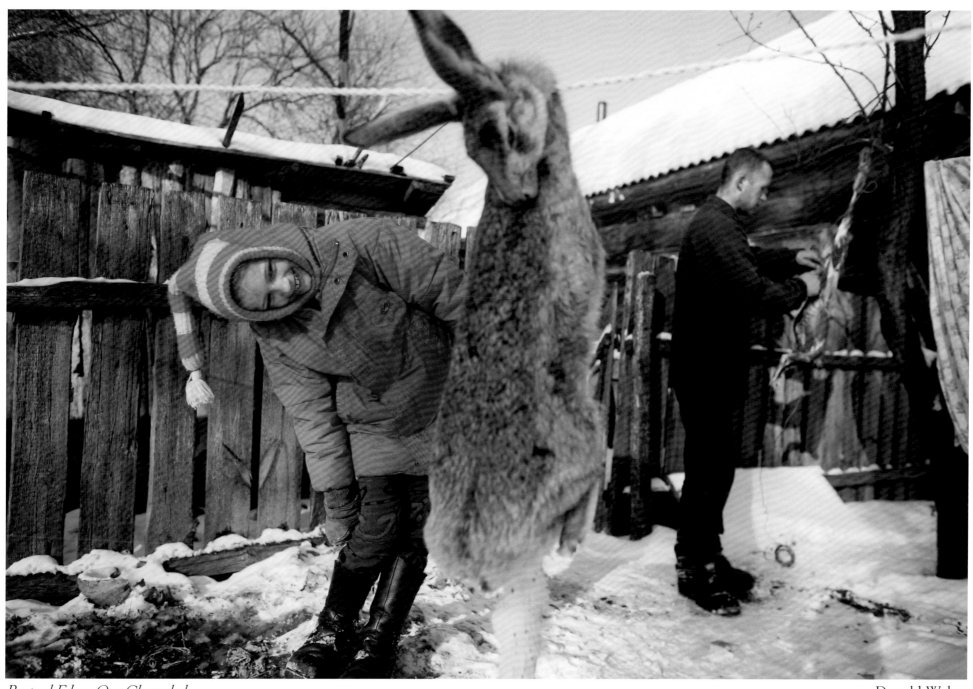

Bastard Eden, Our Chernobyl

Donald Weber

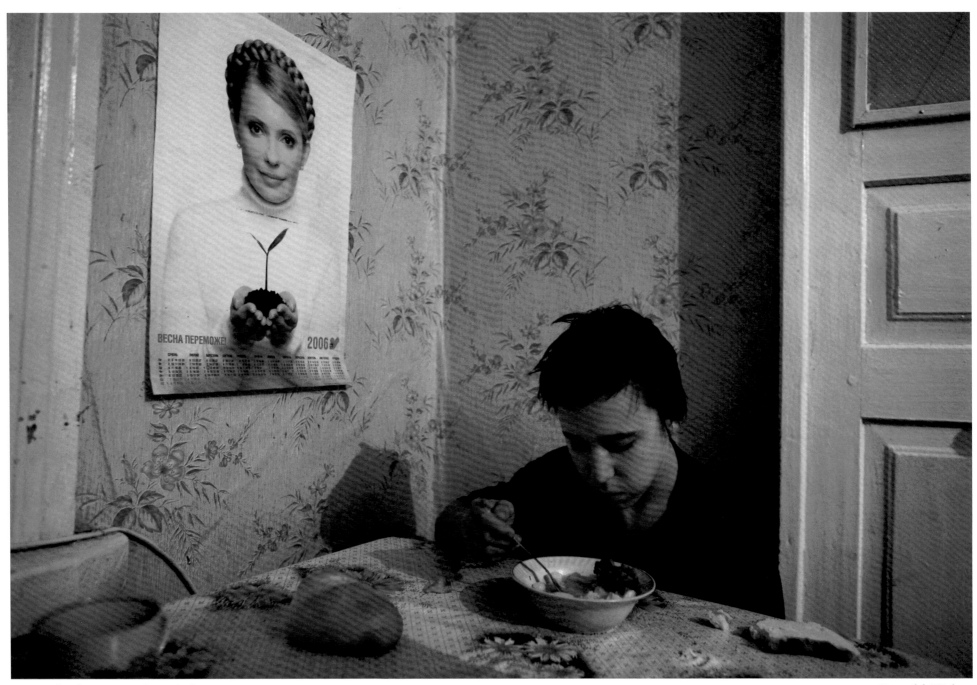

Bastard Eden, Our Chernobyl Donald Weber

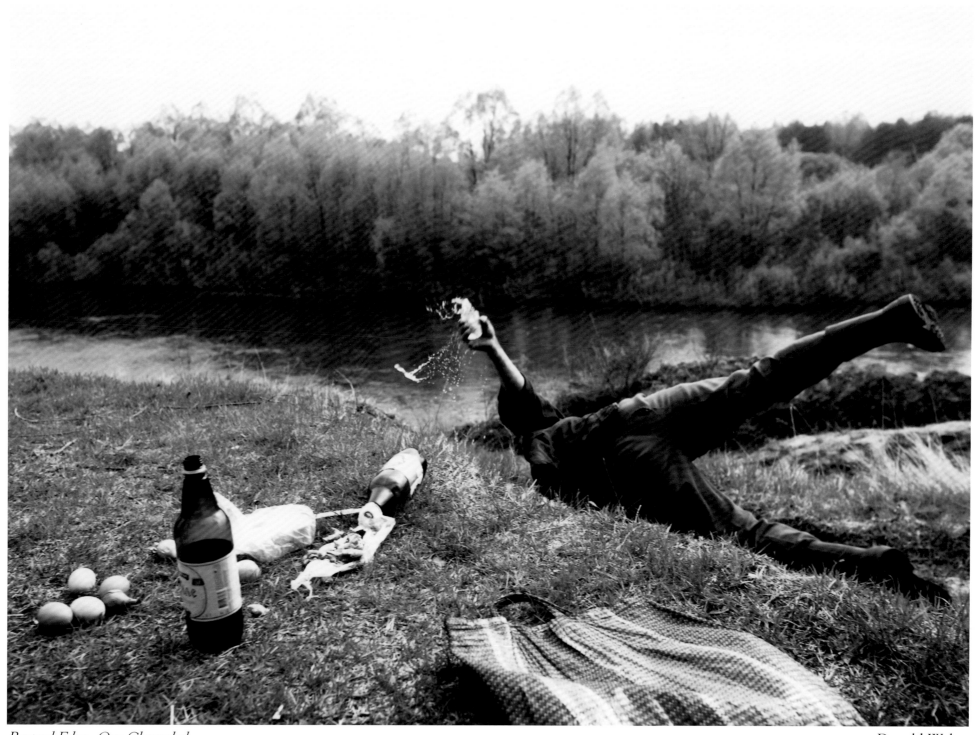

Bastard Eden, Our Chernobyl

Donald Weber

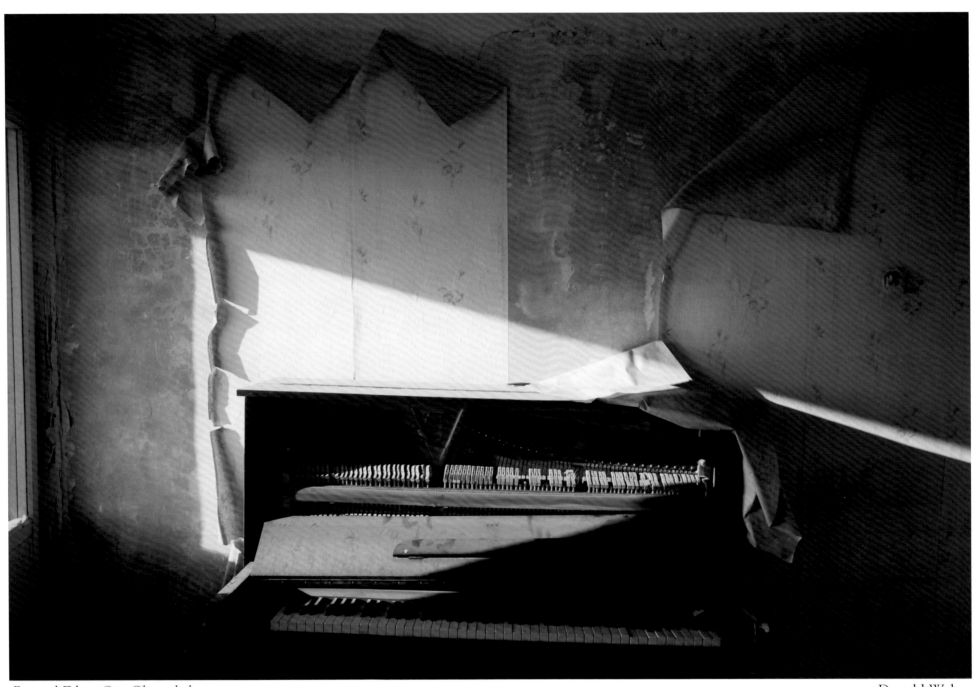

Bastard Eden, Our Chernobyl Donald Weber

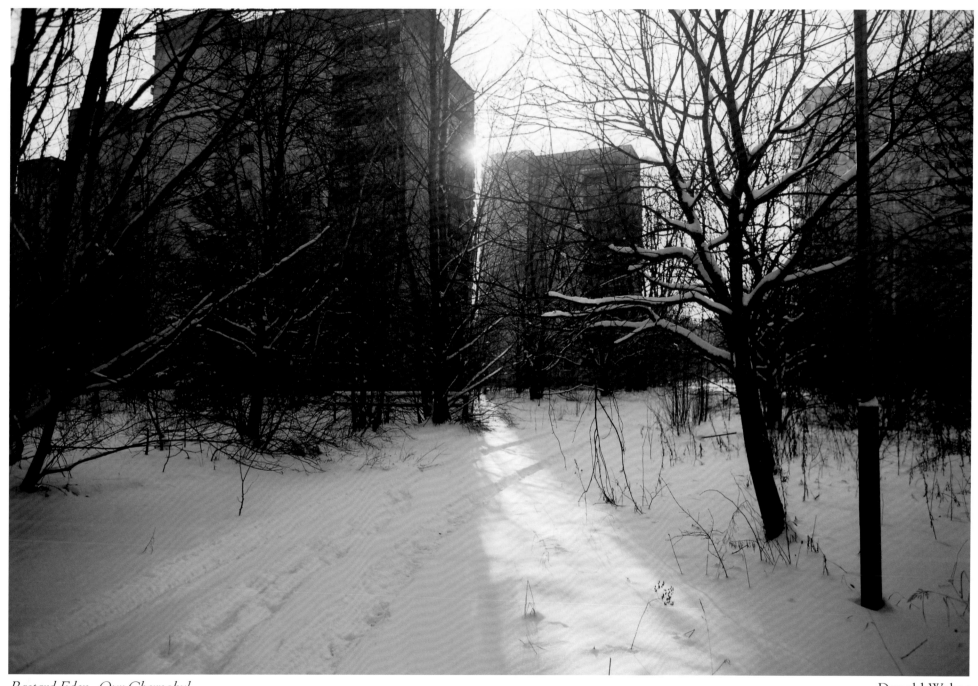

Bastard Eden, Our Chernobyl

Donald Weber

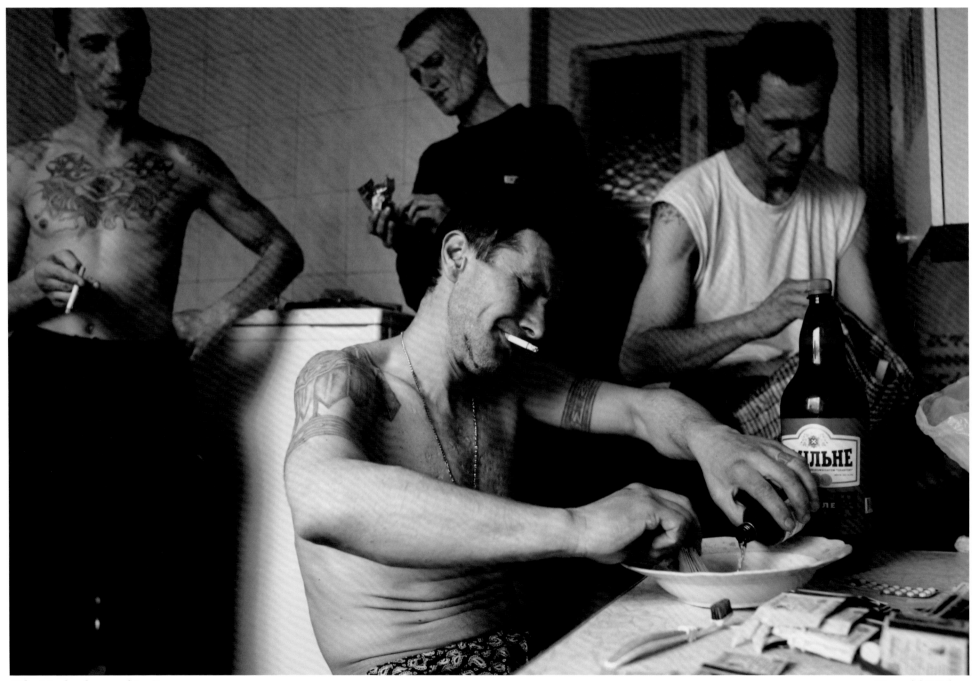

The Underclass and its Bosses Donald Weber

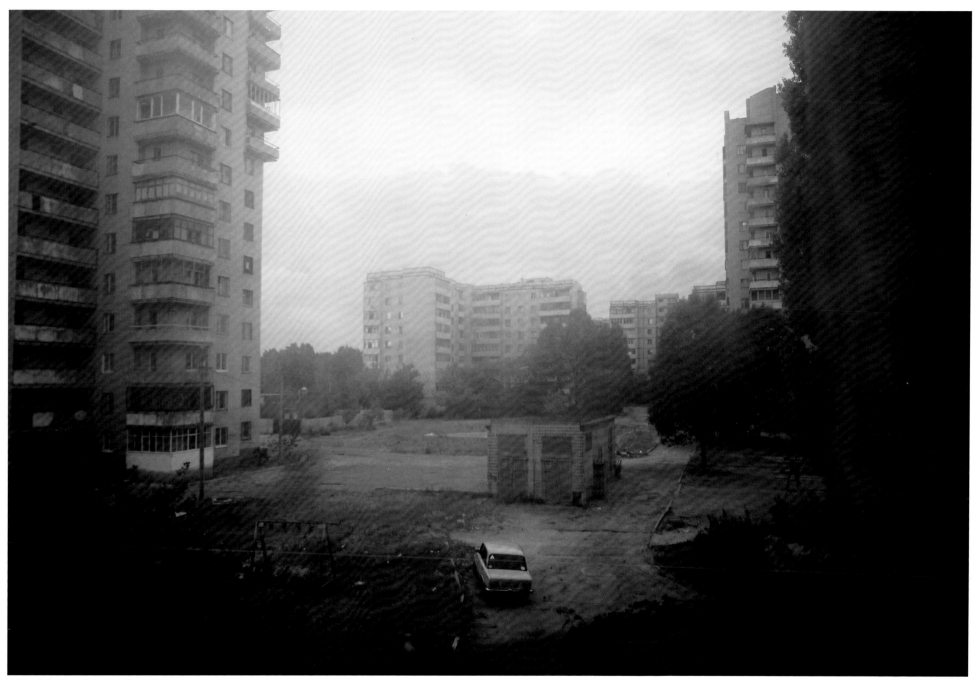

The Underclass and its Bosses

Donald Weber

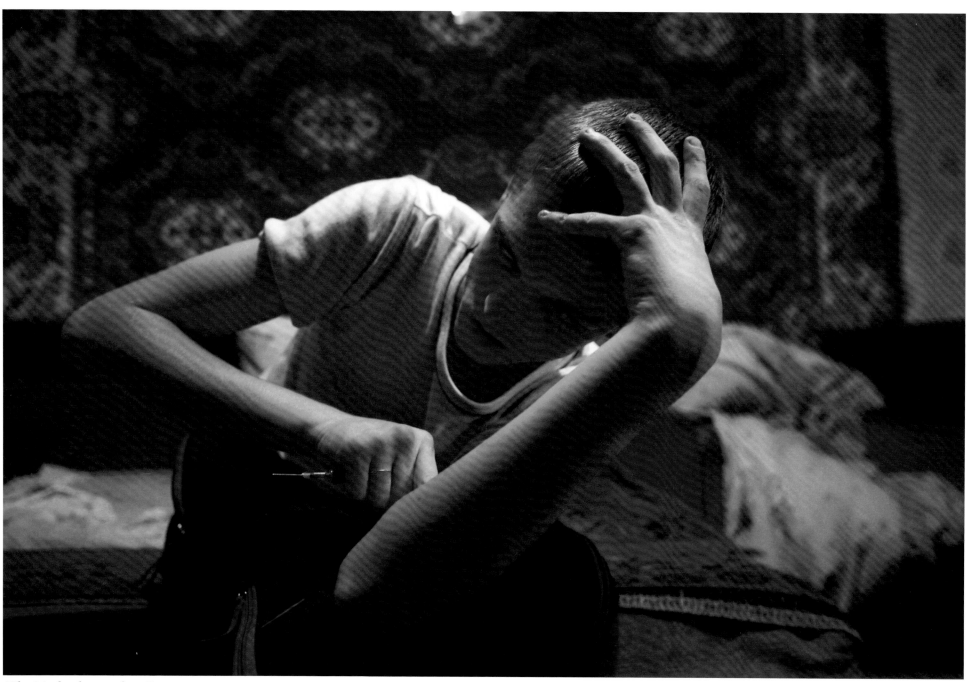

The Underclass and its Bosses

Donald Weber

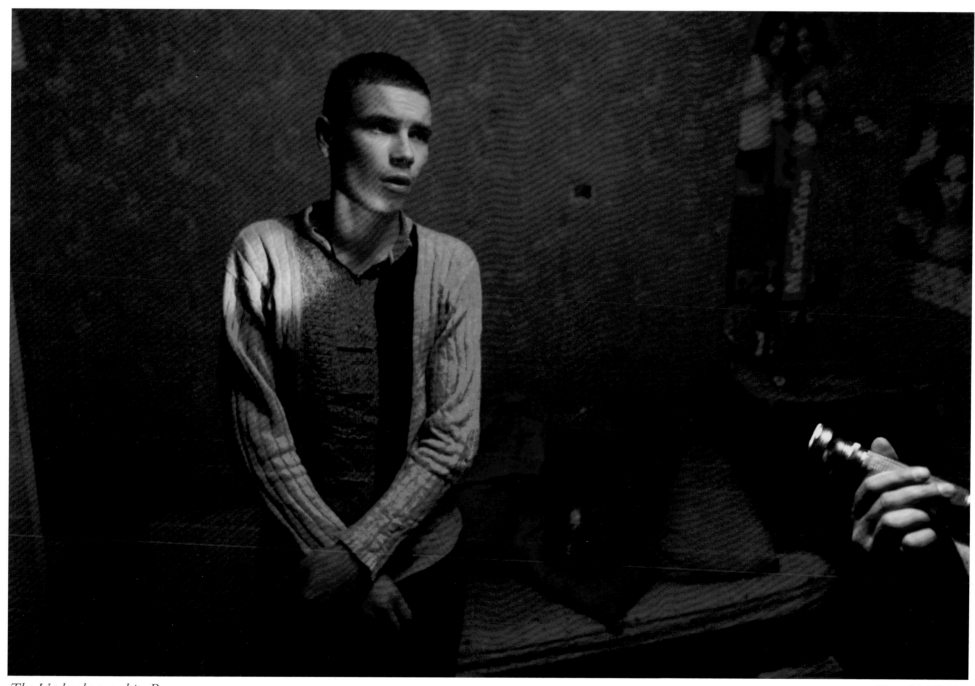

The Underclass and its Bosses

Donald Weber

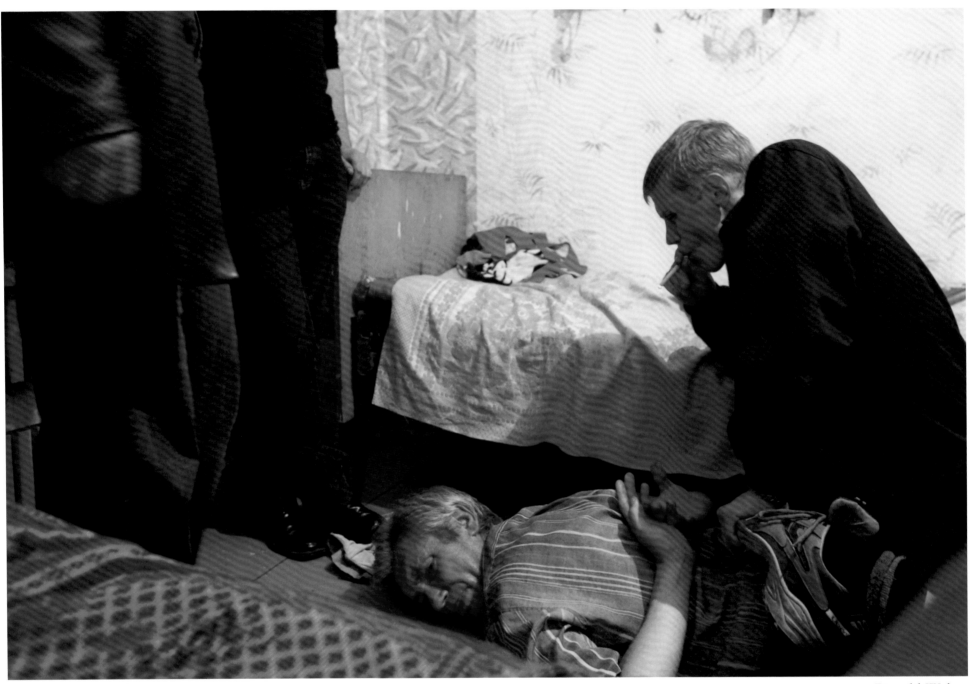

The Underclass and its Bosses

Donald Weber

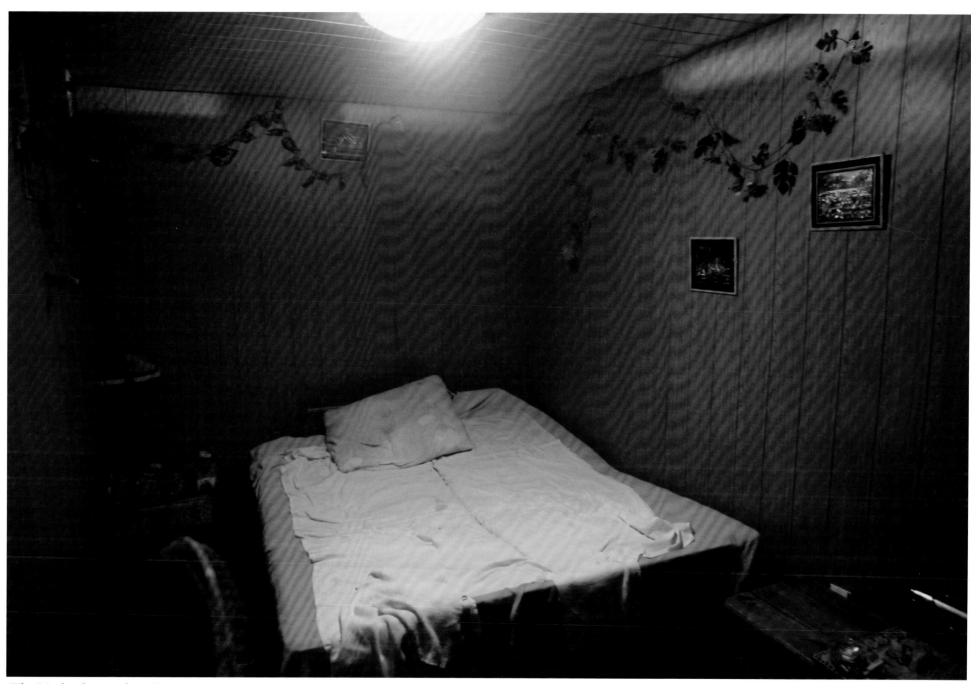

The Underclass and its Bosses

Donald Weber

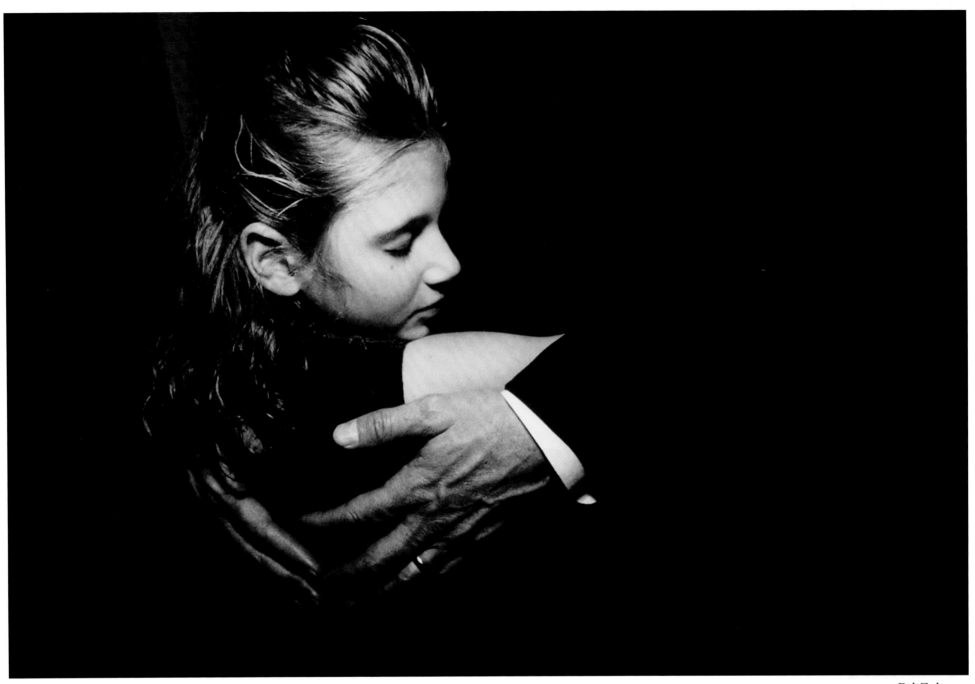

Bil Zelman

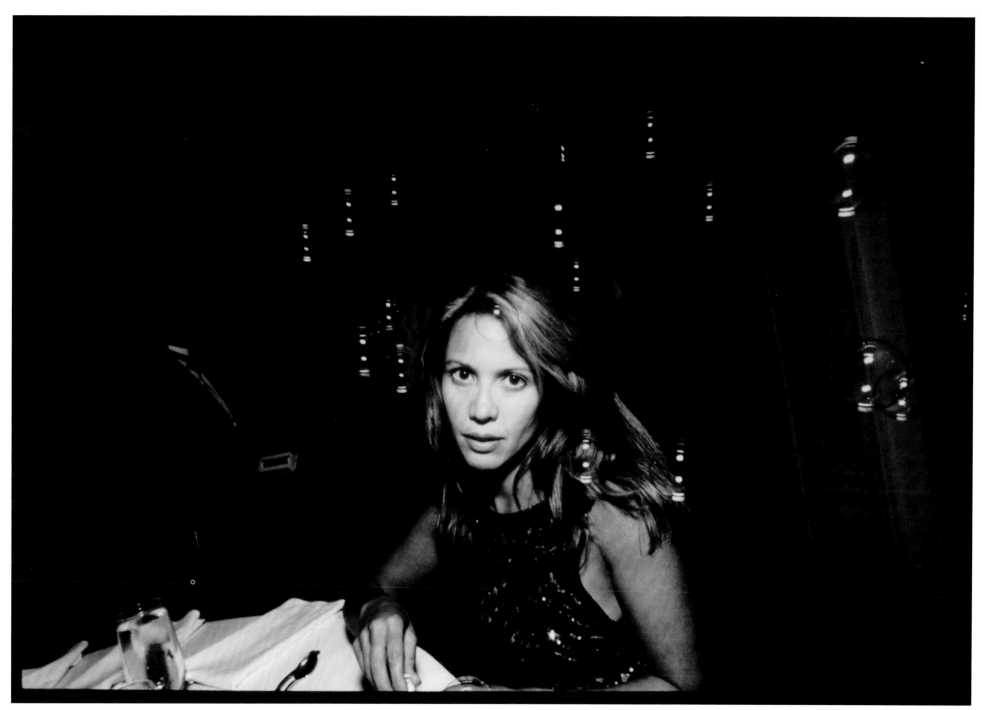

Bil Zelman

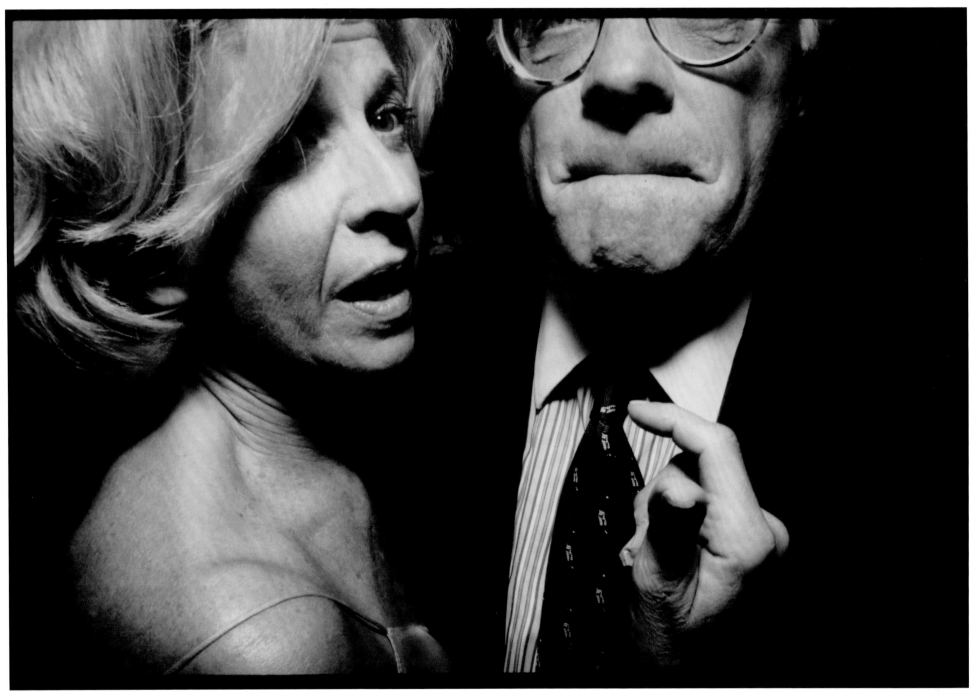

Bil Zelman

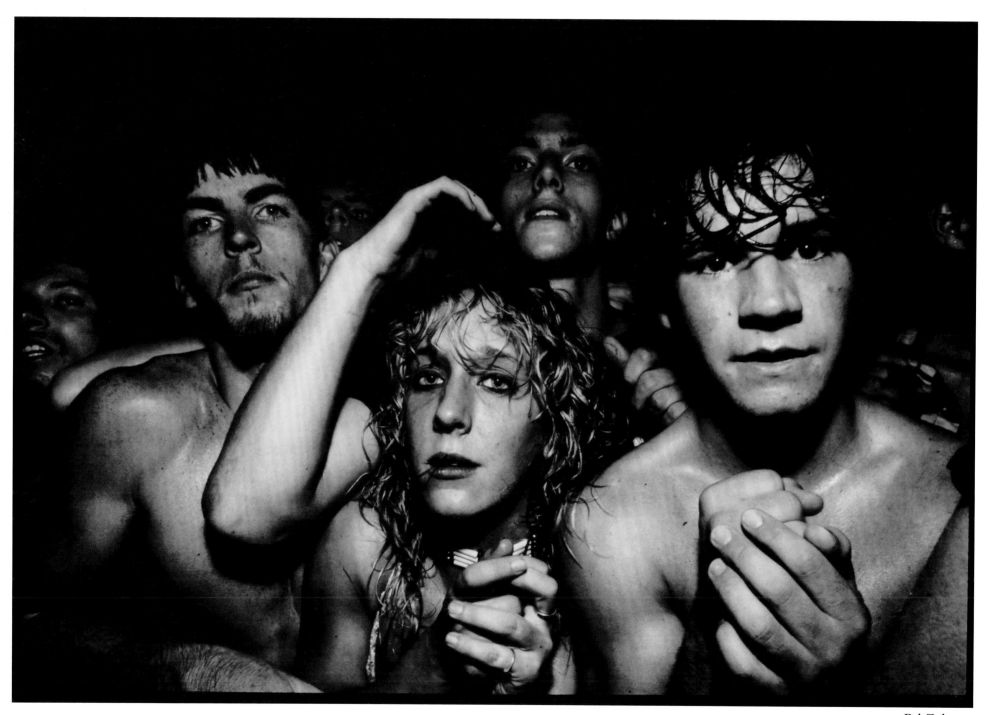

Bil Zelman

"Bil Zelman's way of making pictures reminds me of an early work by John Baldessari, a photograph from the mid-'60s transferred to canvas and captioned by a sign-painter. The image shows the artist standing on the curb near his house. Dead space yawns before him, and a palm tree behind him appears to spring from his head like an unhealthy growth. The single word painted in the margin below—"Wrong"—rubs it in that conventional rules of visual composition have been broken. But there's the image anyway, not in the discard heap but on a museum wall, "wrong" in a dozen ways, but right in at least as many more, from its brash, self-conscious dumbness to its sly, subversive brilliance.

In Zelman's photographs, all sorts of things feel wrong: the edges of the frames slice off valuable facial features, arms and other errant body parts; expressions are too taut or too slack; lips purse or droop, and the same happens with eyelids, which seem in active battle with gravity, either forced open or succumbing to an irresistible weight. The people in this humble pageant, it's safe to say, don't look their best.

Since Garry Winogrand, Larry Fink, Diane Arbus, William Klein and so many others, the aesthetic of the "wrong" has become accepted practice in photography. Aggressive framing, dramatic contrast, unconventional subjects, unflattering shots—all have become comfortably ensconced in the standard repertoire. These photographers—and Zelman positions himself among them—are not exactly conceptual pranksters in the Baldessari mold, but they're agitators of a related sort, purposely getting it wrong in one way so as to get it right in another, disrupting visual order to ignite a kind of visceral disorder".

–Excerpt from Leah Olman's essay on Isolated Gesture, 2006

Bil Zelman

Although Blue Sky is a non-profit organization, the work that we show is actually for sale. If you would like to buy a print to support the artists and the gallery, let us assure you that that will be very deeply appreciated. Here is a list of the prices for the works in this catalog at the time that they were shown at Blue Sky. The good news and the bad news is that it is quite common for artists' prices to go up after they show here. Please send us an email at director@blueskygallery.org to check the current price.

Phil Bergerson – $2000
Stephen Berkman – $3500
Victor Cobo – $1800
KayLynn Deveney – $1200
Beth Dow – $1800
Doug Dubois – $2600 to $3600
Alex Fradkin – $2500
Karen Glaser – $2300
Rita Godlevskis – $2000
Raphael Goldchain – $2500
Nicole Jean Hill – $1000
Jason Horowitz – $4250
Edis Jurcys – $750
Brenda Ann Kenneally – $1200
Elaine Ling – $1600
Danielle Mericle – $6000
Ntare Guma Mbaho Mwine – $400 to $1600
Robert Rauschenberg – $15000 to $25000
Saul Robbins – $1200
Lisa Robinson – $1500 to $2500
Sage Sohier – $1000
Ellen Susan – $975 to $1500
Kirk Thompson – $495
Joseph Vitone – $2800
Donald Weber – $1050
Bil Zelman – $1000

Blue Sky Gallery
Oregon Center for the Photographic Arts
122 NW 8th Avenue
Portland, Oregon 97209

The front cover image is "Irene, 2004" by Rita Godlevskis.
Check out our website at www.BlueSkyGallery.org
Blue Sky is a non-profit gallery supported by our members, the Paul G. Allen Family Foundation,
Digi-Craft, the National Endowment for the Arts, and Portland's Regional Art & Culture Council.

ISBN 0-931194-12-1

REGIONAL
ARTS & CULTURE
COUNCIL

WorkforArt